Praise for *The Power of Daily Practice*

"*The Power of Daily Practice* has radically changed my practice and my thinking, evoking a richer and more expansive understanding of the possibilities and the power of daily practice. Coaches, therapists, and lifestyle medicine professionals will find *The Power of Daily Practice* a wonderful resource. I plan to use it as a primary text in all the wellness classes I teach!"

— **Kathleen Jones,** certified health and wellness coach

"Eric Maisel's ⌐ *Daily Practice*, is a constellation of pra⌐ ⌐reate and make more thing⌐ switch, and the whole boo⌐ ⌐ and supporting you all the time."

— **SARK,** auth⌐ ⌐, PlanetSARK.com

"In *The Power of Daily Practice*, Eric Maisel does more than illustrate why a daily practice can be any creative person's (that means all of us) most powerful tool. He also gives us, point by inspiring point, components that make up such a practice. He leads would-be practitioners through a variety of potential daily practices that can enrich their lives. Finally, with generosity and clarity, Maisel offers practical solutions and creative ideas to meet any challenges along the way. This is an altogether complete and invigorating manual for living a rich and meaningful life, day in and day out."

— **Judy Reeves,** author of *A Writer's Book of Days* and *Wild Women, Wild Voices*

"*The Power of Daily Practice* is the most powerful and comprehensive guide to the art and benefits of daily practice that I have ever seen. It is all you need to cultivate a life-enriching practice of your own. Read this inspiring book, and you will see your daily life, and what you choose to include in it, in new, vastly expanded ways!"

— **Lynda Monk,** director of the International Association for Journal Writing

Praise for *The Power of Daily Practice*

"Creators intuitively understand the benefits of paying daily attention to their art. Eric Maisel spells out those benefits in his brilliant new book, *The Power of Daily Practice*. He describes every element of practice, what challenges to expect, and what you can do to meet those challenges. Every visual artist, every writer, every composer — every creative person — must get his or her hands on this astonishingly good book."

— **Roccie Hill,** executive director of the Mendocino Art Center

"Blending his roles as philosopher, psychotherapist, masterful creativity coach, and human being, Eric Maisel invites us into a life of deeper purpose and abundant joy through the power of daily practice. Thank you, Eric, for this comprehensive, inspiring book. It's right on time!"

— **Jacob Nordby,** author of *The Creative Cure*

"Creating a daily practice and engaging in it is proving to be an enormously rewarding, life-changing, and exciting experience for me. I'm very much looking forward to deepening my experience in the months to come. I've found *The Power of Daily Practice* to be a highly effective guide and an invaluable resource filled with practical advice, engaging stories, and real wisdom. I've built a rewarding daily practice, and finally I'm making progress toward my business, personal growth, educational, and artistic goals."

— **Ann Debontridder,** international ESL teacher

"*The Power of Daily Practice* encouraged me to bring reverence to my daily practices, elevating their meaning and bringing real possibility to my life. My daily practices now truly reflect my goals in life and have given me a satisfying framework for living my most productive and meaningful life possible."

— **Elena Greco,** singer, creativity coach, and holistic counselor

THE POWER OF
DAILY PRACTICE

Also by Eric Maisel

NONFICTION

Affirmations for Artists
The Art of the Book Proposal
The Atheist's Way
Become a Creativity Coach Now!
Brainstorm
Coaching the Artist Within
Creative Recovery
The Creativity Book
Creativity for Life
The Creativity Workbook for Coaches and Creatives
Deep Writing
Everyday You
Fearless Creating
The Future of Mental Health
Hearing Critical Voices
Helping Parents of Diagnosed, Distressed, and Different Children
Helping Survivors of Authoritarian Parents, Siblings, and Partners
Humane Helping
Inside Creativity Coaching
Life Purpose Boot Camp
The Life Purpose Diet
Living the Writer's Life
The Magic of Sleep Thinking
Making Your Creative Mark
Mastering Creative Anxiety
Overcoming Your Difficult Family
Performance Anxiety
Redesign Your Mind (forthcoming)
Rethinking Depression
Secrets of a Creativity Coach
Ten Zen Seconds
Toxic Criticism
20 Communication Tips at Work
20 Communication Tips for Families
60 Innovative Cognitive Strategies for the Bright, the Sensitive, and the Creative
The Van Gogh Blues
Unleashing the Artist Within
What Would Your Character Do?
Why Smart People Hurt
Write Mind
A Writer's Paris
A Writer's San Francisco
A Writer's Space

FICTION

Aster Lynn
The Black Narc
The Blackbirds of Mulhouse
Dismay
The Fretful Dancer
The Kingston Papers
Murder in Berlin
The Pen
Settled

JOURNALS

Artists Speak
Writers and Artists on Devotion
Writers and Artists on Love

MEDITATION DECKS

Everyday Calm
Everyday Creative
Everyday Smart

PROGRAMS

Diet Like You Mean It!
Mastering the One-Person Business

THE POWER OF DAILY PRACTICE

How Creative and Performing Artists
(and Everyone Else)
Can Finally Meet Their Goals

ERIC MAISEL, PhD

New World Library
Novato, California

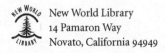 New World Library
14 Pamaron Way
Novato, California 94949

Text design by Tona Pearce Myers

Library of Congress Cataloging-in-Publication Data

Names: Maisel, Eric, date, author.
Title: The power of daily practice : how creative and performing artists (and everyone else) can finally meet their goals / Eric Maisel, PHD.
Description: Novato, California : New World Library, [2020] | Summary: "In *The Power of Daily Practice*, a creativity coach discusses the value of mindful daily practice as a method of self-improvement in all facets of life, with examples drawn from art, music, literature, athletics, political activism, and business. Each chapter includes case studies and questions for reflection." -- Provided by publisher.
Identifiers: LCCN 2020018371 (print) | LCCN 2020018372 (ebook) | ISBN 9781608687060 (paperback) | ISBN 9781608687077 (epub)
Subjects: LCSH: Self-actualization (Psychology)--Case studies. | Creative ability--Case studies. | Conduct of life--Case studies.
Classification: LCC BF637.S4 M3347 2020 (print) | LCC BF637.S4 (ebook) | DDC 158.1/3--dc23
LC record available at https://lccn.loc.gov/2020018371
LC ebook record available at https://lccn.loc.gov/2020018372

First printing, September 2020
ISBN 978-1-60868-706-0
Ebook ISBN 978-1-60868-707-7
Printed in Canada on 100% postconsumer-waste recycled paper

 New World Library is proud to be a Gold Certified Environmentally Responsible Publisher. Publisher certification awarded by Green Press Initiative.

10 9 8 7 6 5 4 3

For Ann, forty-two years into this adventure,

and

*for everyone who grows a daily practice
in the service of the greater good*

CONTENTS

Introduction *1*
Frequently Asked Questions *21*

Part I: The Elements of Practice

Element 1: Initiation 33
Element 2: Simplicity 38
Element 3: Regularity 43
Element 4: Seriousness 48
Element 5: Playfulness 52
Element 6: Honesty 56
Element 7: Self-Direction 60
Element 8: Intensity 65
Element 9: Lightness 70
Element 10: Presence 74
Element 11: Ceremony 79
Element 12: Joy 84
Element 13: Discipline 88
Element 14: Devotion 93

Element 15: Repetition 97
Element 16: Innovation 101
Element 17: Self-Trust 105
Element 18: Love 109
Element 19: Primacy 114
Element 20: Completion 118

Part II: Varieties of Daily Practices

Practice 1: Your Creativity Practice 127
Practice 2: Your Recovery Practice 131
Practice 3: Your Life Purposes Practice 136
Practice 4: Your Meaning-Making Practice 141
Practice 5: Your Spiritual Practice 146
Practice 6: Your Mindfulness Practice 150
Practice 7: Your Health Practice 155
Practice 8: Your Mental Health Practice 159
Practice 9: Your Relationship-Building Practice 164
Practice 10: Your Personality Upgrade Practice 168
Practice 11: Your Business-Building Practice 173
Practice 12: Your Activism Practice 178
Practice 13: Your Performance Practice 183
Practice 14: Your Warrior Practice 187
Practice 15: Your Healing Practice 192
Practice 16: Your Problem-Solving Practice 196
Practice 17: Your Kirist Practice 200
Practice 18: Your "Any Activity" Practice 209

Part III: Challenges to Daily Practice

Challenge 1: Mindset 219

Challenge 2: Chaos and Noise 224

Challenge 3: Restlessness 228

Challenge 4: Time and Space 233

Challenge 5: Self-Talk 237

Challenge 6: Bodily Sensations 242

Challenge 7: Difficulty 247

Challenge 8: Anxiety and Distractibility 252

Challenge 9: Skill Set Issues 256

Challenge 10: Circumstances 261

Challenge 11: Health 265

Challenge 12: Defensiveness 269

Challenge 13: Lack of Progress 274

Challenge 14: Mistakes and Messes 279

Challenge 15: Failures 284

Challenge 16: Personality 288

Challenge 17: Conflict 293

Challenge 18: Boredom and Meaninglessness 298

Epilogue: The Power of Daily Practice 303

About the Author 307

Part III: Challenges to Daily Practice

Challenge 1: Murder 216

Challenge 2: Chaos and Loss 224

Challenge 3: Restlessness 229

Challenge 4: Time and Space 231

Challenge 5: Sobriety 237

Challenge 6: Being Adventurous 242

Challenge 7: Difficulty 247

Challenge 8: Anxiety and Unsteadiness 254

Challenge 9: Silly or Nasty 258

Challenge 10: Performance 260

Challenge 11: Death 264

Challenge 12: Defensiveness 269

Challenge 13: Lack of Progress 274

Challenge 14: Monkeys and Horses 279

Challenge 15: Humor 284

Challenge 16: Personality 288

Challenge 17: Control 294

Challenge 18: Boredom and Formalization 298

Postscript: The Way of Mindfulness 305

About the Author 306

INTRODUCTION

In this book, I want to help you make sense of a simple idea that can make a big difference in your life. It's the idea of *daily practice*. Daily practice, as I'll explain it, is as much about paying attention to your life purpose choices as it is about getting something done. If your daily practice were just the way you got your novel written, grew adept at yoga, calmed yourself through meditation, paid good attention to your health, or built your online business, that would be valuable enough. But it is really much more than that. It is an invaluable way to make daily meaning and to live your life purposes fully.

I would also like to introduce you to *kirism*, a contemporary philosophy of life that I've been developing over the past fifty years. I won't say very much about kirism in this book, as this is a hands-on volume about daily practice, not a book about philosophy. But if the little I do say piques your interest, please visit kirism.com to learn more. Kirism presents a comprehensive, coherent, and thoroughly modern philosophy that addresses the exact

challenges you and I face. I think you'll find it an interesting and maybe important take on life.

But back to daily practice. Let's start with the simple idea that there are likely things you want to get done. Many people want to get a particular thing done that requires them to show up in a daily or a regular way. It might be anything from building their online business to writing their novel, from exercising their body to playing their musical instrument, from maintaining recovery from an addiction to building up their health after an illness. Most people have several of these to-do things that would greatly benefit from daily or regular attention.

At the same time, people find creating and maintaining a daily practice very hard to do. In working with creative and performing artists, first as a therapist and, for the last thirty years, as a creativity coach, I've encountered countless clients who want to get to their creative work in a regular way — and who can't seem to manage to do that. They can always point to the culprit: too much busyness, not enough time, too many distractions and interruptions, and so on. But in their heart of hearts they know that they could be doing a better job of showing up. What is preventing them from doing the thing that they would love to be doing or the thing that they really need to be doing?

A daily practice may sound like too much regimentation. In fact, it is the path to freedom.

"Freedom is not given to us by anyone; we have to cultivate it ourselves. It is a daily practice."
— Thich Nhat Hanh

There are many reasons for their difficulties: their thoughts are likely not supporting their intentions, the

thing they mean to do may be harder than they wish it were, positive results do not accumulate fast enough to provide ongoing motivation, they have doubts about the meaningfulness of the thing they intend to be doing, they feel merely interested in the thing rather than genuinely devoted to it, and many more. The list of reasons why it's so hard to maintain a daily practice is very long (and we'll address eighteen of these challenges in part III of this book).

In the face of these many challenges, having a daily practice can help. What do I mean by "having a daily practice"? I'm guessing that, while it's possible you have never spelled out the idea of daily practice, you nevertheless have an intuitive understanding of what the idea might mean. Consider the following scenarios.

When someone says that she maintains a spiritual practice, we have an intuitive sense of what that person means and what that practice might entail. We envision her engaging in certain activities in a ceremonial way, whether that is lighting candles or sitting meditatively; we expect that she spends a certain amount of time every day, probably first thing each morning, formally engaged with her practice; and we picture her practice informing all aspects of her life, such that, for instance, when a crisis occurs, she uses her belief set (about an afterlife, say) and her techniques (like prayer or meditation) to see her through it.

Likewise, if someone tells us that he is training for a marathon, a prizefight, or a high-altitude climb, we immediately get a picture of what that likely entails. We

expect that he exercises every day, even on days that he doesn't want to; that he watches his diet and passes on the hot fudge sundaes, even though he craves them; and that he visualizes success and in other ways talks himself into the right frame of mind. We picture him taking charge of his mind and his body and engaging in a goal-oriented process that naturally includes pushing himself in ways that on many days he might hate.

Martial artists provide us with another model. We picture their formality: the way they bow when they enter the martial arts studio and when they face an opponent before a match. We picture their intensity: the way they shout at the right moment, the way they drive themselves, the way they focus on a given move and a given routine. We picture the value system by which they operate, which revolves around the honorable use of force and which sanctifies self-control, including the self-control to walk away rather than to fight.

Then there's the path of the dedicated thinker, someone who lives for intellectual problems to solve and whose main meaning investments have to do with unraveling the laws of the universe, finding cures for diseases, or inventing ever-better mousetraps. We picture a self-directed person who takes it upon himself to pick his path, even if it runs counter to the path his peers are following; to bite into his problem as a starving man bites into a sandwich; and to demonstrate a resolve and a tenacity that are periodically punctuated by joyous shrieks of "Eureka!" when the right answers come.

And what if someone tells us that she has spent a

lifetime battling for the release of political prisoners? In our mind's eye, we see her engaged in a dedicated, daily way with an enterprise that she feels is important, persevering in the face of setbacks and indifference. We don't picture her smiling much; we don't picture her activist life punctuated by a great many successes; but we understand why she is bringing every ounce of fortitude she can muster to this enterprise, why she values spending her time on earth in this way.

And what if we met a woman at a cocktail party and learned that she had written and published twenty novels and thirty nonfiction books? Certain thoughts about how she must live her life would immediately come to mind. We would picture her chatting easily and regularly — maybe even every day — with marketplace players like agents, editors, and publicists. We would see her attending book signings, giving interviews, and traveling in support of her books. If she somehow contrived to avoid all of that, we would still be pretty sure about the following: that whatever else she did or didn't do on a given day, she would be doing some writing.

> Daily practice is the path to freedom. It is also the path to excellence.
>
> *"I know you've heard it a thousand times before. But it's true — hard work pays off. If you want to be good, you have to practice, practice, practice."*
> – Ray Bradbury

In each instance, we intuitively understand what's going on. But for us to create and maintain our own daily practice, we need more than an intuitive understanding. This book provides that "more." First, in part I, I'll identify and describe the twenty elements that make up a daily

practice. In part II, we'll examine a wide variety of daily practices. In part III, we'll look at how to handle the many challenges to practice that regularly arise. With this guidance, you'll be able to create your own daily practice and keep it going in the face of adversity.

A note: I suggest that you read through the whole book before starting your own daily practice. It will serve you to have gotten a sense of the elements of practice, the types of practices available to you, and the challenges you're likely to face before you launch your own daily practice. It isn't essential that you follow this plan, but I think it's a wise one.

Part I: The Elements of Practice

A daily practice is easier to maintain if it is made up of certain key elements. In part I, we'll look at twenty of these key elements of practice.

A molecule of water is known to us as water, not as its constituent electrons, protons, and neutrons. It can't be water without those constituent parts, but we experience it as water, not as a collection of entities. The same is true with your daily practice. It is useful to name and look at the elements that make up a practice, but what matters is the whole thing — the practice itself.

What is a daily practice? It is a way that you take your existence seriously, one breath at a time, one thought at a time, one moment at a time. It is your daily routine of paying attention to the areas where you have set your intentions. It looks like the silence of deep space filled with

the brilliant fire of a single star. It is you spending a significant amount of time every day focused in one direction.

Maybe you are focused on writing poetry. Then yours is a daily writing practice. That is the way you turn your passion for creating into poetry. Your writing practice is you attending every day to one of the loves of your life, poetry. You sit there and you write your poems. You do that again tomorrow and again the next day. That is a writing practice.

What exactly are you practicing? Being your human best. How exactly are you practicing? By entering the space that you've created and by staying put. And what if you're anxious and afraid? Then you strive to manage that anxiety. And if some fear remains, you practice anyway.

Where exactly do you start your practice? You start your practice right where you are: deficient, proficient, anxious, calm, ready, unsteady. Maybe you would like to start your practice in another place? No; you must start it where you are. Where else can you start it?

Maybe a voice in you says, "Why bother?" That is a very powerful voice. It represents your sincere doubt that you matter, that you count. It represents your conviction that all is illusion. It represents your fatigue in the face of reality. "Why bother?" you hear yourself say. That could easily be a day of no practice. Instead, you counter that voice, you affirm your existence, and you practice anyway.

What, then, are the elements of practice? I've identified twenty: initiation, simplicity, regularity, seriousness, playfulness, honesty, self-direction, intensity, lightness, presence, ceremony, joy, discipline, devotion, repetition,

innovation, self-trust, love, primacy, and completion. I'll explain each of these in turn in part I. You may also want to explain them to yourself, maybe in writing, maybe by addressing the questions I'll be posing at the end of each chapter.

That we are discussing twenty elements of practice may make the idea of creating a daily practice seem complicated and daunting. But it isn't. When all is said and done, all those electrons, protons, and neutrons come together simply as water. When all is said and done, your daily practice is simply you paying attention to what you deem important.

Learn the elements of daily practice and then forget them; just get on with your daily practice. It is only if and when you have trouble with your daily practice that these elements may need to be considered again. If all is going well, you don't need to ask yourself, "Oh, what about joy?" or "Oh, what about intensity?" All of that will take care of itself!

If your practice is working, you need not think about any elements of practice at all. If it isn't working, then it makes sense to wonder if one of the challenges discussed in part III is making itself known or if revisiting the elements of practice might be the path to take.

Part II: Varieties of Daily Practices

In part II, we look at a variety of daily practices or, more properly, our basic daily practice used in different ways.

Whether you're putting together a creativity practice, a yoga practice, a recovery practice, or a problem-solving

practice, the elements remain the same. The content and focus are what make them different practices. Some practices will be more about doing, like writing or sculpting, and some practices will be more about being, like practicing calmness. So one practice may have quite a different flavor from another practice. But in each case the elements underlying the practice will be consistent.

Maybe you are ordinary in a lot of ways. But you can be extraordinary at your daily practice.

"I've always considered myself to be just average talent and what I have is a ridiculous insane obsessiveness for practice and preparation."
— Will Smith

You build and maintain your daily practice in the following ways:

- **Read part I and familiarize yourself with the elements of practice.** If you feel so inclined, you might describe each of the twenty elements in your own words, so as to begin to own them as ideas. You might also chat a bit with yourself about how the polar opposite elements of practice — pairs like seriousness and lightness, repetition and innovation, and discipline and playfulness — hang together. Taking some time to consider each element of practice in turn will pay dividends in the long run.

- **Read part II to get a sense of where you might want to focus your daily practice.** You might begin by making a list of possible daily practices. You might then sit with your list and let the right practice announce itself. You might also think through

whether some practices on your list want to com-
bine in some way — your prospective diet practice
and your prospective exercise practice, for example,
perhaps combining into a daily health practice.

- **Decide if you want to start building one daily
practice or if you want to try your hand at mul-
tiple daily practices.** You might decide simply to
focus on building a writing practice, or you might
decide to build a writing practice, to align with
that life purpose choice, and simultaneously to
build a health practice, to align with another life
purpose choice. Is it possible to create even more
practices than two? It certainly is, but you may
want to wait a bit and see how your first practice
or two work out before aiming at more.

- **Describe your practice to yourself.** What exactly
will it look like? What are its goals and intentions?
Will it happen at the same time each day or at a
different time each day? If at a different time, do
you want to ceremonially plan for it each morning
as part of a life purpose morning check-in or in
some other way? You might also go through the
twenty elements of practice and, with each one
of them, explain to yourself the place of that el-
ement in your proposed practice. That is: How
will you keep your practice simple? How will you
keep your practice honest? How will you foster
real presence? And so on down the list. Likewise,
you might visualize yourself living your practice
by trusting yourself, imbuing your practice with

ceremony, and taking other self-supporting actions. Aim for getting as clear and concrete a sense of your proposed daily practice as you can.

- **Implement your practice.** After you've finished reading this book, pick a day, sooner rather than later, and begin your daily practice. If you don't manage to begin it that day, set the intention of beginning it the following day. Get started and try your best to have your practice become a daily activity. If you find yourself having trouble getting to or sticking with your daily practice, revisit part III to see if you can identify what challenge is getting in the way. Then, think through what you might try to do in order to meet that challenge.

- **Monitor your practice.** What are you liking about your practice? What aren't you liking? Is your practice serving your intentions? Is there some element of practice that feels missing? If you feel like it and if it makes sense to you, you might keep a journal as a place to monitor your practice. In it you might keep track of your goals, if you're setting goals, and you might chat with yourself about what's working or not working. You might also use your journal as a place to record if you miss a day of practice, to think through why you missed it, and to pledge to return to it the next day.

- **Make changes to your practice.** Your daily practice may work well from its inception. But as likely as not, it will need some tweaks along the way, and it may need some quite significant changes. You

may need to switch out the physical place where you practice, the length of time you practice, and even the nature, focus, and content of your practice. Try to strike a balance between giving your initial conception a chance, on the one hand, and promptly making those changes you deem necessary, on the other.

- **Address any challenges that may arise.** It would be lovely if your daily practice felt easy, but it may not, at least not in the beginning. Challenges will almost certainly come up. So you want to be careful not to use feeling challenged as an excuse to drop your daily practice. Do an honest job of identifying the nature of the challenge, think through what changes might be sensible to make, and implement those changes. Treat challenge as a natural part of this process. Accept that you will need to honestly notice what is going on and deal promptly with any challenge that may be derailing or threatening to derail the process.

- **Resume your practice if you stopped it.** If you miss a day, simply start again the following day without fuss or drama. But if you begin to miss many days — which can easily turn into months and forever — then you need to mindfully, intentionally, and formally begin again. A good procedure is to pick a number of days that you can miss without considering that a problem or a crisis: say, two days or at most three days. When you reach that number, make a special point of returning to

your practice the next day. Employing this simple tactic may make the difference between keeping your practice alive and losing it.

- **If you've set up multiple daily practices, follow the above steps for each one.** Your first practice may be working beautifully, and your second practice may not be working at all well. Each practice will have its own requirements, demands, and challenges. Try not to use the thought "Well, at least one is working" as an excuse to throw in the towel on your other practice. That second one is almost certainly worth saving. Your multiple daily practices are likely serving multiple life purpose choices, and each daily practice is valuable in its own right. Pay good attention to each of the daily practices you've inaugurated.

- **Be in it for the long haul.** Your daily practices provide lifelong benefits. My hope is that you experience their value and want to have at least one daily practice in place at all times. But life can throw us curveballs. Can you envision a strategy for reminding yourself about the value of a daily practice when some crisis strikes and you lose all appetite for practicing? Spend a little time right now answering this question, since you're unlikely to be in the mood or have the wherewithal to think about saving your daily practice when you are in the middle of upheaval.

- **Institute a daily practice as part of kirist living.** Kirism neither spells out nor demands any

particular or necessary practices. Each kirist has the task of inventing his or her own best practices. But I do strongly suggest that creating and maintaining one or more daily practices is a smart way for kirists to support their intention to live their life purposes and to coax meaning into existence. To get a sense of the connection between creating and maintaining a daily practice and living a kirist life, please visit kirism.com.

What distinguishes someone — say, an actor — who maintains a daily practice from one who doesn't? The actor with a daily practice takes his craft more seriously; he takes looking for roles more seriously; he takes the production he is in more seriously; he takes his preparations more seriously, whether those preparations involve having new head shots made, creating a personal website, or mastering accents.

Practice is a way to make use of your mind. Mind and practice go together.

"Many roads lead to the path, but basically there are only two: reason and practice."
— Bodhidharma

Each day he decides where he will make meaning investments, and then he actively makes them, either in support of his career or in support of the rest of his life. He doesn't make a fuss about auditions; he simply auditions. He doesn't make occasional phone calls in support of his career; he makes them regularly. He solemnly swears to find good roles, even if they are few and far between, and honestly appraises his efforts, redoubling them when he finds that he hasn't been active

and persistent enough. In these and similar ways he lives his daily practice.

Part III: Challenges to Daily Practice

Maintaining a daily practice can be as easy as getting to your writing, getting to your online business, or getting to your yoga mat every day, without fuss, without resistance, just because you want to be there and there's nothing you'd rather be doing.

To have that sort of relationship to daily practice is a blessing, but it is one that eludes many of us. Most people struggle to maintain their daily practice, and the vast majority ultimately let go of their daily practice, even if they've been able to maintain it for months and years. This happens because powerful challenges arise that erode their ability to show up.

In part III we look at eighteen common challenges to daily practice. This is not the complete list of possible challenges, but it represents a good sampling of those you're likely to encounter. Your tasks, if you want to maintain a practice that is slipping away, are the following:

1. Admit that your practice is in danger and needs real attention.
2. Name the challenge and identify what's going on.
3. Implement a plan for dealing with whatever you've named and identified.
4. Resume your practice, even if you can't quite identify what's going on and even if you can't fully fix the problem.

Better to have a leaky, intermittent, problematic daily practice than no practice at all. But better still to have one that works well, one where you identify, address, and remedy any problems as they arise.

To deal with those challenges, you'll need some strategies at your disposal. In working with clients, I tend to bring up a particular handful of such strategies. I don't hand them a checklist; rather, the list is somewhere in my mind, and, depending on the person, the situation, and the challenge, I'm more likely to bring up one strategy or another. Here are the seven that I employ most often.

1. **A cognitive approach.** I advise clients that their primary goal with respect to the thoughts they think is to think thoughts that serve them. I explain what "thinking thoughts that serve you" means and provide a bit of an array of tactics for achieving that high-bar goal, including the simple three-step tactic of hearing what you're thinking, disputing those thoughts that aren't serving ("No, thought, you are not serving me!"), and substituting a more affirmative or useful thought. If you're interested in this particular approach, please take a look at my book *60 Innovative Cognitive Strategies for the Bright, the Sensitive, and the Creative.*

2. **A ceremonial breathing-and-thinking approach.** A good way to marry the physiological benefits of deep breathing with the psychological and emotional benefits of right thinking is to drop a useful phrase into a deep breath, saying or thinking

a portion of the phrase on the inhale and the remainder of the phrase on the exhale. I've dubbed these breath-and-thought bundles *incantations* and described a dozen particularly useful ones in my book *Ten Zen Seconds*. You can increase your motivation and reduce your experience of anxiety by using incantations like "I trust my resources," "I feel supported," "I embrace this moment," or any incantation that you dream up yourself.

3. **An anxiety management approach.** Anxiety makes us want to flee an encounter and leave our daily practice. One solution is to possess some anxiety management tools that you've tested out and know work for you. Many kinds of anxiety management tools are available to you: relaxation techniques, guided visualizations, discharge techniques (where you expel anxiety through movement), reorienting techniques (where you turn away from the stimulus that's raising your anxiety level and turn toward a neutral stimulus), dis-identification techniques (similar to the idea of detachment in Buddhism), and many others. Acquiring one or two of these techniques is likely a must. For more on this approach, I'd recommend my book *Mastering Creative Anxiety*.

4. **A focused journaling approach.** This problem-solving journaling technique is made up of the following eight steps: (1) identify an issue; (2) examine its significance; (3) identify core questions; (4) tease out intentions; (5) notice what shadows

get activated; (6) identify the strengths you bring; (7) align your thoughts with your intentions; and (8) align your behaviors with your intentions. By carefully examining an issue in writing, by coming to some updated intentions, and by then aligning your thoughts and your behaviors with those new intentions, you can work through virtually any issue that may be derailing your daily practice.

5. **A sleep thinking approach.** I regularly suggest to clients and workshop participants that they try solving their problems, including any problems they may be having with their daily practice, by engaging in some *sleep thinking* — that is, turning the problem over to your sleeping brain. If you go to bed with a sleep thinking prompt, like "I wonder what my daily practice needs from me?" or "I wonder why I'm avoiding my daily practice?," your brain will run with that question while you're sleeping and often provide you with a clear answer in the morning. This works especially well if you give yourself a moment when you wake up to process your sleep thoughts. This is a robust problem-solving technique and one that I recommend. To learn more about sleep thinking, take a look at my book *The Magic of Sleep Thinking.*

6. **A life purposes approach.** When you put your daily practice in a larger context, in the context of your desire to live your life purposes, that helps you stay motivated, focused, and on track with your practice. It is a kirist axiom that identifying

our life purposes and figuring out how to actually live them on a daily basis are vital tasks that we must mindfully set ourselves. If we don't set them, who will? If you're interested in learning more about making the shift from life purpose to life purpose*s* and about how to actually live your life purposes, please check out my book *Life Purpose Boot Camp*.

7. **A kirist approach.** Over the years I've developed a complete contemporary philosophy of life that provides new ways of thinking about who we are and how we might live. The best way to meet any challenges that arise with your daily practice may be to anchor that daily practice in the bigger context of a comprehensive philosophy of life. If you think that doing this might interest you, you'll find many free resources, including a *Kirist Living Guide* and the first twelve books of kirism, available to you at kirism.com.

In part III, we examine how the folks I've worked with have tried to deal with the challenges they've faced in their daily practices. I hope this section helps you identify and meet any challenges that may arise with your daily practice.

Getting Started

More than fifty years ago, I marched young men like myself around the grounds of Fort Dix, New Jersey, as a drill sergeant. Over the decades I've guided people as a teacher,

workshop leader, psychotherapist, counselor, and coach. The headline? Folks find it hard to do the things they would like to do.

A related headline: they find it particularly difficult to do the things they would *really* like to do. Let's change this for you by harnessing the immense power of daily practice, so that you can live a life full of meaning and purpose.

I hope that this book does more than present you with another useful self-help tool. I hope that it opens the door to a lifelong kirist practice, one that I believe will serve you beautifully. This book is not a guide to kirism; to learn more about kirism, please visit kirism.com. But whether or not you take a look at kirism, please do give real thought to the idea of a daily practice.

What will you practice? That which you want to accomplish.

"Why should I practice running slow? I already know how to run slow. I want to learn to run fast."
— Emil Zátopek

There is great power in creating, maintaining, and living a daily practice. Your daily practice will help you accomplish a particular goal, like getting your novel written or building your online business. But it will also do much more than that. It will help you live the life that you've always intended to live. It is that important.

FREQUENTLY ASKED QUESTIONS

Q. What is a daily practice?

A. A daily practice is the formal way you pay daily attention to something that is important to you. You can have more than one daily practice if several things are important to you — say, writing your novel, maintaining your recovery from an alcohol addiction, and practicing yoga. It is a time carved out from the day when you pay real attention, it has a beginning and an end, and it is characterized by certain elements of practice that are described in detail in part I.

Q. Well, then, isn't a daily practice the same as writing every day or meditating every day?

A. Not exactly, though if you are writing every day or meditating every day you probably do have a daily practice in place. Daily practice is time you carve out independent of what you do with that time. *It is the very idea of carving out time.* It could have any sort of content, anything you

find important. It is like having a drawer in your dresser that you dedicate to your important things and that always contains something worth keeping separate from everything else. What's in the drawer may change, but you don't put junk in it. Maybe it's even empty sometimes. But it's still separate from all the other drawers, special, if you like that word, or sacred, if you like that word. Picture that dedicated drawer, sometimes filled with one valuable thing, sometimes filled with another valuable thing. That's daily practice.

Q. But doesn't that mean that the content of a daily practice might change every day? Where's the consistency or power in that?

A. While theoretically the content could change frequently or daily, in practice it won't. This isn't like changing hats or changing your mind. Your intention is to pursue something important — namely, living your life purposes — and while your life purposes may and do change, they do not change daily. If one of your life purposes is to get your novel written, that life purpose doesn't change daily. If one of your life purposes is to maintain recovery from an alcohol addiction, that life purpose doesn't change daily. If one of your life purposes is to defend liberty, that life purpose doesn't change daily. So you will not be constantly changing the content of your practice. You will be working on that novel month in and month out, paying attention to your recovery month in and month out, or being

an activist in support of liberty month in and month out. That's where the power and consistency come from, from your intention to live your life purposes.

Q. How long is a daily practice?

A. Any length under the sun. It might be as short as a certain breathing-and-thinking centering sequence that takes half a minute. It might be hours of writing or hours of piano practice. It could be three different daily practices of differing lengths. It could even be all of the time, if you live your life that intentionally and mindfully. Your life could be a series of daily practices, which would functionally mean that you were living your life purposes all the time.

Q. What exactly am I doing during my daily practice?

A. That is as varied as the things that human beings can do. You might sit at your desk writing your novel. You might practice your musical instrument. You might visualize forgiving an enemy or practice loving-kindness. You might do the chores associated with building your business. You might practice contentment through ceremony. You might go on an inner journey. You might go out every day and visit your elderly aunt. You might meditate or do yoga or tai chi. You might engage in an hour of political activism. It might take two minutes or two hours. Whatever you deem important can be translated into a daily practice.

Q. Do I have to do it at home, in private?

A. Absolutely not. In fact, you might construct a daily practice that must be done out in the world — for example, a personality upgrade practice that requires that you manifest your new personality in public, in real time. Maybe your daily practice is to devote your lunch break to really relaxing, or to be of service at an emergency nursery, or to perform folk songs in a neighborhood park. Your daily practice can happen anywhere.

Q. Is a daily practice always about doing something?

A. That depends on whether or not you consider being calm, being content, being passionate, or being anything "doing" or "being." If your daily practice centers around sending loving-kindness energy into the world or practicing forgiveness, is that about "doing"? In whatever way that you hold the distinction between "doing" and "being," your daily practice certainly need not be only about "doing" in the sense of running a mile, writing a thousand words, or making ten business calls.

Q. Is a daily practice more about repeating something, more about getting good at something, or more about making progress?

A. That will depend on your particular practice, intentions, and goals (including the goal of not having a goal). For

example, your relationship-building practice, where you visit your elderly aunt every afternoon, may not be the sort of practice where your intention is to get good at it or make progress with it. Your evening practice, however, when you work on your screenplay for an hour, may well have built into it the hope that your screenplay moves forward. In both instances, the core concept is showing up.

Q. Is daily practice connected to Buddhism or to any other spiritual or religious practice?

A. No. I will try to explain how it connects to the philosophy of life I've developed over the years that I've dubbed *kirism*, but it is completely independent of any spiritual or religious practice and independent of kirism as well. It is a stand-alone beneficial practice. As an analogy, some philosophical, spiritual, or religious tradition might make the demand that you meditate daily. But deciding to have a daily meditation practice is separate and distinct from that demand and, being your decision, would be up to you to devise, design, and execute.

Q. Should every day's practice be identical in terms of time spent on it?

A. No. One day you might spend twenty minutes writing your novel. Another day you might spend four hours. One day you might attend an AA meeting far from your home, which takes you three hours round trip. Another

day you might attend a nearby meeting and be home in an hour. One day you might do your full meditation practice or your full yoga practice, and another day you might do a shortened version, either because of time constraints or because the shortened version feels right. For consistency's sake and to keep the bar high, you might demand of yourself that you spend the same amount of time every day on your practice, but that is nothing like a requirement.

Q. Does it always happen exactly once a day or at exactly the same time each day?

A. No and no. It might; and there might be good reasons for it happening in those ways. But except for the great value of creating a sturdy habit by arriving at your practice the same time each day, there is no particular reason why, for example, you can't write once on Monday, three times on Tuesday, twice on Wednesday, and so on; or write at 6 AM on Monday and 9 PM on Thursday. It can prove harder to maintain a daily practice if you don't anchor it to a particular daily time, but if it works for you to vary its timing and to vary how many times a day you engage in it, then do what serves you.

Q. Will you be presenting us with a model practice?

A. No. There is no model practice, and there can be no model practice. To present one would be to present dogma, whether it's dogma about sitting versus standing, about

an hour versus a minute, or about indoors versus out-doors. I can easily describe my daily writing practice, but that ought to mean nothing in particular to you. What if I wrote for ten minutes or ten hours? What if I started it with a ceremonial cup of tea or a war cry? All of that might be interesting to hear but nothing like a model. I will be describing the elements of practice in detail, and that should help you put your own daily practice together. But there is no single model to emulate.

Q. Why bother creating a daily practice?

A. The reason to bother is that life is difficult. No one faces just the occasional challenge. We all face multiple challenges all the time, from maintaining our health to maintaining our emotional well-being to getting our creative projects done to our satisfaction to making enough money to figuring out how to relax. Each challenge we face can be partially met and may be best met by a daily practice that focuses your attention on exactly that challenge. Build your daily practice(s) and see what benefits result.

Part I

THE ELEMENTS
OF PRACTICE

In part I we take a close look at the elements that make up a strong, successful daily practice. Each of the twenty elements of practice that are described and discussed play their role. At the end of each chapter I'll provide "Food for Thought" questions for you to consider. I think it will genuinely serve you to spend a little time tackling those questions.

For each of us, some of these elements of practice will come naturally and seem congenial, and others will force us to stretch. One person will have no experience with or taste for ceremony, while another person will be very used to including ceremony in his or her life. One person will be highly self-directing but will have trouble finding joy in what he or she does; another person will find repetition a personality fit and innovation rather less of one.

Part I provides you with the opportunity to consider these natural and inevitable differences, to think through how each element of practice is valuable in its own right and worth nurturing, and to create plans for developing

those elements of practice that amount to a stretch for you. First and foremost, though, it gives you the chance to encounter these twenty elements of practice perhaps for the first time. I hope you'll enjoy meeting them!

Element 1

INITIATION

Practice, as I'm using the word, signifies a daily activity that we take seriously and that we mark off from the rest of the day in a clear way. It has a clear beginning and a clear end and invites our best self into the room, the self that really knows how to think thoughts that serve it, that intends to matter, and that feels itself connected not just to the smallness of the day but to the bigness of everything.

One of the key elements of practice is what I'm calling *initiation*. Your daily practice has a beginning. It is the beginning of a clear, nameable thing, like writing your novel, playing the piano, practicing yoga, or working on your start-up home business. Even if it's something as abstract as a spiritual practice or a mindfulness practice, you nevertheless want to know that you've actually begun it — you want to feel the experience of beginning.

Maybe you start it in some ceremonial way, or maybe no particular ceremony is needed. But you are clear that your daily practice has begun and that you are now creating menus for your private clients if you are a personal

chef, learning your audition piece if you are an actor, or preparing your class if you are a yoga teacher. You are doing that and nothing else.

You might initiate your daily practice in some very simple way — say, by selecting your favorite cup for your morning coffee. I have six favorite cups, from Prague, Berlin, New York, Rome, Paris, and Savannah, and I enjoy choosing my daily cup. Your simple initiation step might be to put on a little Bach or spend a moment at your writing altar or water the plants in your study. By starting out the same way each day, you reinforce the idea that your daily practice matters.

You could wait to begin your daily practice until you are the exact right person to practice and perfectly equal to practicing. Or you could just begin.

"Meditation practice is not about later, when you get it all together and you're this person you really respect."
— Pema Chödrön

Cheryl, a coaching client of mine, explained the initiation ritual that works for her:

My ceremony is to get up promptly at 5:30. I go into my writing room, turn on a soft light, and boot the computer up. I then do all those tasks that will get me out the door for work that would otherwise distract me if I put them off until after my writing session. This lands me at my computer at 6:15. I then have my breakfast while writing. I know it's a good session when I don't remember eating breakfast! I finish at 7:15, which my dog helps remind me of as she usually wanders in at that time for her walk. I don't know how she

knows the time, but she does! I make some quick notes, so that I'll know where to begin the next day, turn the computer off, and then go for my dog walk.

Rachel, another coaching client, created a detailed and beautiful starting ritual for herself:

I stopped working outside of the home, and so I no longer had a daily commute. Then, weirdly, I began to realize that I missed the ritual of my commute to my old job. So I started packing my snack and a big thermos of coffee and a bottle of water for myself when I made the kids' lunch and snack every day. I also put fresh flowers in my office and lit some incense on Mondays to clear the air for the week ahead. And I made an altar with pictures of my childhood cats and wrote a prayer — to the cats? to the muse? — to go along with it. I do one minute of focused breathing and then say the prayer before writing. It's maybe all a little bit odd, but I know that it helps me settle my nerves.

My coaching client Nia described a very different sort of initiation practice:

For some reason, I'm not ceremonial. What I do, though, is I always log my start and stop times in a spreadsheet. It's really dry, but I've been able to

be consistent with it for years now. It's basically punching a time clock. It works, but... I feel a kind of heavy energy in myself starting this way, and I'm going to experiment with something light. I can visualize what light and happy looks like, and I'm going to try the coffee cup selection idea, because it makes me smile. Well, I have to get some new coffee cups. But that can be fun too! And I don't want to scorn my spreadsheet habit, because it's been working for years.

Folks living a kirist life think in terms of life purposes, rather than imagining that there is a single purpose to life. If this idea resonates with you, you might think about using the following pledge, or one you create, as your initiation ritual. This is a long version, and you might shorten it to something as simple as "My daily practice supports my life purposes." Here's a long version of a possible starting pledge:

I am choosing to live my life purposes. One way I do that is by creating and maintaining a daily practice. By-products of my daily practice are that I will get really good at something and that I will get a lot of something done. But those are added benefits and blessings. The main reason I attend to my daily practice is that it is a wonderful way to support my intention to live my life purposes and to make myself proud by my efforts. That I finish novels or play the violin beautifully or build my

home business or meditate daily is wonderful, but even more wonderful is the fact that I am honoring my understanding of how my life should be lived.

There are an infinite number of possible initiation strategies. You might employ a mental image of, say, a car starting up smoothly and effortlessly. You might close the door to your study in a ceremonial way. You might hum a meaningful hymn or anthem. The main points to remember are: (1) starting is a key element of practice; (2) starting the same way each day supports your practice; and (3) if you are having trouble creating or maintaining your practice, focus your troubleshooting on how you start.

Food for Thought

1. What does the phrase "starting your daily practice in a ceremonial way" suggest to you?
2. What's one way you might start your daily practice?
3. What are some alternative possibilities?

Element 2

SIMPLICITY

In my experience, the simpler the practice, the more powerful it is and the more likely you are to maintain it over time. One reason that it ought to be kept simple is that if there is even a whiff of difficulty or complexity attached, it becomes really hard to crack through everyday resistance and get to your practice.

You wake up in the morning. Maybe you're going to write, and maybe you're not going to write. On one side of the ledger is your desire to write. On the other side are all of your bad feelings about your current book manuscript. Those bad feelings produce a heaviness that as likely as not will prevent you from writing. If, however, you have a simple daily practice in place that begins with a super-simple mantra, like "I write every day," you've increased your chances of writing on that day, even as heavy as you feel.

If you feel heavy and you also have to face a complicated practice with lots of demands (A thousand words every day, damn it!) and lots of moving parts (Is the temperature sixty-eight degrees? Is the light coming in from the east? Has the rooster next door crowed three times?),

that emotional heaviness combined with practice heaviness is a recipe for a writing day skipped.

Simplicity is both a cognitive sort of thing and a felt sort of thing. As a cognition, it might be a thought such as "I'm off to my practice" or "Time to practice" or "Here I go!" As a felt sort of thing, it is the same body lightness that comes when you anticipate something being easy. It's like a sigh and a smile rather than a groan and a frown. It's like a pillow rather than a rock. Picture something being really easy. Feel the ease in your body?

Simple doesn't mean static. *Simple* doesn't mean doing exactly the same thing each day. *Simple* means doing the thing appropriate to that day's practice.

"I find it's only when something is trying to come through I really practice. And then, I don't know how many hours. It's all day."
— John Coltrane

You might combine these two ideas, of simplicity and of ease, into the following ceremonial mantra: "I'm light, and I'm off to practice." Imagine how lovely it would be if every day you were able to say, "I'm light, and I'm off to practice." Can you remember the childlike simplicity of running out the door to play? There was nothing in the world easier. Be as easy as you can be and keep your daily practice as simple as is humanly possible.

Remember that we're talking about your practice itself and not the content of your practice. The content of your practice may be very complicated. Maybe you're working on a hard problem in physics or in the app you're creating. Your practice can still be blissfully simple. Even

if the song you're writing is challenging, your practice can still be simple. Even if the mathematical problem you're trying to solve is knotty, your practice can still be simple. Keep this important distinction in mind.

Robert, a workshop participant, shared his experience:

I got very excited about the idea of a life purpose practice where every day I would look at my list of life purpose choices and decide which one or two I was absolutely going to get to on that day. If I'd kept it that simple, it would have been a beautiful thing! But for some reason I had to overlay it with all sorts of demands: that I prioritize my life purpose choices, that I tackle at least one from my top three choices every day, that I spend an equal amount of time on each life purpose choice so as not to shortchange any, and fifteen other demands.

It started to feel like the worst kind of job imaginable! I had to chuck that whole way of looking at my practice out the window and return to the beautifully simple starting place: looking at my list each morning and making a choice or two. Period. That made all the difference! It turned a chore into a light thing.

You can run a quarter mile but not a mile? Then run a quarter mile. And run another quarter mile. And run another quarter mile. And run another quarter mile. That's a mile. Simple.

"Do what you can and you'll soon be able to do what you can't."
— Hunter Post

Sandy, taking the two-month kirist challenge (to live a kirist life for two months to see if it is a good fit), explained how it worked for her:

I had a hard time defining my practice. I wanted to write, I wanted to paint, I had health issues I knew needed addressing, I was craving a spiritual practice or maybe something like a meaning-making practice…I couldn't make up my mind what my practice was "really about." So, of course, I never started it, and I never engaged with it.

It wasn't working trying to decide what was most important. Each thing was important in its own way. I was about to throw in the towel, and then I had an inspiration. I decided that I would take "simple" to mean just showing up. I would just go to my designated daily practice space in the spare bedroom and do whatever needed doing on that day. I would just go there and stay put for an hour.

That kind of made for a magical change. One day I would work on my nonfiction book. Another day I would research alternative health treatments. Another day I would sketch. I realized that it didn't matter what I did — each thing had its own importance and its own resonance. My practice simplified itself to "I show up for an hour." And during the next two months I got a lot written, I created a new health regimen, and I made a lot of meaning, one hour at a time.

Food for Thought

1. What does a simple practice look like to you?
2. Is it your nature to make things more complicated than they need to be? If so, what might you do to rein in that impulse when it comes to creating your daily practice?
3. Explain in your own words how a practice might be kept simple even if the content of the practice is difficult or complicated.

Element 3

REGULARITY

To have a daily practice means that you arrive at your practice every day. You do not skip your practice because it is gloomy outside or because you are gloomy inside. Every day means every day: that is the essence of regularity.

You can, of course, skip a day and still have a daily practice. Skipped days are built into the idea of daily practice. Life is life, and you may need to pay full and complete attention to some other aspect of it. Or you may simply get overly busy and forgetful and lose that day. A single skipped day and the occasional skipped day are not significant.

But when you start to skip several days, and then weeks, and then months, well, then you no longer have a daily practice. All of the benefits that you would have received are lost. Your novel doesn't get written; your relationship with your child doesn't improve; your personality doesn't get that hoped-for upgrade.

How do you know you have missed too many days? There is no exact number. But you might decide on how

many missed days are permissible and make that a very small number, like two or three. This would sound like, "If I miss two days in a row, I *will* show up on that third day, no matter what." Even two days may prove too high a number, as we could experience two missed days as a slippery slope toward practice abandonment. In that case you might make one your acceptable number.

> What will you lose if you don't practice regularly? Maybe your voice and your career.
>
> *"It happens to the best of them. You lay off singing and your throat gets out of practice. No excuses. I blew it."*
> — Bobby Darin

Part of us loves regularity, and part of us hates regularity. We must deal with the part of us that hates it if we are to have a daily practice. Martin, an independent filmmaker, seemed to have a particular aversion to the idea of "doing the same thing every day." He claimed to love chaos, to require "everything to be new and fresh each day," and he rejected ideas like marriage for the same reason.

Not surprisingly, he had great trouble getting his films made. Most remained half finished or a quarter finished. Money from his parents allowed him to continue on this path of daily novelty and a long string of incompletions. He came to see me because there was one film he really did want to complete.

"I'd like you to think about the following," I offered during our second chat. "I'd like you to think about beginning a daily practice in the service of your filmmaking." I went on to describe what I meant.

"Every day?" He sounded stunned.

"Every day."

"But I can change up what I do with that hour, right? Maybe write poetry on some days, or do some drawing? That's more my style."

"Nope," I said, smiling. "Well, of course you can. But I'd love it if you played it my way. Because the ideas I'm trying to have sink in are ideas about repetition and regularity. I want 'I repeat myself' and 'I love regularity' to become your mantras. And not to be about prunes but about a real change in your life."

Martin did not look happy. "I just don't think that's my personality."

I quickly explained my ideas about personality: original personality (who we are at birth), formed personality (who we become over time), and available personality (our remaining freedom to be the person we want to be). "So look at it this way. You've been doing things one way a long time, and that's kind of written in stone. But I know you're hearing me and toying with the idea of regularity. That means that part of you is available to think about this daily practice and to maybe give it a try."

"A very small part," he said dourly.

I laughed. "But a part!"

We discussed in detail how his daily practice might look over the coming two weeks. "That's a very long time," he said, "to keep doing the same thing."

"It is."

"The very same thing."

"Or you might think of it as 'new each day.'"

He brightened at that thought. "Maybe if I call it 'new

Can a given daily practice stop serving us? Of course it can. But until it really no longer serves us, we keep at it. Just not being in the mood or having lots to do isn't a good reason to miss our regular daily practice.

"We need to learn how to honor and use a practice for as long as it serves us."
— Jack Kornfield

each day' I can fool myself into not being bored."

"Could be."

"And maybe I could get leg-irons."

"Well, maybe we don't need to overdramatize this."

"It feels very dramatic to me!"

I chatted with Martin two weeks later. "So how did it go?"

"Not very well. It kind of made me crazy."

"What did? Showing up each day at the same time?"

"I never got that far! The *idea* of showing up each day at the same time made me crazy. I couldn't sleep, I binged on mixed nuts — I think I put on three pounds!" A coach always has the following question in mind at such times: Should you invite your client to try again, or should you move in a different direction? I wondered which way to go. As I was thinking, Martin spoke.

"I don't want to try again," he said. "But I'd like to try again."

I nodded. "Should we set it up differently somehow?"

He thought about that. "Could it be a rotating schedule? So that one day I do it in the morning, the next day in the afternoon, and the next day in the evening? Then maybe I wouldn't feel so…stifled."

Martin had come up with an imaginative solution to his own resistance. A key element of a daily practice is that it be daily. Its power comes in great measure from

its regularity. By showing up every single day, or the vast majority of days, you build muscles, you live your life purposes, and you get a lot of work accomplished. Getting to your practice in a daily way may prove a struggle, but it is the high-bar goal to aim for.

Food for Thought

1. Do you sense that you may have problems with the very idea of daily practice?
2. If so, what might you do to try to change your mind?
3. How will you deal constructively with missed days?

Element 4

SERIOUSNESS

The kirist way is to organize your life around your life purposes because you've decided that you and your efforts matter. They do not matter in a grandiose, narcissistic, unrealistic, or childish way. They matter as injustice matters, as wars matter, as love matters, and as life and death matter. We can live life frivolously, caring only about our golf handicap and our gold fixtures, or we can put the world on our shoulders and, in our small but not abject way, support the very best principles, like keeping fascists out of office and children safe from harm.

This seriousness of purpose informs our daily practice, even if our daily practice is "just" playing the guitar or exercising. You bring this seriousness to your daily practice because it matters to you; because it is meaningful; because it supports one or more of your life purposes; because it is respectful of the vision you hold for yourself as someone who lives your values; and because it is one of the ways that you manifest your heroism and your humanity. Because you hold it in this high esteem, you treat it seriously.

Remembering this element of practice can make the difference between willing yourself to do courageous activist work and avoiding it, willing yourself to make ambitious content choices in your art and avoiding them, or willing yourself to upgrade your personality and avoiding that effort. In each of these scenarios, we possess multiple powerful reasons to opt for avoidance. It can help us to brave that difficult encounter by saying, "I'm a serious person, and my practice is serious business."

Arriving at this acceptance of seriousness as an element of practice and of life may prove its own circuitous journey. If, as a child, you were tirelessly told not to take yourself seriously, if you were witness to so much chaos and carelessness that the idea of seriousness could only be held as a bad joke, if seriousness was the purview of the select few and you were not in that inner circle, then it will likely prove its own real work to reach the place where you embrace the idea of taking yourself seriously. But what journey could be more important?

This necessary seriousness, however, if and when you acquire it, can produce its own real challenges. That's why it must be balanced out by lightness, playfulness, simplicity, and the other elements of practice that help reduce its weight. Without that balancing effect, the following can easily happen: You're writing a novel. It is *so* beautiful in your mind, and it matters *so* much to you. But getting it just right becomes such a heavy, serious matter that your fear of ruining it stops you from writing it.

Your novel can remain perfect only if it's not worked

on, so you avoid working on it. Additional elements of practice must therefore come into play if you are to actually write this novel. First of all, the element of honesty must get its due. You must be honest enough to understand why you are not writing. You must be honest enough to accept that the process demands you show up and write without any wishful thinking about the perfectibility of art. If honesty is a solid component of your daily practice, it will help you counteract your dread of ruining this prospectively beautiful thing.

Not the solemnity of dirges. The solemnity of rivers. The solemnity of sky. The solemnity of wood.

"Here on the river, as I lurch against a freshening of the current, is the practice of rivers. In navigating by the glow of the Milky Way, the practice of light. In steadying with a staff, the practice of wood."
— Barry Lopez

Likewise, the element of discipline is crucial. You may not be disciplined in every aspect of your life, and you may not even much love the idea of discipline, but your daily practice requires it, and without it you may find yourself paralyzed. In this scenario, we need our writer to show up to the page at the self-appointed time no matter what, perhaps using "no matter what" as his or her discipline mantra.

Primacy and presence will also help this writer. If you're committed to your daily practice coming first when its appointed time arrives and if you're committed to being present to the content of your practice, these elements will help keep thoughts about perfectibility and ruination on a back burner. If you are present to what Mary wants to say to John in the chapter directly in front of you, then exactly

that will be your focus. You will be taking your novel seriously by virtue of taking the interaction between Mary and John seriously.

You want to take your daily practice seriously, just as you want to take your life seriously. That seriousness connects to the ideas of self-obligation and self-authorship that are central kirist tenets. That seriousness is a measure of your devotion to living your life purposes.

Food for Thought

1. How would you describe the difference between taking something seriously and being worried about something?
2. Do you suspect that you will bring too little seriousness, too much seriousness, or just about the right amount of seriousness to your daily practice?
3. If you think that you may bring too little, what might you try to counteract that?
4. If you think that you may bring too much, what might you try to balance that out?

Element 5

PLAYFULNESS

What could be simpler than the idea of playfulness? Yet it is one of the most complicated and loaded words we use.

When, for example, clients say that they want to bring more playfulness to their daily practice, they may mean very different things.

One client will mean, "Composing my symphony is hard work, and I wish it weren't. So I'll engage in some wishful thinking and imagine that there is some way to play and still get it done, which I know isn't true." Here playfulness is being used as an escape strategy. This sort of playfulness is not a helpful addition to a daily practice.

A second client's version might sound like: "I'm injecting much too much heaviness into my work and trying to exert too much control. I'm not allowing for imagination and genuine creativity. This is the fruit of tough teachers in parochial school and even tougher parents, none of whom would have given you a plugged nickel for playfulness. I need to bring some playfulness into my practice to balance out that heaviness."

A third client will hold playfulness as a release, as the essential opening of a pressure valve. Remember the sit-com *M*A*S*H*? Those combat doctors were completely committed to the well-being of their soldier patients. But outside the field hospital tent, they just had to be a little goofy and slapstick. They had to bring some levity, some moonshine, and some relief to their absurd, intolerable situation.

A fourth client will mean yet something else. For him, playfulness will connect to art-based ideas like atonal music, shape poetry, surrealist painting, Antoni Gaudí's architecture, performance art, the playfulness-cum-irony of Albert Camus's protagonist in *The Fall*, novels made up of a single sentence that runs for a full three hundred pages, the surprise in a surprise symphony, the sound of actual cannons in an overture, and the countless other whimsical, tongue-in-cheek exercises in the long history of the arts.

The first client is bringing up playfulness as a way to avoid hard work. The second client is craving playfulness because she feels how her efforts at tight control are harming the process. The third client needs relief and release and finds some small measure of those in playfulness. The fourth client sees playfulness as a tactical or stylistic element in art. And there are more meanings and subtleties than just these four.

Playfulness as an element of practice is the lightness we bring to an almost unbearable reality. It is the smile that accompanies completely serious business, the comedy

that is the other face of tragedy, Charlie Chaplin as Adolf Hitler. It is a partner in a marriage with seriousness, each partner bringing what it needs to in order to create a practice that is both airy and solemn.

Jeffrey, a painter, explained his understanding of this marriage in the following way:

> I can tell you what I mean by giving you painterly examples. Joan Miró and Paul Klee are both extremely playful. But for me, Miró isn't also serious. His tongue is too firmly in his cheek, he's too self-consciously clever. Paul Klee is playful but also definitely serious. There's something about the weight of the world in his painting, even as he's making you smile. Jackson Pollock is another sort of example, wildly playful and also wildly serious. Mark Rothko is serious but not playful. And here's the big reveal: Pablo Picasso is playful but not serious. He could have been serious; he had that in him. But over time he became an entertainer and a decorator.

What, concretely, does it mean to include playfulness as an element of practice? It might mean ending your serious violin practice with a little mountain music. It might mean continuing your painting onto the frame. It might mean stopping your serious business of the moment — the work you're doing on your mental health, on your personality upgrade, on your principled cause — and dancing a little jig. It might mean smiling a little or

laughing a lot, no matter how serious your practice essentially is.

In kirism, we talk about the need for absurd rebellion: how the individual is charged, by himself or herself and not by anyone else, with holding up the whole world, as crazy an idea as that is. Don't you have to shake your head and smile a bit as you picture yourself holding up the whole world? That's a version of the playfulness we're describing. Holding up the whole world! How silly.

Playfulness as an element of practice is not a ready excuse, not an escape strategy, and not a joke. It is a way to balance solemnity with lightness and allow the air to circulate. A practice, like a life, can get claustrophobic and stuffy. Laugh, throw open the windows, and pay a small homage to the value of play, as we are using that word.

One kind of playfulness? Improv! Maybe that's what your practice needs today, some improvisation!

"It sounds obvious, but I wonder how many people, whatever their medium, appreciate the gift of improvisation. It's your one opportunity in life to be completely free, with no responsibilities and no consequences."
— Twyla Tharp

Food for Thought

1. Describe in your own words the sort of playfulness that might serve your daily practice.

2. Is this particular playfulness something that will come easily to you? Or will it be more of a stretch?

3. If it feels like it will be a stretch, what might you try in order to aid you in that stretching?

Element 6

HONESTY

Your daily practice demands honesty. If you play a passage on your musical instrument and it isn't strong yet, you are honest enough to say, "This isn't strong yet." You don't then berate yourself, pester yourself, rail at the gods, or create any other sort of inner or outer drama. You just calmly say, "Not strong yet." Then you practice more.

If you skip too many days without attending to your new start-up business, you are honest and say, "I skipped too many days." You don't then also lament, "I've wasted so many days!" or "Now I have no chance!" or "I missed that golden opportunity!" You nod to the truth — that you skipped days you shouldn't have — and proceed with some simple affirmation, like "Right here, right now" or "Back to work." And you get to work.

Being 80 percent honest or 90 percent honest is lovely and a pretty high bar for human beings. But you and I are actually aiming for 100 percent honesty. We are aiming this implausibly high because that tricky, untruthful 10 percent or 20 percent can scuttle our ship. One blind spot, one area of denial, one little white lie the size of an elephant, and our practice may not survive.

Imagine a general honestly admitting that her troops need more training and then increasing their training. Good for her. Imagine her honestly admitting that their rifles jam too often and getting them better weapons. Good for her. But imagine her refusing to acknowledge the enemy's air superiority. For all the honesty that she managed to muster, she will likely lose the war.

That last 10 percent is often the hardest to admit because it is the hard truth. That general can admit that her troops need more training, because she can do something about that. She can admit that their rifles jam too often, because she can do something about that too. But what if there is nothing she can do about the enemy's air superiority? Many a mortal will be inclined to refuse to look that hard truth in the eye.

Take a memoir writer with a daily writing practice. Maybe she has faced the truth that her siblings will be upset with her for writing about them and made peace with the fact that they will be angry. Maybe she has faced the truth that she will be revealing embarrassing family secrets and made peace with that. Maybe she has faced the truth that she herself doesn't come off that well and has made peace with that. But what if she hasn't quite admitted that she is physically afraid of her ex-husband and dreads him reading it? Not facing

The content of your practice needs to be the actual content it needs to be, not some simulation, substitute, or likeness. If your daily practice is writing a novel, you need to write your novel, not read a novel, dream about novels, or do something novel.

"You need mountains; long staircases don't make good hikers."
— Amit Kalantri

There is no "way" to practice. There is only honesty and intention. Let your practice honestly and intentionally serve your desire to live your life purposes.

"[Many] Yogis are blindly attentive to their particular system of meditation...[and] forget about the goal, which is the Self."
– Santata Gamana

that last hard truth is likely to cause her not to write.

She should rightly congratulate herself for dealing with all those truths she did acknowledge. That took a lot of courage. But she mustn't let herself off the hook with respect to the last one. That one must be faced also, not out of a moral imperative, but because if she doesn't admit it and deal with it one way or another, she's unlikely to get her memoir written. And that will deeply disappoint her.

I think you can see that honesty of practice requires that we face many hard truths, not just one or two. Take a yoga practice. You may have to face the truth that on some days it bores you. You may have to face the truth that certain positions are actually injuring you. You may have to face the truth that, as you'd intended to start a yoga business, you don't need more training but, rather, the courage to start a business. You may have to face many other truths as well. Each of them is its own knotty problem, its own taxing challenge.

Be honest about whether you are attending to your daily practice enough. Be honest about whether you are creating dramas so as to avoid your practice. Be honest about whether you are truly engaged with your practice or just going through the motions. Be honest about whether you tend to leave your practice too soon. Be altogether honest: anything less jeopardizes your daily practice.

Consider Larry, an established inventor and engineer. Larry set as his daily practice the study of a certain aspect of artificial intelligence. He loved the problem he set for himself and couldn't understand why he wasn't getting to his practice regularly. He spent a lot of time thinking about it, journaling about it, and chatting online about it with other AI specialists. Finally, it came to him.

"I've known this all along," he explained to me, "but I've kept it hidden away so that I wouldn't have to face it. The truth is, it scares me where AI will lead. Just go see the movie *Ex Machina*. I love AI as an intellectual puzzle, but I actually hate where it may take us. What am I supposed to do about something that I'm so completely invested in and that I also despise?"

With that cat out of the bag, Larry had no choice but to give up his intellectual passion for AI. A few months later he began a very different sort of daily practice: writing a book exposing the dangers of AI. In his heart of hearts, he wished that he had never admitted that truth to himself. But he also knew that the truth was going to win out eventually. If it hadn't, it's very likely that Larry would have found himself unable to complete *anything*.

Food for Thought

1. Discuss the role of honesty in daily practice, as you see it.
2. Is there some area you already know you had better be more honest about?
3. Discuss the difference between being "rather honest" and being "totally honest."

Element 7

SELF-DIRECTION

You and you alone guide your practice. You may learn from others and make note of what others are doing, but you still must make your own choices and your own decisions. You decide which novel to write or which research to conduct; you guide yourself through the process; you make your own mistakes; and you learn from your own mistakes.

Only rarely do you look for teachers, since you are committed to learning by doing. Only rarely do you look for models. When you do not know what to do, you take a deep breath and say to yourself, "Before I look for help or a way out, let me consult myself. What do I think?" You train yourself to always go there first, to your best personal understanding of what works and what doesn't work and what is true and what isn't true.

This isn't easy. We're bombarded by a billion opinions. Everyone has a way. Everyone has a method. Many want to sell you theirs. In order to sell you their method, they are rather obliged to say that theirs is the best, that theirs really works, that theirs has such-and-so-much

scientific research behind it or such-and-so-many satisfied customers.

It isn't easy to ward off all that opinion mongering and sales pressure. Even as you manage to ignore that opinion over there, whispering something about how practicing the guitar so much will inevitably lead to arthritis, here comes another opinion over here, claiming that scientific research shows guitar playing to be linked to antisocial behavior. It's endless! It takes determination to keep a clear head, not get seduced, and not be misled. The mantras to keep returning to: "What do I really think?" and "What works for me?"

Consider diets. Can you really adopt some all-grapefruit or all-cheese or all-nut or all-spinach diet if it doesn't suit your body? Maybe a pound a day of Havarti works for someone. Does that mean that it will work for you? What if a Mediterranean diet rich in shrimp, mussels, and clams works for a whole continent? Will it work for you if you have a shellfish allergy? You can bet that the latest diet craze will come with the most amazing endorsements. "I lost fifty pounds in three days flat, and I feel wonderful!" Will you trip and fall into that rabbit hole?

You decide. Who else should?

"We are our own greatest teachers....Making a conscious decision to create our day...takes some good practice, but the end result is worthwhile."
— Angie Karan

I remember taking in a Richie Havens set at a café in Greenwich Village in the 1960s. He was a marvel to watch. No one has ever played the guitar quite the way that he

did, using his thumbs in his characteristic and amazing manner. In online forums even to this day, guitarists complain bitterly about their inability to mimic his style. Then someone will pipe up and provide an essential piece of the puzzle: that Havens's hands were enormous. You can't play in the style of Richie Havens if you have small hands. You will have to play in your own way.

A great many people find it surprisingly hard to direct themselves. Self-direction is a form of leadership, and there are many more followers than leaders. Your daily practice requires your leadership. You are the employee, toiling away, but you are also the CEO, making decisions, and you are also the visionary consultant brought in to observe and upgrade company practices as needed.

You must decide on the contours of your practice. And you must decide to actually practice. You can't begin to practice without deciding to practice.

"It begins as a decision, then it transforms into a practice, and soon it becomes our daily habit."
— Nick Catricala

Let's say that you've set up a regular painting practice after work. You get to your studio every evening directly after your job, five days a week. But, what with having to set up and clean up, you find that you have very little actual painting time available. You wish that you could go on one of those famous Picasso painting binges and just paint through the night, but your day job makes that impossible. So you keep to your current routine, even as you feel yourself losing your resolve and your enthusiasm.

What will you do? There can't possibly be an instructional video somewhere that can provide the answer. You

have to decide. So, rather than saying, "Whom should I consult?" or "Where should I look?," you take a long walk along the esplanade, up and back, up and back, and think.

The following occurs to you. You can't paint all night on Monday, Tuesday, Wednesday, or Thursday, as then you would be unfit to go to work. But what about Friday nights? What would prevent you from painting all night before the weekend?

You notice that the thought is making you terribly anxious, even though it seems like a brilliant part solution. So what is making you so anxious?

You realize you are afraid that you've been kidding yourself about really wanting to paint for hours on end, and now that you've dreamed up a part solution, you have to look your doubts and fears in the eye. So you do just that. You stop, stare out at the river, and hear yourself murmur, "Put up or shut up." You make the decision to add one all-night painting frenzy a week to your daily practice.

You don't stop there. You weigh the consequences of your decision. That change will mean, for one thing, that you will need to sleep most of Saturday. How will the laundry get done? And the other errands? When will you get to just relax? And when will you get to hang out with friends? Is the painting blitz worth all that?

You stare out at the river and think the whole thing through. You decide that giving it a month's try is something that you really must do. It is worth the inconvenience and the risk. And so you commit…and change your practice.

Food for Thought

1. Did something in your upbringing or does something in your personality make it harder for you to lead than to follow?

2. If that's the case, what strategies might you try so as to bring sufficient self-direction to your daily practice?

Element 8

INTENSITY

One of the factors that distinguishes your daily practice from the other things that you do is its intensity. You likely don't pour out your breakfast cereal, send out routine emails, or shop at the market with great intensity. Why would you? Our routine tasks aren't candidates for intensity. Why bring white heat to peeling a potato?

But our daily practice does cry out for intensity, because it is an effort in the service of our life purposes, requires special attention, and deserves the dedication of our whole being. Without it, our daily practice is a lackluster affair. If and when we bring it, we are bringing all its sister qualities as well: passion, enthusiasm, concentration, devotion, focus, absorption, immersion, enthrallment, love. Intensity makes all the difference between mechanical and amazing.

- You can exercise lackadaisically during your daily health practice, or you can exercise with intensity.
- You can write your screenplay during your creativity practice in an absent way or with real presence and commitment.

- You can immerse yourself in your business during your daily business-building practice, or you can remain at arm's length.
- You can care only a little bit about your efforts and your results, or you can care a lot about them.
- You can bring your full wattage to the encounter with your daily practice, or you can bring just a fraction of your passion and your energy.

You can spend an intense hour. Or an intense minute. Either way, make it intense!

"I made the valuable discovery that practicing wasn't a matter of time at all. It was a matter of intensity. Five minutes spent working consciously and hard at the elimination of an error was worth five hours just playing away and ignoring errors as if they hadn't happened."
— Leonard Wibberly

Your practice demands your intensity: every muscle fiber, every moral conviction, every brain cell, and every ounce of passion. Do not fear plumbing your depths, and do not fear exhausting yourself. After all, you're only bringing this necessary intensity to your endeavor for a limited amount of time: for twenty minutes, for thirty minutes, for an hour. Will you burn out in just twenty minutes? Probably not!

However, you may find yourself harboring all sorts of complicated reasons for not wanting to manifest your intensity or not being able to manifest your intensity. Take Nigel, a coaching client living in Brighton, England. Nigel explained how his avoidance of intensity was impacting his composing practice:

I like to keep everything at about equal weight, nothing too exciting, nothing too dull. I don't run marathons, I avoid conflicts, and my girlfriends have always complained about my passivity, which I call "keeping an even keel."

All well and good. But I could not get my symphony composed. Over the years, I've been able to compose short set pieces, maybe two or three minutes in length. But I've never gotten close to being able to tackle the symphony whose themes keep reverberating in my head. So I started a daily composing practice. But I couldn't pull it off. I'd sit there for a few minutes, get all chaotic inside, and have to leave.

Got that scent in your nostrils? Go for it!

"I'm gonna go put my earplugs in and practice the piano for hours until my fingers bleed....Nothing can distract me from the scent of the music."
— Karen Quan

Finally, in considering the elements of practice, it dawned on me that I avoid intensity because intensity provokes anxiety in me. But without that intensity I have nothing. I don't want to compose a mild-mannered symphony, and I can't compose in a mild-mannered way and expect to move people with my music.

So I've committed to intensity. And it's making my whole system shake. I thought that composing was more an intellectual matter than an emotional matter, but did I ever get that wrong! It is — or ought to be — a completely intense emotional event. So I'm trying to live with that

intensity moment by moment. Right now, my daily composing practice lasts about five minutes. That's all I can tolerate. But it *is* intense. And I am making progress!

As with many of the other elements of practice, there are ways to balance out or modulate this intensity. Bringing the elements of lightness and playfulness to your practice helps keep that necessary intensity from boiling over. Imagine marrying deep concentration with dreamy reverie. Or full immersion with feathery lightness. Over time, if you learn as you go, you will discern how to maintain the exact measure of intensity you desire.

Ryan, a sculptor, described his particular balancing act:

When I take a chisel to marble, I'm doing two things. I'm working intensely, and I'm also relaxing. You have to relax, because you have to let the marble have its say. You can't dictate to it. Too much control, too much intensity, too much attachment to an idea, and you will get the idea realized — but in a lifeless way. If you also relax, you get the idea you wanted or maybe another idea, but it's full of life either way.

It's taken me a very long time to understand this. I always had the intensity. But I would keep at things until I chiseled them out of existence. It took me years and years to find the lightness. That's what you want, full absorption and also a thoughtful lightness, as if you were carrying air

on a platter. Do that. Try carrying air on a platter. You'll have to concentrate — and shake your head at your silliness. My recipe: two ounces of lightness for every three ounces of intensity!

Food for Thought

1. Here is a list of rough synonyms for *intensity*: *passion, enthusiasm, concentration, devotion, focus, absorption, immersion, enthrallment, love*. Which ones seem to you to capture the flavor of *intensity*, as we're using that word?
2. Describe the sort of intensity that you'd like to bring to your daily practice.
3. What obstacles, if any, do you see as standing in the way of you bringing that intensity to your daily practice?

Element 9

LIGHTNESS

Naturally, you want to take your daily practice seriously. At the same time, you want to hold it lightly. You want to bring some effervescence, some joy, and some ease to it so as to prevent it from sinking like a stone. Picture the difference between coming to your daily practice wearing a sixty-pound backpack and arriving wearing summer clothes. Bringing a summer-breeze attitude to it keeps your practice from feeling ponderous.

Your daily practice should matter to you, as a source of pride and as the primary way that you accomplish what you intend to accomplish. But piling rocks on it turns what might have been an effortless hour, one that you enjoyed today and won't dread tomorrow or the next day, into something so heavy that it creates a whiff of despair.

How do you engineer that lightness? We are not birds who soar. We are not butterflies who flit from flower to flower. As a species, we are heavier than that. We carry pain, weight, bad memories, and old wounds. We carry a keen awareness of injustice and of our own mortality. We do not possess all that much lightness, and we know it.

That's why we're thrilled to see a great acrobat or dancer almost defy gravity: that lightness seems miraculous.

To bring lightness to our daily practice is nothing short of a miraculous embrace of something that is not really us. It is us finding the way to say, "I do believe that I can float for a bit, like a soap bubble."

When I sit down to write, I do not consciously say, "Lightness, please." But somewhere inside of me I am saying exactly that. I am relaxing into the work, not charging into it. I am floating rather than hunkering down, dreaming rather than tensing. I am attaching but also detaching. I'm announcing that the work matters, but I'm also chuckling just a little bit, keeping this hour or two in perspective. If I make a mess, so be it! Maybe I'm picturing that happy cartoon pig jumping up and down in muddy puddles.

If your life has been hard, it makes sense that it will prove that much harder for you to bring lightness to your daily practice. Wouldn't you likely come to it already frowning, already burdened, already half-unequal to the task? If I have a single overcoat to remove, that heavy overcoat of burdened humanness, you may have two overcoats to take off, or maybe three. What a lot of labor to arrive at lightness!

How can you manage to feel light, given how heavy life usually feels? One partial answer may be that you are asking for lightness only for the length of your daily practice. Yes, it would be lovely for that lightness to inhabit you always. But for now, you are setting the bar in a different

place, at twenty minutes of lightness, at thirty minutes of lightness, at forty minutes of lightness. Maybe that is possible?

Just a brief span of lightness, not so much longer than the life of a soap bubble, or how long it takes for a hummingbird to flit from one bush to another, or the length of time a paper airplane requires to fly across the room. Well, yes, a bit longer than those! But not hours and hours. Can you picture lightness lasting for maybe a full hour? For just that long?

You practice with intensity. And you also practice with lightness. This isn't a paradox but a dance.

"The brush must draw by itself. This cannot happen if one does not practice constantly. But neither can it happen if one makes an effort."
— Alan Watts

We also must factor in meaninglessness. If you're a student of kirism, you know that the activity you undertake in the service of meaning, some meaning investment you make or some meaning opportunity you seize, may not feel meaningful in the doing. It may serve your meaning needs to write your novel, but that heavy writing day, when words won't come or only the wrong ones present themselves, is likely going to feel anything but meaningful.

How can you feel light when you're accompanied by that sensation of meaninglessness? By invoking lightness. You sit there, playing your oboe piece for the thousandth time. How heavy that feels! You prepare to send out an email that may start a commotion and embroil you in conflict. How dangerous that feels! Maybe it's impossible to feel light as you play that passage or hit "send" on

that email. But you can still whisper, "Lightness, lightness, lightness" and maybe float a little bit off the ground, even if it's only a bare quarter inch.

Larry, a colleague of mine and an advocate for children's rights, faces heaviness on a daily basis. He explained what works for him:

> What I do each day weighs me down. Every case is painful, and even the successes, when we win a big judgment against a pharmaceutical company or get a legislator aboard our agenda, somehow just reminds me of all the places where we're losing. I can't do very much about all that heaviness. But I have learned to sigh. That sigh is my way of growing lighter. It's a sigh for all of us, a sigh for humanity. I sigh, and I feel lighter, and that helps me put my nose back to the grindstone, because the children need me.

Food for Thought

1. How would you describe the idea of lightness as it applies to daily practice?
2. Do you suspect that you'll have some extra problems bringing lightness to your practice or just ordinary problems?
3. If you suspect you may encounter extra problems, what strategies do you think you might want to try to help you meet that challenge?

Element 10

PRESENCE

Your daily practice needs your presence. You aren't half thinking about the bills, half thinking about your child's grade point average, or half thinking about your husband's complaints. You shake off all those distractions, quiet your nerves, and gear up for the encounter. You are there and not elsewhere.

It seems simple, but presence is actually a rather complicated concept. There is a certain prejudice in the way we think about and talk about presence. We act as if it ought to mean doing exactly one thing, as in the Buddhist maxim "When you peel a potato, peel a potato." That's certainly one sense of the word. But that isn't the only one, and it may not be the most important one.

You go to your computer to work on your current novel. The task you've set yourself this morning is to go through each chapter and make sure that the physical appearance of your main character, Margaret, is consistent throughout the novel, as you've changed her look a number of times over the course of various drafts. Well, you can do just that and nothing else. Or, because of the

nature of that repetitive task, one that you only have to pay half attention to, you could also be asking your brain to solve that plot problem in chapter 9. In this scenario, part of your attention is on making sure that Margaret's physical appearance is consistent throughout the novel, and part of your attention, maybe the larger part, is on getting Margaret out of that pickle you put her in at the end of chapter 9. You are not perfectly present to either task, as your attention is divided. But you are completely present to your novel overall.

This second sort of presence, where you peel a potato but also dream up brilliant new ways of using a potato, is the way of creativity, innovation, problem solving, and just plain old thinking. You might repetitively play a chord sequence on your guitar so as to really learn it, but you might also daydream a brilliant new song into existence. That would look like you practicing that chord sequence and then, as the new song arrives, beginning to play it. Yes, you changed your agenda. But you were completely present to your musical genius.

That isn't a moment zipping by; that is a moment slowed down to the slowest of slow motion by your participation.

"The basis of the practice is to directly participate in each moment as it occurs with as much awareness and understanding as possible."
— Stephen Levine

It can actually be quite hard to get over the unnecessary prejudice that being present means doing exactly one thing and giving that one thing your undivided attention. Take Diana. Diana practiced her yoga every day and

bitterly complained that, what with her yoga practice and everything else in life, she had no time for building her online business. I wondered why she couldn't build her business during her yoga practice.

That startled her. "What do you mean?"

"You need time to think about your business, yes?"

"Yes! I have to make some decisions about which of three products to launch."

"Okay. That's a thinking task, yes? A task requiring your mind to be present to the problem?"

"Yes."

"So invite your mind to think about the problem while you do your yoga."

She thought about that. "That wouldn't work. You have to be completely present if you're going to bother doing yoga at all. It requires your full attention."

"Does it?"

"It does!" But she was still thinking about it. "What would that look like, anyway? I'm doing a pose and have an idea. What do I do with the idea?"

"Get off the mat and write it down."

"But... that's not the way you practice."

"It could be," I said. "It would just be yoga off the mat. You would be shifting, hopefully seamlessly, between yoga on the mat and yoga off the mat. It would still be your yoga practice. Only it would serve you better, and you would get more time to think about your business."

She shook her head. "It sounds crazy."

"Or subtle." I laughed.

"It just seems so... wrong."

Two weeks later, Diana reported:

I did that completely goofy thing you suggested. The first few times it felt absolutely terrible. Like I was betraying my yoga practice and somehow even betraying my ideals. After so many years of meditation and yoga and other mindfulness practices, you get it into your head that your task is to be quiet, empty, focused, and present, all in a certain way. It was very close to an earthquake to imagine that there could be another way to think about presence, where you were focused and present but in a divided way. Still, after several days it came to me how that could be... or, really, ought to be. I began to do my yoga and my business at the same time. I can't tell you how weird that felt! But I'm beginning to love it — and I've got my product chosen.

Kneading the dough? That requires your presence. Cutting the onions? That requires your presence. Whatever your practice is, be present.

"Great cooking is all about the three p's: patience, presence, and practice."
— Michael Pollan

Presence is a vital aspect of every practice. You, however, get to think through and decide what presence means to you. In one set of circumstances, it may mean being fully present to the potato you are peeling. In another set of circumstances, it may mean peeling a potato and designing a skyscraper in your head. The second way is you being present as a creative person is present, the way that someone can both brush her teeth and dream up

a symphony or ride her bike and move physics forward. Presence is vital and also subtle. Figure out its nature for yourself.

Food for Thought

1. How would you describe presence as it pertains to a daily practice?
2. Do you suspect that you're going to have trouble being present? If so, what strategies might you try so as to increase your presence while you practice or to regain it if you get distracted and lose it?
3. Chat with yourself about the idea of being present while also having a divided attention.

Element 11

CEREMONY

When you treat your daily practice ceremonially, you give it an added measure of respect and poignancy. You can imbue what you do with a ceremonial feel by translating your good intentions into small, studied gestures that you repeat each time you engage in your practice. It might just be the ceremonial way that you ready yourself to work on your upcoming presentation as your computer boots up. Even just a small sense of ritual can make a big difference in how you experience your practice.

Religions have always employed ceremonies to increase a sense of reverence. That slow processional down an aisle, the formal removal of a sacred object from where it's kept to a place front and center, the repetition of words, gestures, and music, the donning or removing of a particular vestment or some other piece of clothing: all these repetitive, formalized, slow-moving activities demarcate worship from the rest of the day, creating a distinction in the parishioner's mind between the sacred and the secular.

As I mentioned earlier, the daily ceremony that precedes my writing time is about as mundane as it gets. It

has to do with picking a coffee cup for the day. I have quite a few coffee cups, but I keep a special place for my six favorites, which, at the moment, are coffee cups that I purchased in cities that I love. In that brief moment of choosing, I get to travel to those places, I get to experience writing in a Parisian or Roman café, and I remind myself of my own personal traditions. I don't just grab that cup — I cherish it a little.

What sorts of ceremonies do I have in mind? Here are a few from my clients.

From Leslie, a writer:

Bach! I could not live without Bach! I begin every writing session with Bach as his music magically orchestrates all the fragments of me into the one I call "writer," and then she is held in the vibration where those harmonies exist. In that harmony, the writer writes, and all is right in the world. Thank you, Johann Sebastian Bach.

From Larry, a painter:

The whole painting process is pretty ritualistic. The laying out of the palette. The choosing of brushes. Then, at the end, the cleaning up. But I include a special ceremony. I spend maybe fifteen or twenty minutes looking at art books before I begin to paint. It isn't that I want to be influenced by what I see or that I'm looking for

ideas. It's really two different things. One, I want to commune with my traditions. I'm interested in the whole history of painting. The other is that it excites me. That ceremonial twenty minutes provides me with a sense of community and also an adrenaline rush.

From Belinda, a writer:

I live in an old-world city with lots of cafés (and, yes, many Starbucks too). I could probably make a ceremony out of going to a particular café each morning to write, but I've found that my preference is to begin each day by thoughtfully deciding on which café I want to frequent. I go downstairs into the courtyard, open the heavy door to the street, and stand there a moment, feeling the early morning life of the city, feeling grateful that I get to write, and mindfully deciding which café will be today's café. Then I stride out right or left.

From Robert, an orchestra musician:

Handling the violin is a ceremonial kind of thing for an orchestra musician. The way you take it out, the way you touch it, the feel of the varnish, the feel of the bow, the way you return it to its case — everything about the experience feels ceremonial, unless you've lost your love for playing.

If you just have to crank out another rehearsal or another performance, then nothing about it feels ceremonial or special. So love and ceremony must be connected somehow. If you love something, you almost automatically add ceremony to it. If you don't love something or if you stop loving something, the magic vanishes and with it, the feeling and the desire for ceremony.

You have a ceremony in mind that might support your practice. But you don't really know all the parts of the ceremony, or whether it's exactly right, or whether it's maybe on the silly side? Try it anyway.

"If you wait until you are positive you understand all aspects of the ceremony before beginning to work, you will never begin to work."
— Lon Milo DuQuette

Indeed, love and ceremony feel connected. Likewise, majesty and grandeur. But also connected are humbleness and the glory of small gestures. Both crowning a queen and picking a flower for your first girlfriend have ceremonial resonance. The power of weddings, funerals, coronations, and inaugurations, but also the power of everyday moments, like bringing out the birthday cake, singing "Happy Birthday," and blowing out the candles, comes in large measure from their ceremonial nature.

Without that sense of ceremony and without those actual ceremonial acts, these experiences would feel much emptier and more ordinary. The same with your daily practice. It may take a bit of a switch in mindset to begin to add the ceremonial to your daily life and to your daily practice — maybe even quite a lot of a switch. Maybe you'll have to try out a

variety of things before you land on anything that actually feels ceremonial. But it will prove worthwhile to make that effort. A daily practice without a sense of ceremony about it is a dull affair — and one that's hard to maintain over time.

Food for Thought

1. What do you take *ceremony* to mean in the context of a daily practice?
2. Are you inclined toward ceremony, or do you find yourself a little antipathetic to the idea?
3. If you're a little antipathetic, what would it take for you to give the idea of ceremony a bit of a chance?
4. Can you describe a few ceremonies that might serve your daily practice?

Element 12

JOY

I regularly run a four-month Get Your Book Written! on-line support group. Obviously one goal is to help the writer participants get their books written. But a second goal is to help them establish a daily writing practice. Of course, the second goal supports the first goal. However, they are also separate and distinct goals. A writer might discover that she has good reasons not to be working on the book she thought she was writing, and so that book may not get written. If, though, she's gotten her daily writing practice in place, then she will still keep writing, simply switching to a different project — perhaps a book she had put aside a decade ago, a series of blog posts, or something else.

What typically happens is that the first few weeks are difficult on both counts. Most of the writers in the group find it hard to tackle their book and hard to keep to anything like a daily practice. This isn't surprising, since they joined the group exactly because they were having difficulties. My work is to encourage them every day, to hold them accountable, and to help them get very clear on the benefits — I would say, the necessity — of a daily practice.

To begin with, they balk. But after a few weeks, something interesting begins to happen. One of the writers will say in her daily check-in, "I enjoyed writing today!" This is so different a message from the ones the participants have been posting that the group explodes with excited emails. "You enjoyed it! Amazing! You mean…this could be enjoyable?" I smile, sit on my hands, and say nothing, letting the moment — and the joy — just be.

Then, two days later, another writer will share a similar, maybe even more excited bit of amazement: "I had fun today! I can't believe it!"

This doesn't last. The jubilation is typically quickly replaced by resignation. Back to the slog, back to the hard work, back to not knowing what the book wants, back to being agitated and distracted, back to doubting the whole project, back to…the norm. But each writer in the group now has a trace memory of joy, and their grumblings are somehow less grumbly, ameliorated by that memory — of a pleasure that may not even have been their own! Just the fact that someone in the group enjoyed herself, maybe even only for a day, maybe even only for half an hour, has made an impact.

This is all by way of saying that your daily practice is unlikely to prove a joy day in and day out. But joy may sometimes punctuate it. Maybe only a quiet joy, a joy so humble as to hardly raise a small smile — but real, palpable joy nonetheless. And the joy may begin to come more frequently and may begin to stay longer. Maybe you'll actually enjoy your whole summer of practice. Maybe you'll

simply love learning that concerto. Maybe you'll paint for a full month with enthusiasm. A secret power of daily practice? It will increase the amount of joy in your life.

Can you forcibly add joy or demand that it come and visit your daily practice? No. But you can invite it in. This is a kirist idea, the idea of invitations. Without quite realizing it, rather inadvertently, we're likely to have gotten down on life, maybe even so far down that we find life a cheat. Having given life that rousing thumbs-down, we also execute joy, like some cruel Roman emperor. It is our job, then, to give life a thumbs-up, even if we can't exactly find the reasons to do so. From that calculated stance, we open our heart and invite joy in.

Your daily practice is rehabbing your body? Invite joy in. Your daily practice is sending out begging emails in support of some much-needed research? Invite joy in. Your daily practice is mindfully managing your anxiety? Invite joy in. Your daily practice is memorizing your one-woman show? Invite joy in. I think you can sense how less likely it is for joy to arrive without that invitation. None of these activities are particularly joy producing by their nature. They aren't anything like being silly with your child or sharing a quiet moment with your

There can be such joy in paying attention, in living one's life purposes, in doing a beautiful thing, in doing an excellent thing, in contributing, in creating, in being present. But our habit may be to downplay the joy, as if it were unseemly or illicit. Enjoy!

"Enjoy what you are learning and doing. This is one of the hardest concepts in the entire world to understand. Harder yet to put into practice."
— Carew Papritz

lover. They don't cry, "Joy!" on the face of it. So you must say, "Come in, joy, come in and visit."

In what must have been a moment of rapture, the poet and critic Louise Bogan averred: "I cannot believe that the inscrutable universe turns on an axis of suffering; surely the strange beauty of the world must somewhere rest on pure joy!" *Pure* joy? I wonder. But *some* joy? Most definitely. Each of us has personal knowledge of that. Some joy is not only not impossible but, if you prop open your door, throw open your windows, and invite it in, even likely.

Let your daily practice bring you some joy as you take pride in your efforts to live your life purposes and to make and maintain meaning. Your practice may not bring you joy every day, and it can bring at least as much pain as joy, as you do your real work and confront life's realities. But at its heart, it is a joyous thing to meet life with genuine effort, responsibility, and personal pride. See if a quiet sense of joy can begin to inform your daily practice.

Food for Thought

1. How can a daily practice be made to feel more joyful?
2. Do you experience much joy in life? If not, do you have a sense of why that is?
3. Visualize inviting joy in. What would that look like for you?

Element 13

DISCIPLINE

This element of practice, discipline, and the next element of practice, devotion, go hand-in-hand. It can prove very hard to be disciplined when you aren't also devoted. Consider a man who is talkative and can hardly keep his tongue from wagging. But it is wartime, and if he wags his tongue, he may cost lives. He will likely find the discipline to keep quiet because he is devoted to the cause. Yes, human beings in this situation still fail themselves and engage in undisciplined chatter. But it is much more likely that he will keep silent with so much at stake.

Many of the elements of practice combine to help you maintain the discipline required to show up every day to something that may be hard sledding, like building your online business or rehabbing an injury. The habit of regularity will help. The sister habit of repetition will help. The seriousness you bring to your endeavor will help. The ceremonies you've thought to include will help. That you are self-directing and see self-obligation and self-authorship as virtues will help. That is, the many ways that you are on the side of your daily practice — that you are

holding its importance — will help you maintain daily discipline.

Still, for many people discipline is hard to come by. Some folks have serious trouble tolerating the very experience of discipline: the act of sitting there, doing a single thing in a step-by-step way, not reacting to the hardness of the task, not jumping out of their skin, and not leaping impulsively to a default behavior or acting defensively to halt the encounter. Discipline *feels* a certain way, and many people can't abide that feeling, often because childhood trauma or other negative childhood experiences have become a hardened feature of their formed personality.

If this is your challenge, your daily practice is threatened. You may therefore need to choose, in addition to some primary practice, a secondary practice that supports your intention to be disciplined, such as the personality upgrade practice or the mindfulness practice described in part II of this book. For example, you might maintain a separate five- or ten-minute "I can sit here and tolerate these thoughts and feelings" mindfulness practice that precedes, say, your daily healing practice or recovery practice. If you find that you can't get to your primary daily practice in a disciplined way, this additional mindfulness practice might prove to be the missing necessary ingredient.

Discipline is an excellent thing...if you are actually choosing it. The shadow side of chosen discipline is pressure-induced discipline, that is, a discipline that is forced upon you by outside social forces or inner psychological forces. If you're a young musician practicing

your instrument in a disciplined way because your parents demand that of you, that isn't the excellent, generous, self-determined discipline you ideally want. Nor is being a stickler for rules because it makes you anxious to break a rule. Nor is being a disciplinarian because you feel compelled to punish others.

Janet, a coaching client, had to sort this matter out. She had always been a disciplined person, doing everything right at school and then, later, at work. She did more than her share at her job, always turned things in early, and held in a well-masked contempt for the people around her who acted in an undisciplined manner. But she couldn't write her fantasy novel. In the realm of invention, there seemed to be no discipline available to her. It made her shake her head.

When the greats say that it isn't talent, it's practice, should we believe them? There must be a downside to taking them at their word, since we may be running a fool's errand if great talent is required. But mustn't there also be an upside, in case industry really is the main part of success?

"What I have achieved by industry and practice, anyone else with tolerable natural gift and ability can also achieve."
— J. S. Bach

"What *is* going on?" she lamented.

"Well, you say that your parents were sticklers?"

"They were."

"And you took that to be a good thing?"

She hesitated. "A mixed thing."

"How so?"

"Because things got done. Which was a good thing. But it was all a little...brutal."

"So...want to go all the way and call them authoritarians?"

It took her a while. "They were."

"So maybe you haven't actually been a disciplined person. Maybe it's more like you've been…an obedient person."

This brought tears to her eyes. She didn't respond for some time.

"Maybe," she finally said softly.

"Let's play with the following distinction, that there's a difference between forced discipline and free discipline. You've been great at the former. But the latter? Maybe that isn't in your repertoire yet?"

"Free discipline," she murmured.

I nodded.

"It feels impossible for those two ideas to go together," she said. "Freedom and discipline."

"But they have to, don't they? This must be some kind of key."

She nodded. "But," she said quickly, "it can't be in a sentence like 'I'm free to be disciplined.' That doesn't capture it at all."

We sat there.

"It's more like this," she said. "'Discipline freely given.' That feels very different from 'I'm free to be disciplined.'"

"Okay!" I exclaimed. "And what would you like to do with that?"

She thought for a moment. "I want to just say, 'Discipline freely given' many times. I don't want to 'do' anything else with it. I don't want to attach it to the writing or burden the writing with it or anything. I don't want a plan. I just want to say it many, many times. And then see."

"That is a plan." I smiled.

"Then, that's the plan!"

Your daily practice is a primary way that you manifest your willingness to be disciplined at least for a portion of your life. By manifesting discipline here, by showing up every day at your practice and by making the effort to do this work, especially on those days when you would prefer not to, you build your muscles for disciplined action overall. Being disciplined even just for the duration of your daily practice will lead to excellent disciplined action elsewhere in your life.

Food for Thought

1. Think about how you hold the word *discipline*.
2. Do you object to the idea of discipline, maybe on the grounds that it's boring or not a personality fit? If so, can you see changing your mind, for the sake of living your life purposes?
3. If you're a pretty disciplined person, would you say that it's more a forced discipline or more a free discipline? If it's more a forced sort of discipline, how might you transform it into a free discipline?

Element 14

DEVOTION

Devotion has about it a sense of love and also a sense of worth: we are devoted to something because we sense its worth and also because we love it, feel passionate about it, feel deeply curious to learn more about it, and so on. If we are lucky, our daily practice is a devotional one, maybe one of the few places of devotion in our very secular calendar.

Luciano Pavarotti understood this well. "People think I am disciplined," the late opera star said. "It is not discipline, it is devotion. There is a great difference." And there is. I would have a very difficult time, maybe an impossible time, working hard on book after book just for the sake of maintaining a disciplined approach to life. It is, in fact, a place of love for me. Though that love can wax and wane, it doesn't fully vanish. Some mist of love always remains.

If you hold something as one of your life purposes, if in a quite visceral way that something is a part answer to your meaning questions, if you deeply love something, then that something may rise to the level of object of devotion. It may still tax you, annoy you, frustrate you, and

bedevil you. But it remains close to your heart as something worth embracing.

A kirist idea is that meaning is the sort of thing that can be coaxed into existence. As a child, maybe music moved you. As a teenager, you went to concerts that thrilled and mesmerized you. Whether it was a sensible idea or an absurd one, you devoted yourself to music. Now music remains consistently and persistently a place of meaning for you. You make meaning investments by practicing a lot and by playing a lot, and you seize meaning opportunities by jumping at the chance to sit in with good musicians.

What is devotion? It is something like the ratification of the human spirit, something like wonder and amazement, something like abiding love, and something like hope bobbing merrily in a sea of hopelessness.

"Only one who devotes himself to a cause with his whole strength and soul can be a true master. For this reason, mastery demands all of a person."
— Albert Einstein

Maybe in a conscious way or maybe in an unconscious way, you viscerally experience music as the answer to your meaning questions. Music is a real and almost complete antidote to the feeling of meaninglessness. It is largely a matter of luck, of course, that some pursuit fills the void so well as to become an object of devotion. But you have been vouchsafed that piece of luck, and music is that for you.

That doesn't mean that blocks won't arise — of course they still might. But it is a very different matter to be blocked with regard to the scientific problem you are trying to solve and to be blocked because your scientific specialty no longer holds any particular meaning for you. Those are very

different experiences in the realm of meaning, and that second block is rather likely to become a permanent one.

It is lovely if you are devoted. But does devotion come with a lifetime guarantee? Sadly, it doesn't. Say that you aren't earning much money as a musician and you work at unpleasant day jobs while trying to make it. You do this year after year after year. You get married, you have children, you go to your day job, you jam with your band, you play the occasional gig, but now you are just going through the motions.

Music has lost its luster. Yes, you still love it in some deep way. But now it is also a source of terrible pain. You envy your friends' successes. You stop hungering for gigs. You start missing practices. The dramas and foibles of your bandmates annoy you; then they upset you; then you begin to lash out at them. At some point, you will probably hang up your guitar. The love is still there, but the devotion has ended.

How does this connect to your daily practice? First, whether you actually feel devoted to the thing you are doing on a daily basis may amount to a matter of luck. If you don't actually feel devoted, then you may have to demand an extra measure of discipline from yourself. Where there is devotion, discipline is hardly required. Where there is little or no devotion, better bring in the discipline.

Second, even if you do feel devoted, that devotion can wane. I know a nun who was devoted to her order, to her Mother Superior, and to God. At some point, even *that* devotion ended. Maybe you've gotten down on the thing you're practicing: maybe your surreal painting or

performance art no longer impresses you or interests you. Or maybe you've gotten down on yourself, thinking you ruined your own chances or failed yourself. There are many reasons why our devotion may wane. But since it can, you will want to monitor it carefully. If it is waning, maybe you can rekindle it before the flame dies out completely.

Food for Thought

1. Do you tend to experience much devotion in life?
2. Is whatever you are pursuing in your daily practice a place of devotion for you? If it isn't, might there be some way to love it more and to nurture devotion to it?
3. If you feel your devotion waning, what strategies might you try to rekindle it?

Element 15

REPETITION

Repetition is so…repetitive.

That isn't to say that human beings don't like repetition and even crave repetition. Watch folks at a Las Vegas casino playing the slots. Some are gambling and seem to care whether they are winning or not. But many appear to be in a happy trance, one made up of their own repetitive gestures and the repetitive sounds all around them. Even the periodic return of the hostess inquiring if they'd like something to drink is part of the repetition. That looks to be an environment of repetition that we actually sometimes crave.

Some repetitive acts, like toiling away on an assembly line or providing quality control, bore us and tire us out. Others, like watching an episode of our favorite show for the umpteenth time, please us and soothe us. That must be proof that whether a given repetition is desirable or problematic depends on the nature and context of the activity. So if you hear yourself saying, as you engage with your daily practice, "I hate repeating myself!" know that you aren't saying something precisely true. Because

sometimes you don't hate repeating yourself; sometimes you actually crave it.

Not only do we sometimes crave repetition, there is power in repetition. Often, repetition is the only possible path to mastery. Shooting hundreds and hundreds of free throws, repeating phrases in a language we're trying to learn, rehearsing our lines for the role we're playing in *Hamlet*: all of this is crucial. How many times did Cezanne stare at and paint his mountain? How many times must a soldier disassemble her weapon and reassemble it before she can do it blindfolded? Many, many, many times.

> Repetition of the right sort does something wonderful to the brain. It shapes it in its own best image. Neural pathways start to sparkle, so to speak.
>
> *"Any neural pathway is built and strengthened through repetitions. This is why practice is so vital."*
> — Britt Andreatta

Often repetition is simply necessary. I have to proofread each chapter of the book I'm writing many times over in order to catch that last dropped word or other small error. No computer program can catch a dropped word. Only a human being can manage that, and rarely on the first try. On that first try, and often on the second try as well, the writer's mind simply supplies the word that isn't there, because the writer expects it to be there. So a third time is necessary, even if the chapter seemed perfect on the first two reads. That repetition is not pleasant, not a joy, and not a treat. It is just necessary.

Does it really matter if you learn that chord sequence, play that sonata well, capture something about that mountain, know your weapon inside out, or catch that dropped

word? Yes, it does. It disappoints us if we do a slipshod job or less than what's required. That isn't to say that we shouldn't forgive ourselves if a dropped word appears (or, rather, doesn't appear) in our finished book or if we flub a note at our concert. But even as we are easy with imperfection, we can still stand on the side of excellence.

Repetition is a subtle concept and comes with a shadow side. Repetition is one of the ways that we reduce our experience of anxiety, as in repeatedly washing our hands to deal with our nervousness around germs and around life itself. A painter repeats his subject matter, not because it interests him, but because it soothes him to do something that he finds easy; or a singer repeats her set over and over again, so as to avoid the unease that would well up in her if she upset her audience by giving them something unexpected. Artists often repeat themselves to avoid experiencing anxiety — but at the cost of growth, change, and meaning.

But what does *repetition* mean? It might mean playing the same chord over again and again. But it might also mean moving on. What you are repeating is your daily practice, not necessarily the content of the practice!

"You become a great writer by writing lots and lots of stories, not by rewriting the same story over and over again."
— Scott William Carter

One of my clients, an interior designer, relied on bold patterns dominated by triangles. That was his go-to style, which people loved. But over time it became a crutch. He knew he needed to move past triangles, but his clients demanded them, and he himself felt reluctant to make the switch. Another client, a romance writer, wrote romance after romance even after the genre

stopped interesting her, because the novel she really wanted to write made her anxious to contemplate and seemed completely beyond her reach. In these instances, repetition was not the answer.

Because of these complexities, it's on our shoulders to maintain awareness and do a good job of distinguishing between when repetition is a crutch and when repetition is a requirement. Often it will prove to be an absolute necessity. Excellence can sometimes come out of the blue, but more often it comes because we've been applying ourselves again and again, playing that chord sequence or checking for that dropped word. Repetition has a shadow side, but more usually it is the lifeblood of our daily practice.

Food for Thought

1. *Repetition* is a subtle word. Explore and consider some of its subtleties.

2. Describe in your own words the sense in which repetition is a good thing and even an essential thing when it comes to your daily practice.

3. Describe in your own words the sense in which repetition might prove a more problematic thing when it comes to your daily practice — for instance, if it were to become too mechanical or too obsessive.

4. Do you have the sense that you may have trouble with repetition? If so, what approaches might you try so as to deal with that challenge?

Element 16

INNOVATION

We have a daily writing practice. It is our time to write. But we really, really don't want to write. We can tell that, in this mood and this state, we are actually not going to write. We can feel how close we are to throwing in the towel for the day. But we remember that innovation is also an element of practice. So we say, "I need to do something new today. I need to take my writing to a café. It and I need a vacation, not apart from each other, but with each other. I'm going on a writing vacation this morning!"

We have a daily performance practice. We've written a new song, the first one in a long time that we really like. But we can tell that just practicing it again today is a bit of dodge, as it's about time to let someone else hear it. That thought provokes our performance anxiety, which we know is a problem that needs addressing. So, rather than doing what we might usually do, practice our song yet again, we text a friend: "Let's hop on Zoom so I can play you my new song! Up for that?" This is not how we normally use our performance practice time, but we know that it is exactly the right way to use it today.

We have a daily life purposes practice. We've been doing a modestly decent job of getting to our life purposes in a regular way, certainly a better job than before we named our life purposes and initiated a practice around them. On balance, we're very proud that we've been keeping to a daily practice and paying such good attention. But something has been seeming off. So this morning we come to our life purposes list with fresh eyes and ask the potentially disrupting question: "Do I need to update my list?" This feels very scary to ask; the answer might feel as if an earthquake has struck. But we have the sense that this question needs asking.

Even though we are prizing regularity, routine, discipline, and repetition, *how* we practice is not a static thing. It can have newness about it, or it may need some newness. We need to be honest. If we're skipping our practice, if getting to it feels like too much drudgery, if something about it just feels off, we are entitled to ask the question, "Is some innovation needed? Some change? Some creativity?" While we prize repetition and routine, we also embrace the idea that when it comes to our practice, we may sometimes need to be inventive.

Gerry was a successful writer with many books under

> When you bring your intelligence, your wit, your curiosity, your talent, and your full creative self to the encounter, you are bound to innovate. Practice alone doesn't lead to innovation: it takes practice plus a hankering for the personal, the new, and the excellent.

> *"Practice makes perfect, but it doesn't make new. The gifted learn to play magnificent Mozart melodies and beautiful Beethoven symphonies, but never compose their own original scores."*
> — Adam Grant

her belt. She actually made the family money, which annoyed her husband, whose landscape business was a hit-or-miss affair. He displayed his envy and anger passively by working on the garden right in front of Gerry's writing window. Gerry had a lovely spot with a lovely view and cherished writing there. Now, though, she had to look at her cross husband.

For several weeks, she thought nothing of it and acted as if she had no problem. Except she was having trouble writing, a kind of trouble that she rarely experienced. Finally, it dawned on her what was bothering her. But still, partly out of stubborn pride and partly because she feared altering her routine, she stayed put, trying to write in her usual spot at the window. The writing ground to a halt.

Then, one morning, she up and moved to another room. The requirements of her writing life and her daily practice demanded it. She knew that her husband would comment on this, make some kind of quiet fuss, and turn it into an accusation and grievance. She could hear him saying, "You had to move? Was I disturbing you that much?" She recognized this trap: it was supposed to make her feel stuck not being able to say either yes or no. But not this time. She prepared her answer: "Not a lot. Just enough to keep me from writing."

Then the oddest thing happened. She discovered that in this alternate space, she wanted to write a different book. In her long writing career, she had never worked on two books simultaneously. Of course, she had often jotted down ideas and scenes for a different book while working on the book in front of her. But to actually write

two books at once? That had never crossed her mind as a genuine possibility. But here it was, happening.

Her husband finally stopped puttering in front of the window, so Gerry was able to return to her customary place. But now, each afternoon, she would gleefully move to her second writing spot and manage a second daily writing stint. It amused her a lot that her husband's antics had produced this outcome: her doubling her daily output. It made her think that maybe she might make enough money from writing to actually leave him.

Your daily practice doesn't require any innovation, inventiveness, or newness just for the sake of doing something different. If your practice is chugging along on all cylinders, you don't want to make changes willy-nilly. But you do want permission to innovate, to be inventive, and to try something new when and if your practice requires it. It would be rather too dogmatic to say, "My practice never changes!" The better mantra? "I keep to my daily practice exactly as it is, unless a little innovation is needed!"

Food for Thought

1. If you currently have a daily practice in need of some innovation, what might that innovation be?
2. Do you have the sense that you are more likely never to change a practice you've put in place or more likely to too often change a practice you've put in place?
3. What might you try in order to strike the right balance between repetition and innovation?

Element 17

SELF-TRUST

It's fine to follow the recipe. But mustn't it also be okay to add a few more carrots to the soup if you really like carrots? It's fine to learn the customary way a thing is done. But shouldn't it also be acceptable to change up the method a bit because you see a way to improve it? It's fine to look to the experts; but aren't some experts only self-proclaimed and neither very knowledgeable nor very honorable? Isn't a little healthy skepticism sensible? Isn't one of the more solid life principles that you ought to trust yourself before others?

Indeed, your daily practice rises on self-trust and is likely to crumble if you can't trust your own decisions: your decision to live your life purposes, your decision to take charge of the meaning in your life, your decision to stand up for your values, your decision to work in a disciplined and devoted way at a particular thing. You bring trust to the process to start with; by getting to your practice day after day and year after year, you grow ever worthier of your own trust. If you can go in trusting at least enough that you persevere, the self-trust will grow.

What does trusting yourself look like when it comes to your daily practice? Say that you're in the first month of a healing practice. You love that you've committed to healing your body; or, rather, you loved that idea when you began. Now you're more than a little bit doubtful, since you haven't seen any benefits yet. Still, it's so early in the process that you ought to stand behind your commitment, oughtn't you? But many folks abandon their practice when they don't see quick results. Doesn't your new healing practice deserve to be trusted, certainly for a little while longer? Isn't doing that identical to trusting you, the person who gave birth to the idea of a healing practice?

Or say that you're endeavoring to build your online business, and you've set aside a specific hour each day to reach out to celebrities, influencers, and other important marketplace players who are in a position to help your brand. This is your special business-building daily practice...and one that you rather dread. You simply don't feel big enough or important enough to reach out to these almost otherworldly creatures. Can you find a way to trust that in some fundamental sense you are their equal? Can you find a way to trust that you and your online business matter?

Or say that you're contemplating an activist daily practice. You have a cause in mind. People are being terribly mistreated, and it makes your blood boil. You intend to organize, march, write, and put yourself fully on the line. You've decided that you will do anything you can to help. But you don't trust that you can contain your rage. You know your own nature, and you worry that you will

step dangerously over some line and say something or do something fraught with danger. So you table your plans and rage internally. Might it have been possible to trust that you could maintain control of yourself? Or, if you really couldn't trust that, might you have been able to trust your ability to find a modest way to be of help, rather than landing where you've landed, being of no help at all?

Or, as a last example, say that you've put into place a relationship-building daily practice. To repair your ties with your sister, you're focused on constructing a bridge by chatting with her on a daily basis. But her remarks continue to inflame you, just as they did when you broke with her, and you don't trust that she will ever stop insulting you. Can this practice be maintained if she continues to insult you and if you're certain that she always will? What sort of self-trust makes sense here? Maybe trusting that you are right and that letting your sister go is necessary for your emotional well-being? If that's the truth, that's the truth. This daily practice may have run its course. Here, trusting yourself may lead to the end of a daily practice — and so be it.

Is your daily practice a private one? It could be. But it doesn't have to be. Practice in public, if that's what your heart desires. Trust yourself to understand what your practice requires!

"I could never sit in a room and just play all by myself. I needed to play for people and all the time. You can say I practiced in public." — Bob Dylan

Trust yourself. This will mean different things in different situations. Sometimes you will need to trust that you are equal to continuing. Sometimes you will need to trust that you ought to stop. Sometimes

you will need to trust that you have the personality resources needed to meet a challenge or to solve a problem. Sometimes you will need to trust your worry that some personality shadow will get the better of you if, say, you go into that bar, join that march, or send that email.

It is, of course, possible to trust yourself too much. It would be a symptom of something — narcissism, grandiosity, delusion, obstinacy, fantasizing, wishful thinking, naïveté — if you thought that you could sing the lead in *Aida* without ever having sung a note, or play center for a professional basketball team when you're only five feet tall, or walk on water. Trusting that you can walk on water is over an edge. But basic, everyday, staunch self-trust is a necessity. Otherwise you will be buffeted all over and find yourself halfway out to sea. You are not a feather to be blown about at the discretion of others. You must lead, and you must trust yourself.

Food for Thought

1. Think carefully about how well or how poorly you trust yourself.
2. Do you perhaps trust yourself too much and incline toward narcissism and grandiosity? If so, what might you do to rein in those tendencies?
3. If you trust yourself too little, how might you go about increasing your self-trust? Might a separate personality upgrade practice make sense?

Element 18

LOVE

You sit there slogging away trying to solve a problem in theoretical mathematics. What's to love? That it's given you a headache? That you're no closer to solving it? Maybe you can feel some respect for your efforts. Maybe you can appreciate your discipline and your devotion. Maybe you're charmed by the way you're able to bring a little lightness and playfulness to such a heavy endeavor. But love? What's to love?

Life, I think. The love that you might let filter into your daily practice, like light filtering in through sheer curtains, is a gentle love that has something to do with those rare bits of life that are worth loving, bits like freedom, decency, and a child's smile. Can the love that fills you up when a child smiles find its way into your daily practice? Somehow, it should. Wouldn't that be lovely?

Or maybe it's a fierce love, not a mild love at all. I love singing "*La Marseillaise*." I sound terrible, but I belt it out. All that rebellion and that ironclad demand for freedom. A song banned by kings and emperors. Exactly! "Tremble, tyrants!" Yes, the precise meaning of its lyrics is up

for debate, given that it was written by a monarchist. But, seriously, we know what it signifies. Just ask the ghost of Humphrey Bogart in *Casablanca*, still smoking that cigarette, still letting Ingrid Bergman go, still walking off with Claude Rains to fight some fascists.

Likewise, I love visiting the Treasures Gallery of the British Library. There you'll find, virtually side by side, the original handwritten *Alice's Adventures in Wonderland* and an original copy of the Magna Carta. The Magna Carta! Or, precisely, Magna Carta Libertatum (The Great Charter of the Liberties). To my mind, they are intimately connected. Skeptical Alice, not at all pleased by queens lopping off heads, a child of liberty falling asleep in the bucolic English countryside, permitted her skepticism by the document right there in the nearby case.

Similarly, I love the D-Day invasion that helped turn the tide in World War II. Has the world ever seen anything like it? Seven thousand ships crossing the English Channel. Thousands of aircraft overhead. Has there ever been anything more magnificent, more important, more heart pounding and more heartbreaking? Hundreds of thousands of casualties, wounded and dying for the very best of reasons. Do you share my love and my reverence?

These are obviously not daily practices, but they suggest where a person's fierce love may reside. Somehow that love infiltrates my daily practice (as it is doing right here). What do you love with a burning, unquenchable love? How might that awesome love infiltrate your daily practice? Stop for a moment and think. There must be a way! How sad if there isn't.

Or maybe yours is a very quirky love. I wrote a book called *Brainstorm: Harnessing the Power of Productive Obsessions*. In it, I described all sorts of oddball fascinations. A love of the cemeteries of Queens, New York. An obsession with keeping track of the local tides. A preoccupation with printing-press font types. A fascination with fallen leaves. A love of the science of wine making. A passion for the joys of stargazing. A fixation with restoration.

> **What are you loving? Maybe the dive!**
>
> *"I love all men who dive. Any fish can swim near the surface, but it takes a great whale to go downstairs five miles or more."*
> — Herman Melville

If the obsession prevents you from doing the next right thing, like picking up your fallen child or showing up at your day job, that's another matter entirely. But if you love something with what we might call an innocent love, and even if that something is wet, fallen leaves or the microbes that make wine, who's to say anything? And if you want to build a daily practice around that quirky love or celebrate it by, say, surrounding yourself with autumn leaves, why not?

I remember working with a woman who loved Italy. She ran Tuscan-based nonfiction writing retreats for popular science writers and traveled to Italy as often as she could. She got her love of Italy into her daily writing practice by painting the stuccoed walls of her small study Naples yellow. It didn't matter that she was writing about subjects that had nothing to do with Italy, like nanotechnology and chaos theory. That yellow warmed her heart and warmed her books.

Then there was Barry. Barry was fascinated by the Doomsday Clock, that metaphoric device maintained by members of the *Bulletin of the Atomic Scientists* announcing how close, in their estimation, human beings are to the midnight of global catastrophe. He loved that we were at a mere two minutes to midnight. That macabre love motivated him to work ten hours a day on his paintings. "Not a moment to lose," he would say, laughing. "The clock is ticking!" That sardonic love was somehow also genuine love, like the love at the heart of the writings of the great ironists. Wouldn't Mark Twain and Jonathan Swift have loved the Doomsday Clock?

I have a small daily practice that is a place of love for me. Every day I glance for a moment or two or three at the compilation of artists' quotations that I've put together over the years. I have hundreds and hundreds that move me. This all began thirty years ago, when the publisher Jeremy Tarcher asked me to gather quotes for the margins of my book *Fearless Creating*, which he was publishing. I love the quotes that I gathered then and have continued to gather over the years, and I love spending a little time with them each day.

Or maybe it's the sky!

"I love to [paint] skies. It must be the old Greek gods Zeus and Apollo stirring within me."
— Stephen Maniatty

It's clear where an element of practice like discipline or repetition fits in. But love? How can you translate the idea of love as an element of practice into some actual loving? I hope that you can find the way, and I invite you to really try. A loveless practice is exactly that. It is colder

than it need be and maybe too cold even to contemplate. Warm it up with love.

Food for Thought

1. Describe in your own words the idea of love as an element of daily practice.
2. How might you go about getting more love into your daily practice?

Element 19

PRIMACY

While you're engaged with your daily practice, it comes first. It has primacy. Many things in life are important, but for that period of time, those other important things are not permitted to intrude on this important thing. You do not think about the other things you might be doing, you do not think about the looming day, you do not think about all those other practices that are also worthy. This current important thing takes center stage.

Priority, a related idea, has a head feel to it. *Primacy* has a body, heart, and energy feel to it. It feels close to *primal*. Your whole being — and not just your head — has chosen this as your focus. Practicing your guitar may not be your top priority in life, but for this period of time it has primacy, because, as you look at your day and your life, it is the appropriate next thing to do.

A kirist goal is to do the next right thing (and the next right thing after that). This implies that there are multiple possible next things to do, that more than one thing might vie as the next right thing, and that you are obliged to intentionally choose one as *the* next right thing. You

might fight for a cause, work on your novel, have a heart-to-heart chat with your child, repaint the spare room, or relax. Any one of those might be the next right thing, in context. But one has primacy, because you've made it your choice.

There is some primal prioritizing necessary — and not just this one time, but at all times. The activities that make up a day are exactly a sequence of primal prioritizing. If it is the appointed time for your daily practice, and unless there is some compelling or urgent reason to choose differently, you choose your practice. You make it your sole focus for its minutes or hours. Since it is an intentional choice, it is also a rededication: a rededication to your noble effort to live your life purposes.

You arrive at your daily practice, not through mere habit, not through mere repetition, but instead because each time you announce, loudly and clearly enough that you hear your announcement, "This is important." In fact, most people have trouble doing this thing which sounds so simple in principle: announcing that one thing is more important than another thing. It isn't as a matter of importance that they spend hours in front of their television set or hours shopping online. Importance doesn't enter into it. Their mantra is more "Let me pass the time" or "Let me satisfy a craving" than "Let me do the next right thing." They have not organized their life around what they genuinely value.

Primacy involves a reckoning of values. You reckon that, right now, this has more value than that. It is a ten,

that other thing is a nine, and that other thing is a two. Ah, but that two is so shiny. That three would taste so good. That four would produce oblivion. That five would pass the time. You shake your head: ten is ten. It tops the list, a list where what's appropriate and what's right are determining the ordering.

You pick your next right thing, not in a vacuum, but as an integral part of the way you are sequencing and negotiating your day. The next thing you choose may have primacy because it is serving the thing that follows it, which *really* has primacy. For instance, you might take a nice hot shower before you settle in to write your novel, support your cause, or upgrade your personality — just so long as that is indeed the right sequence and just so long as you actually get to your novel, your cause, or your upgrade. If that is the appropriate order, then that is the appropriate order.

Does your daily practice last only a minute or two? Well, all right. Does it last an hour, two hours, three hours? All right then. What matters is that it has its important place in your life. When its time comes, you attend to it fully.

"You are how you spend your time."
– Ian Rogers

The peas don't have to come before the ice cream, but you do need to get to the peas. That nap may have been for its own sake, but it may also serve as a strength-building prelude to the hard conversation you intend to have with your daughter. That hour of television may be half frivolity and half relaxation, but it may also be the absolutely necessary relief between two serious daily practices.

When it is time, your daily practice needs to rise to that place of

primacy. If it's its turn, it moves ahead of everything else except the urgent. It takes its place at the head of the table. Most people have trouble with the very idea of priority, so you may need to prove the exception. For your daily practice to last, you need to embrace the notion that life is a series of choices and that, once made, each choice gets a felt sense of primacy bestowed upon it.

Food for Thought

1. How would you describe the idea of primacy as it applies to a daily practice?
2. How would you describe the idea of primacy as it applies to spending one's life oriented around doing the next right thing?
3. Do you have any special difficulties (as opposed to ordinary difficulties) around prioritizing choices on the basis of their value and importance? If so, what strategies might you try to help you do a better job of prioritizing this way?

Element 20

COMPLETION

Just as you want your daily practice to have a clear beginning, you also want it to have a clear ending. You have spent your time with it, and now you get on with the rest of life, with all those other tasks, responsibilities, and life purposes. You do not have to mourn that you are stopping, because you know that you get to return to it, maybe as soon as later in the day but at the very worst tomorrow. Let it end; maybe end it on a ceremonial note; and come back to it again when it's time.

That's the essence of the matter. However, the concept of completion is rather more complicated than that. You've been painting for an hour; it's time to get ready for your day job; you end your painting session; but must you stop thinking about your painting? No, of course not. Your painting is still alive, and your brain is still working. Likewise, if our practice is centered around a personality upgrade, our recovery from an addiction, or our attempt to better manage our anxiety, then it makes complete sense that we would still be manifesting that personality upgrade, working our recovery program, or employing

our anxiety management skills throughout the day. In one sense your daily practice has ended. But in another sense, it never ends, not if its content is important to you.

That said, there should also be a clear line between our daily practice and the rest of the day. You mindfully and ceremonially stop writing. You mindfully and ceremonially clean your brushes and finish painting. You mindfully and ceremonially get up from your meditation practice. You mindfully and ceremonially roll up your yoga mat. Yes, you will continue practicing yoga off the mat. But your formal yoga practice hour has ended.

One hindrance to maintaining a robust daily practice is stopping too soon. A challenge of the sort that we'll be discussing in part III may be provoking you to leave your practice early — for example, anxiety and distractibility, a felt sense of a lack of progress, boredom with repetition, or the difficulty of the task. You want to be aware that the desire to stop too early may well up in you, you want to plan for that oh-so-common problem, and you want to stay put even though you are itching to leave. You do not want to mindfully and ceremonially end your practice if it isn't really time to end it yet.

For most people, getting started is the greatest challenge. For a lot of people, stopping too soon is the greatest challenge. But for some people, stopping at all is the greatest challenge. They do not want to leave the scientific problem they are chewing on and return to a dull day of routine. Their brain is still working, and their thoughts are still whirring. They are obsessed with that problem,

energetically manic, and can hardly tolerate the thought of stopping. For this person, focusing on completion and brilliantly managing stopping are vital.

In kirism, we talk about original personality, formed personality, and available personality. A person who is so obsessed with her project and so manic as to be almost vibrating with energy must make use of her available personality to announce to herself that she is stopping. She must mediate her manic energy so that she is in charge of her racing locomotive self rather than it being in charge of her. This is much easier said than done, but it is such an important matter that, for a person facing this challenge, mastering stopping may be worth its own daily practice.

> Maybe you'll complete your practice once a day. Maybe you'll complete it twenty-one times!
>
> *"I do the same series of five exercises twenty-one times each day — an ancient Tibetan practice that stimulates your chakras."*
> — *Harry Dean Stanton*

Part of the power of our daily practice comes from the sense of completion that we get from doing something with a clear beginning and end. You start to clean your room, and you end up with a clean room. That feels good. You work on lesson three of the online course you're creating for the whole two hours you'd intended to devote to it. That feels good. You practice those chord sequences without much ardor, but you do practice them, you stay put for the allotted time, and then you proudly and ceremonially put your guitar away. That feels good. Make it a point to finish up as seriously as you practice so as to provide yourself with a welcome sense of completion.

Food for Thought

1. How will you ceremonially complete your daily practice?

2. Describe your relationship to stopping in the context of a daily practice. Do you tend to stop too soon? If so, what will you do so as to stay with your practice for its appointed amount of time?

3. If, on the other hand, you have trouble stopping, describe what strategies you might try to help yourself bring your practice to completion in a better way.

Part II

VARIETIES OF
DAILY PRACTICES

n part II, I describe eighteen distinct and different daily practices. Of course, an infinite number of daily practices is available to you. But these eighteen make for a useful sampling. I think that they will help you see how such diverse activities as composing a symphony, advocating for a cause, recovering from an addiction, building your business, or improving your marital relationship can be held as a daily practice.

They may also suggest the idea of multiple daily practices. You might work on your symphony in the morning, turn next to building your online business, break for lunch, spend time working your alcohol recovery program (say, by going to an AA meeting), and then, later that afternoon, lobby legislators in support of a cause close to your heart.

This would amount to a rich, full day organized around your life purposes and composed of four distinct daily practices: a creativity practice, a business-building practice, a recovery practice, and an activism practice.

This is an excellent way to live a life! I hope you'll enjoy learning about these eighteen daily practices — and giving each one of them some real thought.

Practice 1

YOUR CREATIVITY PRACTICE

I've been working with creative and performing artists for more than thirty years, and so the most usual daily practice that a client of mine needs to create is one centered around creativity. This might be a writing practice, a painting practice, a composing practice, an instrument practice, or something else expressive. I encourage every client to begin and maintain such a practice, because without it, an already hard thing, living a creative life, is made that much harder. Having a strong daily creativity practice in place is the best way to realize their dreams and accomplish their goals.

Consider Joanne. Joanne had been hoping to write a fantasy novel for more than a decade. She had a vague idea for it and a handful of notes but spent very little time actually being with her novel. The way she let herself off the hook was by saying, "I don't feel inspired." Partly she meant it, as she did hold a core belief that without inspiration she would produce a lifeless thing. But more centrally, invoking that need for inspiration was the way that she avoided the hard work of bringing a novel-length work of fiction into existence.

Inspiration may come. Let's hope so! But perspiration first.

"Trailing behind every successful writer are a million words that never saw the light of day. Sometimes it takes five million words. The most important piece of writing advice anyone can give or get is simple, and therefore can seem uninteresting, but it's true: just keep writing."
— Charles Finch

I shared with her one of my favorite quotes, from the Russian composer Tchaikovsky: "I'm inspired about every fifth day, but I only get that fifth day if I show up the other four." She smiled at that and nodded. "I'm sure that's true," she said, but without much conviction. She did, though, agree to commit to a writing practice of twenty minutes a day, first thing each morning. But over the course of those first few weeks, she got to her writing only a total of three times.

As she struggled to get her daily practice into place, it became very clear to her which element of practice was the hardest for her: discipline. "It isn't that I can't be disciplined," she told me. "It's more like I'm fighting with the idea of it. I feel like a little kid who's been told to sit still and just hates the idea."

I advised her to try a very simple thing: to write "Hate" in big letters on one side of a sheet of paper and "Love" on the other side of that same sheet of paper in equally large letters. "Right now, in some deep place you hate the idea of discipline. Let's see if we can turn that around," I said. "Just do the following thing. When you think about your daily writing practice, look at that sheet of paper. Look at the 'Hate' side. Really be with your hatred. Then turn it over and really be with 'Love.' You are trying to turn hate into love."

A week later, in a Zoom session, she caught me up. "I wrote four days this week," she said. "And I had this

vivid memory. It had to do with practicing the piano. My mother wanted great things from my piano playing. I think that secretly she wanted me to become a concert pianist. But I hated it. Not the piano, not the music, not even the idea of it, but the ridiculous pressure, her watch-fulness, her false praise, the whole thing. Discipline and my mother are the same thing."

I asked her what she wanted to do with that insight. "Maybe I could ceremonially cut something — a thread, maybe — to cut the connection between my mother and the idea of discipline. I do want to love the idea of discipline. Maybe somehow literally cutting a cord is the thing to try?"

Joanne knew that she was embarking on something edgy, something that almost felt like a betrayal of her mother, but she committed to that ceremonial cutting. Afterward, she told me, "It's funny. I did that cutting. I literally cut a piece of rope. And something really did change. All that work around the word *discipline* and around the idea of discipline, and suddenly that all receded into some distant background. It was like it was never an issue at all."

As with so many clients, Joanne then proceeded to work steadily on her novel. She had her bad days, her days of crisis, and her days of loss of faith in the project; and she had all those skipped days because life got too busy, too chaotic, or too pressure filled with other things. But most weeks she wrote four or five mornings, which naturally led to the novel getting built over time. Within six months she had a draft of her book, a feat she hadn't believed she could pull off.

There is no single more important thing that a creative

person can embark upon than creating and maintaining a daily creativity practice. That practice will likely make all the difference between having and not having a creative life. When nothing could feel more natural than that daily practice, you will become one of those very rare creatures, someone who virtually effortlessly produces a body of creative work.

Maybe you are very skillful. Maybe you've practiced thousands of hours. But are you an artist? To be that person, you may need a separate creativity practice, one where the focus is not on the notes but on the music.

"Practice transforms a skill into an art."
— Siddharth Joshi

You'll be asked, "How did you pull that off? How did you become so amazingly productive?" And you won't know what exactly to say, since the true answer will sound too simple. But that simple answer is the true answer. "I just get to work every day. That's about it." What you'll get in reply is a shake of the head, meaning, "No, there must be more to it than that!" All you'll be able to do is shrug and maybe repeat yourself: "No, it's really that simple. I show up just about every day, and the work accumulates."

Food for Thought

1. Would a creativity practice serve you? If you think that it could, what might its contours be?
2. In contemplating your prospective practice, what do you think is going to prove most challenging about it?
3. What strategy might you employ to meet that challenge?

YOUR RECOVERY PRACTICE

A daily creativity practice is easy to picture. It looks like a dancer dancing or a painter painting. But what does a daily recovery practice look like? A recovery practice seems defined by what a person *isn't* doing rather than by what he or she *is* doing: someone not drinking, not shopping, not searching for sex, not gambling. So how should we conceptualize a daily recovery practice?

First, what life challenge is a daily recovery practice addressing? It is addressing the way that a life can run off the rails by virtue of the grabbing power of some substance, behavior, or idea. We know the family of words that we're talking about: *craving, obsession, compulsion, dependency, addiction.* You can't get the thing in question out of your mind, out of your system, or out of your life. Your life is organized around the pursuit of this thing: the alcohol buzz, the gambling thrill, the sexual release.

And what is recovery? *Recovery* is the word we've come to employ to stand for some key ideas: that you've broken through your denial and surrendered to the fact that you have a problem; that you've accepted the need to pay daily

attention to not doing the thing; that you've realized support is vital; that you accept the problematic thing wants to return and indeed is likely to return; and that, because your efforts may well be interrupted by slips and falls, you may have to keep beginning all over again.

Therefore, a daily recovery practice might include any or all of the following. It might mean attending a daily Alcoholics Anonymous, Narcotics Anonymous, or other twelve-step meeting. It might mean starting your day with the Serenity Prayer or some other ceremonial mantra. It might mean journaling and working the steps of your program in writing. It might mean making amends in a daily way. It might mean patiently engaging in cognitive restructuring with the aim of thinking thoughts that support recovery. It might mean daily physical exercise or paying daily attention to your life purpose choices. It might mean all of these and more.

Consider Robert. Robert wondered how exactly he had gotten into the legal profession. He remembered a very clear moment, just after graduating from college, when for hour after hour he had walked by a river trying to decide whether to apply to law school or journalism school. He really wanted to be an investigative reporter and do some good. But law somehow seemed safer and more sensible; it looked like the clearer path to a solid life. So he chose law.

And regretted it. He did well in law school — and drank a lot of alcohol. He did well at his first job — and drank a lot of alcohol. He got married, had kids, bought a big house — and drank a lot of alcohol. Then a moment

came that began to turn his life around. "That smell is coming through your skin, Daddy," his son said. That was Robert's "soft bottom." He felt forever grateful that he hadn't had to hit rock bottom, destroying his liver or plowing into a pedestrian while drunk, before coming to his senses.

We chatted about the possibility of Robert creating a daily recovery practice as a complement to his AA recovery work. Every day at the same time, he would take thirty minutes to examine his thoughts and see which of them were serving him and which weren't. That struck Robert as sensible and easy...in theory, at least. But he found actually doing it nearly impossible. In trying to figure out what was getting in the way, we looked over the elements of practice.

Recovery is a full-time commitment. Your daily recovery practice supports that commitment. Its benefits spill over into your whole life.

"While you are continuing this practice, week after week, year after year, your experience will become deeper and deeper, and your experience will cover everything you do in your everyday life."
— Shunryu Suzuki

"I think it's repetition," Robert said. "I'm having trouble with the idea of doing the same thing every day. It's not even the idea I'm having trouble with — it's more like a feeling in my body. My body is rebelling against repetition."

"You brush your teeth every day," I said.

Robert laughed. "Yes. I bet we can name fifty things I do every day. But how many *important* things could we name?" He stopped, surprised at his insight. "Why would I *not* want to repeat the important things?" He thought about that. "It has something to do with the

specter of failure," he said, "but I don't know what the connection is."

"You go to AA meetings regularly?" I asked.

"Regularly," he said. "But definitely not every day and definitely not as often as I should. The thought of ninety meetings in ninety days is exactly as off-putting as the idea of a daily recovery practice. It's somehow like *Groundhog Day*, life repeating itself not only dully but mercilessly and painfully. The thought of days repeating themselves is some kind of killer."

I had a thought. "Do you repeat yourself at work?"

"God! All the time! My work is crazy repetitive, writing the same briefs, filing the same motions, saying the same things. Just the thought of that makes me want to drink!"

We'd hit on something. Robert ran with it. "I think I'm being done in by repetition at work, and the thought of another repetitive thing, a daily recovery practice, is just too much. That's it exactly." It took several weeks, but finally Robert landed on a reframe that worked for him. Rather than thinking of his recovery practice as something he "repeated" every day, he created the mantra "new every day" and used that phrase as the ceremonial bridge into his daily recovery practice. In fact, it actually began to feel new every day, one day chatting with his sponsor, one day reading the Big Book of AA, another day working one of the steps of the program. Robert's experience demonstrates just how important it is to find the right framing and the right language in support of one's daily recovery practice.

Food for Thought

1. Would a recovery practice serve you? If you think that it could, what might its contours be?
2. In contemplating your prospective practice, what do you think is going to prove most challenging about it?
3. What strategy might you employ to meet that challenge?

Practice 3

YOUR LIFE PURPOSES PRACTICE

A guiding principle in kirism takes a truth — that there is no single or singular purpose to life — and translates that truth into actions to take, namely, identifying and naming your multiple life purposes; making strong, clear life purpose choices; and living your life purposes on a daily basis or as close to a daily basis as you can manage.

This way of looking at life amounts to a gigantic shift in thinking for most people — but a shift that feels natural and logical. The idea that many things in life are important, not just one thing, and that those important things can change over time, rather than remain static, likely matches how you already view life.

It can feel disappointing and discouraging to realize that the universe has no particular purpose in mind for us. But it is also liberating and energizing to realize that you get to decide what's important to you, what's worthy, and what feels meaningful to pursue. What you lose, the wishful thinking that life has a singular purpose, is more than made up for by what you gain, permission to live your life on your own terms.

Your life purposes practice, then, is the way you pay daily attention to your life purpose choices. Having identified, named, and chosen your life purposes, you might consult that list every morning and make decisions about which of your life purposes you intend to pay attention to on that day. Quite likely you'd already have one daily practice in place — say, a mindfulness practice in support of your cognitive health. Your daily decision making would center around which of your other life purposes — say, your activism, business building, relationship nurturing, or service — you intended to get to on that day.

That morning check-in with yourself would constitute your life purposes practice and would help you organize your day around your life purposes rather than around your chores, tasks, and errands. That check-in might take no more than a minute or two: you look at your list, make a few decisions, nod to yourself, and begin your day. But that it takes only a minute or two doesn't make it less important than a practice that takes an hour or two. In fact, that single minute, the minute you spend reminding yourself of your life purposes and orienting yourself in their direction, will likely prove the most important minute of your day.

In practice, of course, figuring this all out can prove more than a little difficult. Consider Jennifer. Jennifer conducted three different choirs, held down a responsible job, had seen her two children into adulthood, and had weathered her divorce as well as could be expected. She had friends, hobbies, a love of nature — so why did these

That you've identified your life purposes and intend to live them means that you are obliged to act on their behalf. One core action is your daily practice in support of your life purposes.

"Mere philosophy will not satisfy us. We cannot reach the goal by mere words alone. Without practice, nothing can be achieved."
— Sri S. Satchidananda

many things somehow not add up to a good-feeling life?

As she approached fifty-five, she knew that she was either coming to a crisis or already in one. When we met, I presented some of the above ideas: about the difference between searching for purpose and making strong, clear life purpose choices; about how things that we do in the service of meaning may not necessarily feel meaningful in the doing ("Like certain choir practices!" she exclaimed); and other kirist concepts. She took that all in.

"I love the idea of life purposes rather than one all-important life purpose," she replied thoughtfully. "That completely matches my vision for life. But I'm sure I would draw a blank if I tried to name what those life purposes are. Oh, I could make a list of the things that interest me or are important to me. But I can feel how making that list isn't the right task."

"What would be wrong with that list?" I wondered.

"It would lack…imagination."

I laughed. "Imagination?"

"I know that's a funny word in this context. But I feel like I need to imagine a different life — a different way of life, a different take on life, I'm not sure what — that isn't just seeing myself traveling or living in another city or anything like that. It feels like those life purpose choices,

whatever they might be, have to flow from a completely reimagined life."

"That's a tall order."

"I know. But that feels like the task."

"You know, I mentioned the idea of daily practice," I said. "One of the elements of daily practice is innovation. I wonder if that might be a starting point? Create a daily practice that is about reimagining your life?"

"I like that!"

"How much time would you like to spend each day on such a thing?"

"A good half hour," she replied without hesitation.

She did exactly that. For weeks, it led to nothing but frustration. The task was hard to grasp, and the answers she found herself coming up with felt more tired and shopworn than imaginative or innovative. But, although she missed days here and there, she stuck with her practice. Finally, she began to get an inkling of where she needed to head.

"Ever since I was a child," she told me, "I've associated choral music with something uplifting. I've spent all these years conducting choruses without ever really thinking about that underlying impulse. Now, when I hear myself say the word *uplifting*, I don't get *choral music*. I get a ghostly image of something I can't see yet, the thing that is the next me. That next me maybe is or maybe isn't conducting choruses. But she is for sure doing something. I'm really, really looking forward to discovering who this new me is!"

Food for Thought

1. Would a life purposes practice serve you? If you think that it could, what might its contours be?
2. In contemplating your prospective practice, what do you think is going to prove most challenging about it?
3. What strategy might you employ to meet that challenge?

Practice 4

YOUR MEANING-MAKING PRACTICE

Meaning, rather than being something to search for out there in the world, is in fact a certain sort of subjective psychological experience. One person will sit by the sea for half an hour and have a meaningful experience. A second person will sit by the sea for half an hour, get sunburned, feel restless and bored, and wish she were watching football. Sitting by the sea is neither intrinsically meaningful nor not meaningful. Nothing is either intrinsically meaningful or not meaningful.

Some things, however, are regularly experienced as meaningful. Hugging your child. Helping another human being. Creating a beautiful thing. Doing good. Being successful. Making oneself proud by one's efforts. Traveling to a lively, vibrant place. Being in nature. Standing up for a principle. Nothing is intrinsically meaningful, but many things like these are regularly experienced as meaningful, and people crave these experiences and pine for them when they are absent.

In this view, you do not hunt or search for meaning, as it isn't to be found out there somewhere. Rather, you

try to coax meaning into existence by making meaning investments (throwing yourself into things that you think may provide you with the experience of meaning) and seizing meaning opportunities (leaping at the chance to do something that you suspect just might provide you with the experience of meaning). Your number one tactic for making meaning is living your life purposes, the presumption being that if you live your life purposes, the experience of meaning may well come along for the ride.

A daily meaning-making practice is your way of trying to coax a bit of meaning into existence. The major, really profound challenge is that something that may ultimately serve your meaning needs — like, say, advocating for a cause — may not be experienced as a meaningful activity in the doing. This is a very important message in kirism and a profound life lesson overall. You may be doing exactly the right thing, and it may ultimately provide you with the experience you are craving, but in the moment, as you do it, it may feel anything but meaningful. This reality is rather hard to tolerate.

Marsha was an educated stay-at-home mom with two small kids and a husband who worked a stressful, high-powered tech job. Objectively, she had everything, including nanny help three times a week, supportive parents who sometimes babysat, time for yoga classes, and even the occasional lunch with friends. But life did not feel meaningful to her.

She knew that she ought not to complain, so she didn't. But internally she found herself unsatisfied. She knew for certain that what she needed was something very different

from a yoga practice or a meditation practice — but she didn't know what. Those were important to her, and indeed she maintained both of those with some regularity, but they didn't address some more fundamental need.

Until we began chatting, she had never considered that meaning might be merely a certain sort of psychological experience, one that might be coaxed into existence and that might actually flow from, and prove secondary to, living her life purposes. In thinking about it, she decided that what she needed was a meaning-making practice. But she didn't really know what she meant by that or how she would go about creating such a practice.

There are many ways to coax the psychological experience of meaning into existence. One way is to spend some time each and every day doing something likely to feel meaningful.

We continued chatting. The phrase "meaning making" remained resonant but still unclear. Where should she invest meaning? What meaning opportunities should she seize? She found herself shaking her head. "I think I get it, and I'm also pretty sure that I don't get it." We went over the

"My son and daughter lost their father quite young, so we keep him present with us. It's just a daily practice."
— Patti Smith

elements of practice, and it occurred to her that maybe the place to start was with the element of simplicity.

"I could start simple by just trying to name those experiences that have felt meaningful to me in the past," she said. "Maybe I'll spend a few minutes every day naming those, as carefully and concretely as I can. No 'gorgeous Hawaiian sunsets.' If there was a real, particular sunset that moved me, okay, but not just generic things." She

frowned. "I can tell this is going to be hard, because there's such a pull to name things that are *supposed* to feel meaningful. But I want to get my head around what has *actually* felt meaningful."

Over the course of a few weeks of her meaning-making practice, she made several important observations.

> I see that lots of things do already feel meaningful, just not meaningful enough. That's a weird distinction, isn't it? It should be that something either feels meaningful or it doesn't. But that doesn't seem to be true. My yoga practice does feel meaningful. Just not meaningful enough. The same with my meditation practice. The same even with being with my kids. I find this idea very weird... but also encouraging. Because it means that I do have lots of meaning in my life already. That's a big deal. It feels like the problem is in craving even more. Maybe the heart of my meaning-making practice is not making meaning at all but honoring and enjoying the meaning that already exists in my life.

This realization turned out to be almost true, but not quite. Over time, Marsha realized that she needed to use her brain and her talents more, which led her to shift from a meaning-making practice to a creativity practice. With that creativity practice in place, producing its own meaningful experiences, and with her honoring her other

meaningful experiences, she was able to say, "I have no meaning problems" and mean it.

Food for Thought

1. Would a meaning-making practice serve you? If you think that it could, what might its contours be?
2. In contemplating your prospective practice, what do you think is going to prove most challenging about it?
3. What strategy might you employ to meet that challenge?

Practice 5

YOUR SPIRITUAL PRACTICE

Whatever precise distinctions you might want to make between the two, religion and spirituality are definitely two different things. Many people who have come to reject organized religion, either in part or in whole, nevertheless still consider themselves spiritual. What spirituality means to each, though, can vary greatly. The amazing diversity of the New Age movement is a natural result of people meaning many different things by spirituality and looking for spirituality in radically different pursuits and places.

One person sees it as spiritual to paint all-blue canvases. Another finds it spiritual to walk in nature. Another finds yoga to be a spiritual practice. For another, the essence of spiritual practice is in manifesting the quality of compassion. One sees angels as spiritual beings, another finds spirituality in channeled books, another in thousand-year-old mystical writings, another in a particular array of Buddhist practices. Then there's the person who feels the need to walk on broken glass or charcoal embers as his or her spiritual practice.

If you feel moved to create a spiritual practice, yours will no doubt prove exactly as personal and idiosyncratic as these examples. It might include vestiges of your birth religion; elements of a religion or philosophy you studied as an adult; rituals you learned at workshops; creative activities like painting, writing poetry, or playing music; tests that you set for yourself, like vision quests; and other practices that help you feel more attuned to the unseen, more connected to the universe and to something bigger than yourself.

But creating a right-feeling, sustainable practice may not prove all that easy. Take Frank. Frank had grown up in what he himself described as a cult. He refused to talk about the details, although he let drop hints about physical abuse, sexual abuse, and ritual torture. What truly amazed him was that he came out of that experience relatively whole. "Some kind of resilience must be built into my DNA," he said to me, shaking his head. "Because I ought to be really screwed up."

He'd been taught all sorts of lessons about a punishing God, about how God looked straight into his soul and disliked what he saw, about how the cult leader was the voice of God, as perfect as God, all-powerful like God, and, well, a god himself. Frank couldn't manage to laugh any

> Maybe your spiritual practice is wild, magical, and otherworldly. Or maybe is it just ordinary.
>
> *"On my journey from the fantastical to the practical, spirituality has gone from being a mystical experience to something very ordinary and a daily experience.... For me, it is the daily practice of kindness, mindfulness, happiness, and peace."*
> — Alaric Hutchinson

of that away. What he felt was fury. But at the same time, he carried something like nostalgia for the cult. A big hole remained where the cult had been.

"No religion for me, not ever again!" he announced. "But I feel very empty. I do believe in something. I don't know what to call it, I don't know how to talk about it, but I feel it…and I feel very divorced from it. I need it, but I don't know how to have it."

"Need it how?" I wondered.

He shook his head. "I don't know. I need to be in touch with it. To not keep it at such a distance. To be…I don't know…to be bathed in it. Like light."

The very fact that he "believed in something" disturbed him. He didn't believe in a God with a capital G, but he felt no affinity for agnosticism and certainly none for atheism. But how do you build a spiritual practice when you don't know what you believe in and the closest you can come is wanting to be bathed in a certain light?

"I'm guessing it's not about light fixtures," I said.

Frank laughed. "No. Actually, I love lighting. If I were some kind of designer, it would be a lighting designer. But no, I don't think it's about light fixtures."

I proposed that, as a place to start, he might use his daily spiritual practice as a time to remain open to discovering what his practice wanted to be. He agreed to set aside an hour each morning and, while there, to surrender to not knowing what he would do for that hour. "Maybe I'll dream up a new lighting scheme for the apartment," he said. "It could certainly use it."

What emerged surprised him.

"I need to write about the cult," he informed me. "I

want to try to get at how something that horrible could also have possessed something so attractive, so magical, that now I miss it. It was a terrible, terrible place, but it also felt more spiritual than everyday life does. If that was all just plain, old-fashioned trickery, I want to get at how he pulled those damned tricks off."

"Are you sure that you want to spend time there again?" I asked. "It's not going to be very pleasant, conjuring that all up."

"That is exactly the thing I want to get at, for my own understanding," he replied. "Because I think that spending time there in memory is going to feel...wonderful. And I'm ashamed to say that. It makes me feel dirty to admit that I want to be there. I just may discover that I'm ruined. Or maybe I'll discover something else. That's what I'm hoping. I'm hoping that I'll discover something that will let me come out the other side."

"Into the light," I ventured.

"Into the true light," Frank agreed. "Hell is brightly lit, too, isn't it? Maybe this will be a journey out from the fires of hell and into the California sunshine."

Food for Thought

1. Would a spiritual practice serve you? If you think that it could, what might its contours be?
2. In contemplating your prospective practice, what do you think is going to prove most challenging about it?
3. What strategy might you employ to meet that challenge?

Practice 6

YOUR MINDFULNESS PRACTICE

To many, *mindfulness* means meditation. But any practice that has as its focus your desire to pay attention or bring awareness to the moment is a mindfulness practice. A given person might want to meditate. But another person might want to indwell differently and create a new inner landscape, while someone else might want to pay fresh attention to her thoughts by listening to them, disputing those that aren't serving her, and substituting more-useful ones. Leslie was in this third category.

Leslie had held different jobs in the beauty industry and was now running her own online business. She sold a line of lotions that she fabricated using essential oils, flowers, herbs, and other natural ingredients. She loved taking photos of the ingredients, the fabrication process, the finished products, and anything and everything else associated with her brand. Her genuine love of her own images and her customers' photos had generated her a large Instagram following, which was the main way she marketed her brand.

She worked on her business every day, because she

loved it. That was her primary daily practice, one that she had no trouble maintaining. But she also put into place a second daily practice, one dedicated to exorcising certain beliefs that she felt were holding her back from taking her business to the next level. These thoughts had to do with her not feeling equal to reaching out to marketplace players, influencers, and industry types whom she saw as being "above" her and who she felt would be "annoyed" if she approached them.

She put a forty-minute daily mindfulness practice into place. The plan of the practice was to hear these thoughts that weren't serving her, to say, "No!" to them as powerfully as she could, and to create new thoughts that she would consciously and mindfully think instead. This all sounded easy enough in theory. But something about it wasn't working. She couldn't quite put her finger on the problem, but she knew that those unhelpful thoughts hadn't been exorcised yet.

"So you're actively disputing the thoughts that aren't serving you?"

She laughed. "I think I am."

"Let me hear a thought that isn't serving you and how you dispute it."

She laughed again. "Okay." She named a well-known daytime talk show host. "'Andrea wouldn't be interested in me.' That's the thought." She hesitated. "No," she said, about as mildly as "no" can be said.

We both had to laugh.

"I think you're doing what you mean to be doing," I

said. "You're following the steps. But you're not disputing your thoughts with much intensity. Why is that, do you think?"

She nodded thoughtfully. "I don't think that I have much permission to be intense. I associate intensity with my father's anger. With the bulging veins in his skull. With him screaming at us with such...intensity. Thinking about that makes me just want to shrivel up and slink away."

"But you do want that intensity?"

"I don't know if I even want it. I'm not sure I could tolerate it."

"Okay." We grew quiet. "What do you think you might want to try?"

"I wonder, do I have to dispute the thoughts? Is there something else I can do with them?"

I laughed. "Of course, you can do whatever you want with them! What were you thinking?"

"I wasn't thinking anything in particular." She smiled a small smile. "But maybe I do have an idea."

She explained her budding notion. Instead of disputing the thoughts that weren't serving her, she would give them a beauty treatment and transform them into something... beautiful.

"Is that a goofy idea?" she wondered.

"It's a lovely idea! But how would that work exactly?"

"I have no idea!" She laughed. "I'll just have to give it a try!"

She did just that. A month later she reported back. "It was completely fun," she announced. "I let go entirely of the idea of disputing thoughts. It stopped being about

thoughts. Instead, I'd picture someone I've been too afraid to contact for whatever reasons. I'd simply picture the person surrounded by my products and smiling. That was my whole practice. I'd just picture the person smiling, and with that image in mind, I'd send that person an email or get in touch some other way. I've been reaching out to people I've always considered out of my league all week. And a few have gotten back to me!"

Put your mind to it. Research proves that helps with everything, from your tennis backhand to your high-wire act.

"The combination of mental and physical practice leads to greater performance improvement than does physical practice alone, a phenomenon for which our findings provide a physiological explanation."
— Alvaro Pascual-Leone

Your daily mindfulness practice might look like anything under the sun. It might look like a formal cross-legged meditation practice. It might look like a walking meditation as you stroll through nature. It might look like you paying daily attention to redecorating the room that is your mind (say, by visualizing installing new windows that allow a fresh breeze in). It might look like you keeping an awareness journal in which you bring your attention to a pressing problem. It might look like you spending the briefest of minutes with your self-created incantations, breathing and thinking thoughts that you've decided you want to think.

Your mindfulness practice might take a minute or an hour. It might be more like you emptying your mind or more like you thinking about things. It might have an active, physical component or be done in complete stillness. It is also the sort of practice that might be a second

daily practice, in addition to a primary one, like working on your novel or building your online business. Take a moment and give the idea of a daily mindfulness practice some thought.

Food for Thought

1. Would a mindfulness practice serve you? If you think that it could, what might its contours be?
2. In contemplating your prospective practice, what do you think is going to prove most challenging about it?
3. What strategy might you employ to meet that challenge?

Practice 7

YOUR HEALTH PRACTICE

A daily health practice might look like making time every day to exercise. It might look like making time every day to rehab an injury. It might look like making time every day for relaxation. It might look like making time every day for a ceremonial cup of herbal tea. It might look like making time every day to research an impending medical treatment choice. These are clear, easy-to-understand practices, at least on the surface.

But often deciding on the exact nature of our health practice isn't a neat or straightforward matter, because our health is ultimately a complicated mind/body affair. Even drinking a daily cup of herbal tea can come with unintended consequences — if, for example, we end up adding too much ginger or turmeric to our system over time. It isn't so easy to discern what our body really wants, needs, or can tolerate, nor to tease apart the exact relationship between our mind and our body.

Such was the case with Erika. Erika had the kind of chronic stomach problems that brought with them all sorts of diagnoses, including psychological ones; all sorts

of treatment plans, many flat-out contradictory; and the powerful sense that no one really knew what was going on. This led her to feel betrayed by Western medicine, leery of every new diagnosis and treatment plan, and completely confused as to how to proceed.

"Given exactly where you're at and given exactly what you know, what might a daily health practice look like for you?" I wondered.

Erika thought about that. "I need the right diagnosis," she said, "but that isn't in my hands. Maybe researching how to get that right diagnosis is in my hands, but I've been down that road a hundred times. So research isn't the practice, I don't think. I mean, I do have to keep at the researching, but my *practice* needs to be different from that. It needs to be…more mental."

"Mental, how?"

"While I figure out what's going on with my body, I want to take better charge of my mind. I don't want to say that the way I think makes my stomach hurt, because that makes it sound like it's all in my head. And I don't buy that. I have *physical* issues. But being anxious and bad-mouthing myself and getting down on everything can't help. How could any of that possibly help my body? So, for right now, I need my health practice to be a mind practice."

Erika and I created a simple three-part health practice

> Your health matters. Do what you can, maybe starting with a daily health practice.

> *"Doctors won't make you healthy. Nutritionists won't make you slim.…Gurus won't make you calm.… Trainers won't make you fit. Ultimately, you have to take responsibility. Save yourself."*
> — Naval Ravikant

that included a calming ritual, a thought-stopping technique, and a short series of affirming incantations. Two weeks later she reported on her progress.

"I'm actually feeling better," she told me. "I still have lots of pain, and I still need some kind of genuine medical help, whether that's Eastern, Western, or from Mars. But it's absolutely the case that I feel lighter, less anxious, and more optimistic. That's not nothing!"

I'm regularly surprised by how many of my creative and performing artist clients are troubled by chronic physical problems. It seems that really just about all of them are. I have no idea why this might be the case, and maybe what's really up is that virtually everyone is suffering from one chronic ailment or another, especially in our modern times, where it's so common to be pre- this and pre- that (for example, prediabetic) and to be on one or another psychiatric medication.

Given what may be nearly ubiquitous health concerns, it follows that almost everyone might benefit from a daily health practice. This might look like designating a certain time each day when you exercise, relax, or cook a healthy meal, coupled with an overarching health plan — for example, adding more leafy green vegetables to your diet, getting enough sleep, and reducing pestering self-talk. It could be as simple as spending an hour each day taking a walk or as complicated as spending several hours each day learning the principles of a health system like Ayurveda or Chinese medicine. It could be as easy as mindfully taking a hydration break at the same time each day (though no new habit is that easy to put into place) or as difficult as

spending a full couple of hours every day rehabbing an injury.

It's almost certainly the case that a daily health practice would serve you. Your health is certainly worth a daily practice and an overarching plan, isn't it? Of course, it would be lovely to behave in healthy ways all around the clock, not just for a designated time each day, and indeed that intention might well go on your list of life purposes. If, say, you want to stop smoking cigarettes, that's an around-the-clock affair, not a fifteen-minutes-here-and-there sort of thing. Your health matters all day long — and surely a daily health practice would serve your intention to live well at all times.

Food for Thought

1. Would a health practice serve you? If you think that it could, what might its contours be?
2. In contemplating your prospective practice, what do you think is going to prove most challenging about it?
3. What strategy might you employ to meet that challenge?

Practice 8

YOUR MENTAL HEALTH PRACTICE

It's very hard to talk about a mental health practice without addressing the problems presented by the currently dominant mental disorder paradigm. If you genuinely have a "mental disorder," then you would be obliged to deal with your mental health in one way. If you don't have a "mental disorder" but in fact are dealing with some other sort of challenge — a life problem, a feature of your original personality, changed circumstances, a blow to your self-esteem, chronic loneliness, and the like — then you would deal with your situation in some other way. And, if you fell into the natural-enough trap of half believing and half doubting that you had a thing called a "mental disorder," then you would find yourself somewhere betwixt and between.

This isn't the place to deal with the extremely troubling questions that those of us in the critical psychology and critical psychiatry movements endeavor to address. I've discussed many of them at considerable length in *Rethinking Depression*, *The Future of Mental Health*, *Humane Helping*, and other books. Here, let me just present a few

headlines and, if these issues interest you, send you off to investigate for yourself.

One headline is this: the leap from you saying (or, to be fancy about it, self-reporting), "I'm very sad" to me replying, "You have the mental disorder of clinical depression" is a completely illegitimate one. That leap, which is currently being made millions of times over, is without any scientific or medical justification whatsoever. You come in with a self-report, that you are feeling a certain way, and without me providing any medical tests, rationales, or anything else solid, I declare that you have a mental illness. That isn't right, and it should stop. But it won't, as just about everyone has bought the supposed reality of this pseudomedical-sounding thing, "depression," and because the forces aligned in support of the dominant mental disorder model — pharmaceutical companies, mental health professionals, and the mass media among them — are too powerful.

A second headline is this: if these aren't medical conditions, what is the rationale for calling the chemicals that psychiatrists prescribe "medications"? In the absence of a medical condition, how can a chemical be medication? It is only metaphoric to say that you are medicating yourself with Scotch because you hate your job. Should a child who is bored and restless be given "medication" to sedate and control him? Should an artist who is sensitive, intelligent, and compassionate, and therefore made sad by the state of the world, be given "medication" to help her flatten her mood? Should anyone be prescribed a chemical with powerful effects, including powerful negative side

effects like an increased chance of committing suicide, when there is no medical justification whatsoever?

As I say, you will need to investigate all of this for yourself, if you're interested. Here, let's take a look at how these contemporary complications are likely to play themselves out in someone with an interest in improving his mental health. Take John. John was willing, even eager, to inaugurate a mental health practice to help with his depression. But he couldn't picture what he ought to be doing. John felt that he'd always been depressed and likely always would be depressed, so what exactly was he supposed to be practicing for that half hour or hour each day?

"I was born with this depression," John reported. "I was born with a pair of tinted glasses that I can't remove and that make everything look dark. It's not that I'm sad, it's more like I'm wearing a tremendously heavy overcoat. Those glasses and that overcoat — they define my life. So what could I possibly do each day that might help, given that I have a mental disorder? Sit there and smile like an idiot?"

"Let me ask you something," I ventured. "Would you say that you've given life a thumbs-up or a thumbs-down?"

He shook his head. "I have no idea. I've never given that any thought."

> You are practicing some state of being, like contentment. Shouldn't that be easier than mastering something really hard, like the cello? No. Why should contentment be easier than playing the cello? As if contentment were easy to come by!

> *"Being content is perhaps no less easy than playing the violin well: and requires no less practice."*
> *— Alain de Botton*

"Okay. How about this. Would you say that you're a sensitive person?"

"Pretty much."

"A creative person?"

"If I could tolerate sitting there and working on my screenplay!"

"But essentially?"

"Yes."

"Would you say that you're intelligent?"

He laughed. "Am I allowed to say that about myself?"

"You are."

"Then yes."

"Okay. Aren't those three things, taken together, a complete explanation for your despair?"

He sat straight up. I could see him taking that in.

"Meaning what?"

"Meaning that maybe you don't have a thing called 'clinical depression.' Maybe you're despairing because you're a smart, sensitive, creative person with more than enough reasons to despair."

It took him a long time to reply. "I don't know," he said, barely above a whisper. "I don't know."

"No. But *that* could be the focus of your mental health practice. Spending a few minutes every day just sitting with a wonder about alternative explanations for why you've always felt low. You wouldn't be 'doing' anything. You'd be daydreaming about the truth of the matter."

"I don't know," he repeated. "I just don't know."

I nodded. "That's exactly right. You don't know."

A daily mental health practice may prove invaluable

to you. Its form and content are very much up for grabs and depend a lot on where you stand with respect to the current mental disorder paradigm. If you believe that you have a mental disorder with a name like depression, bipolar disorder, OCD, ADD, or borderline personality disorder, then your practice would have one flavor. If, however, you felt that something else was going on — that, say, you were sad, lonely, bored, upset, or angry — it would have a very different flavor. The first might involve you in daily medical compliance, and the second, in making inner and outer changes aimed at improving your emotional health.

Food for Thought

1. Would a mental health practice serve you? If you think that it could, what might its contours be?

2. In contemplating your prospective practice, what do you think is going to prove most challenging about it?

3. What strategy might you employ to meet that challenge?

Practice 9

YOUR RELATIONSHIP–BUILDING PRACTICE

On the one hand, it's a funny idea to make special time each day for relationships, intimate or otherwise. It seems a little formal and even awkward to carve out a particular half hour or hour each day to really be with our partner or our child or our friends. Doesn't that somehow suggest that we aren't close enough with those we love the rest of the time?

But that's likely the case. More often than not, we bump into our loved ones more than really being with them. And even if that isn't the case in your life, even if you are nicely intimate with and close to your loved ones, it can still make good sense to dedicate a special time each day to the relationships that matter to you.

That might look like checking in with your seven-year-old right after school each day to see how his day went; and doing that, not in the perfunctory way that parents most often do, but rather in a ceremonial, present, solemn-but-light, honest way — a way that has the flavor of practice about it. "Let's spend five minutes together, you with your juice and me with my tea, and

you'll tell me two things about your day, good or bad, and I'll tell you two things about my day." That might make for a lovely — and, ultimately, really valuable — daily relationship-building practice.

Over time, couples often stop having sex. The reasons are straightforward enough: fatigue; boredom and a lack of interest; performance anxiety; reduced physical attractiveness; habits in bed that reduce arousal; a little embarrassment around initiation; and so on. These aren't end-of-the-world issues, but they are often quite enough to cause weeks, months, and sometimes years to go by without sexual contact.

A regular date night can help a lot in this regard. The brilliantly simple weekly practice of making love every Friday night or every Saturday night can make the difference between a marriage working or not working. We've been focusing on the idea of daily practice, but this weekly date night is a good example of a practice that has a natural, built-in schedule different from a daily one. Many practices, including this valuable one, are of that sort.

What does a relationship-building practice look like in real life? Loretta had three daughters. Jackie, the youngest, had been no easy teenager. Now, as she reached twenty, matters had only gotten worse. Jackie was clearly being abused by her boyfriend — anyone could see that. Anyone but Jackie, it seemed.

Loretta's relationship with all three of her daughters had been volatile during their teenage years. But it had been especially difficult with Jackie. It seemed that they couldn't

say two words to each other without a huge fight erupting. Now they hardly talked. Loretta hated their impasse and didn't want to throw in the towel. But what to do?

"Do you have any ideas?" I asked her.

"Not really." She fell silent. "You know," she said, brightening a little, "we've worked on getting a writing practice in place, something that I would get to every morning before I went off to work. That's been working great. What about a practice around Jackie? Some way of paying special attention to her each day?"

"What might that look like?"

"I think I want a daily practice where I just love Jackie, no matter what she's doing. I want to spend time every day loving her, even if I want to pull my hair out, even if I hate her antics."

"She's living with her boyfriend?"

"Yes."

The goal of your relationship-building practice isn't perfect relating. It is much better relating.

"Setting the intention to practice kindness toward one's partner or family members or friends does not preclude getting angry or upset."
— Sharon Salzberg

"How would that work? How would you go about loving her at a distance?"

"I'm going to text her twice a day, at noon, when I break for lunch, and before I go to bed. And just say, 'I love you.' Nothing else. No 'Hope you're okay' or 'Want to check in?' or anything else that might be inflammatory. Just 'I love you.' Twice a day without fail."

"Simple enough," I said, smiling. We chatted again in a month. I asked about Jackie.

"That's pretty amazing," Loretta said. "I texted her twice a day, every day. For the first few days, radio silence. Then after about a week, she began texting back, 'Love you, too!' Then, last week, she came home. I don't think we've said a dozen words beyond 'I love you' over this whole month. But those were the right words."

A daily practice doesn't have to last an hour or some other significant amount of time. It isn't the amount of time you spend on something that makes it a daily practice. It's how you approach it, how it connects to your life purpose choices and your meaning needs. Maybe it takes only a minute a day, as long as it takes to send a text, pay a compliment, or give a hug. A daily hug is a daily practice, if you are holding it that way. Daily practice is not defined by its length but by its love and attention.

Food for Thought

1. Would a relationship-building practice serve you? If you think that it could, what might its contours be?
2. In contemplating your prospective practice, what do you think is going to prove most challenging about it?
3. What strategy might you employ to meet that challenge?

Practice 10

YOUR PERSONALITY UPGRADE PRACTICE

Kirism provides a simple but robust model of personality. We see personality as made up of three parts, so to speak: original personality, formed personality, and available personality. Original personality is who we are when we come into the world. Formed personality is who we become over time. Available personality is our remaining freedom to be who we want to be. This simple model helps explain why change is difficult and also why change is possible. It is difficult because our formed personality is a rigid thing. It is possible because we retain some freedom to upgrade our personality and become our desired self.

Most people are aware of their pressing need for self-improvement. They really need to be calmer, or more heroic, or more focused, or less impulsive. They need to stop repeating the same mistakes over and over again, or to do a better job of eliminating thoughts that don't serve them, or to find the strength to deal with the ongoing tyranny of their authoritarian parents. If you don't defensively flee from the task, I'm sure that you too could

generate a list of personality upgrades you'd love to see happen. Happen with a snap of your fingers, of course.

There's the rub. We may be clear on the personality upgrade we'd love to see occur but have no stomach for the work involved in making that change happen. That's both typical and natural. It's natural because our formed personality, made up of all of those repetitive ways of being, all those habits, all those hardened opinions, is rather more like concrete than like modeling clay. Who, given their day-to-day realities and their human limitations, has the energy for dealing with concrete? Few of us.

> Looking forward to a personality upgrade? Don't you need to be that upgraded person out in the world? Practice it there, and you will become it!
>
> *"You are what you practice most."*
> — *Richard Carlson*

That's where the power of daily practice comes in. Daily practice is a strong tool with the ability to crack concrete. Maybe it only chips away at that concrete on a given day, as a writer may add only a sentence to her memoir on a given day. But one chip after another chip leads to real, permanent change, just as it leads to completed memoirs. If you focus on doing your daily practice rather than on making progress, achieving outcomes, or anything else in the family of results, paradoxically, you will achieve those results.

Take Frederick, who had one of those great baritone voices that comes along only so often. He'd parlayed his voice into an excellent operatic career, but it was marred by frequent flare-ups, personality clashes, bitter breakups,

business disputes, and so many dramas that you had to believe Frederick actually enjoyed them. He claimed, however, not to.

"I'm completely undisciplined," he lamented, "and just ridiculously reactive. And look at my weight!" He ticked off his foibles. "I have anger issues. I'm a narcissist. I'm grandiose. What should I do with myself? Box my ears?"

I had to laugh. "Well, you could change."

"Right!"

"You don't believe that change is possible?"

"No!"

"Okay. Then let's forget about change. Let's focus on practice instead. You sing every day?"

"Of course not! I should, but I'm too undisciplined!"

"Ah, yes. But you understand the idea of singing every day?"

"Seriously."

"Do you know that Leonard Cohen song? About the gods of song?"

"Excuse me?"

"Do you believe in the gods of song?"

"You're joking, right?"

"I am. Let me rephrase. Are you devoted to anything?"

That made him pause. "No," he finally said.

I nodded. "Okay. Then let's make that the focus of a new daily practice. Devotion."

He thought about that. "I've never understood why I don't sing every day," he said after a while. "Or why I eat so many crackers when I don't like them and they aren't

good for my voice. Or why I'll binge-watch season after season of a show with bad morals."

"So, a daily practice with a focus on devotion?"

He nodded. "But I don't know what that means. I get the idea, sort of. But what am I actually doing? What's the…object of devotion?"

"It really doesn't matter. But let's pick one personality upgrade. Where do you want to be a better you?"

"Fewer crackers. I could spend thirty minutes a day not eating crackers."

"Funny."

"Okay. This comes completely from left field." He paused. "I want to be less afraid of my father."

That made me pause, too. "Okay," I said after a moment. "What would a daily practice devoted to being less afraid of your father look like?"

"It would look like…" He stared off. "It would look like me singing every day."

I smiled. "I'm sure you're clear on the connection there."

"I am." He brightened. "It would also mean me mentoring young singers. Mentoring them, not bullying them. Maybe…it would mean giving a few master classes. Not yet…maybe next year."

"Okay." I paused to summarize. "So you'll institute a daily personality upgrade practice whose focus is devotion and whose practice is daily singing?"

"Yes." He made a face. "But isn't that just more narcissism?"

"Nope." I laughed. "Devotion to your best self is the antithesis of narcissism."

You might want a primary personality upgrade practice because upgrading your personality is a priority in your life. Or you might want to add a personality upgrade practice as a secondary practice, maybe to help with your creativity, your recovery, or some other primary practice. Either way, give the matter some thought. Most of us could use such a practice.

Food for Thought

1. Would a personality upgrade practice serve you? If you think that it could, what might its contours be?
2. In contemplating your prospective practice, what do you think is going to prove most challenging about it?
3. What strategy might you employ to meet that challenge?

Practice 11

YOUR BUSINESS–BUILDING PRACTICE

If you're a self-identified creative or performing artist hoping to have some success in the marketplace, that means that you're also a businessperson running what is probably a one-person business. You are writing but also trying to sell your writing, painting but also trying to sell your paintings, or composing songs and singing but also operating as an indie musician. Just about everyone maintaining a creativity practice likely also needs a business-building practice, whether or not they really want to engage in commerce.

Likewise, all those coaches, therapists, yoga teachers, personal chefs, massage therapists, app designers, software engineers, motivational speakers, social media influencers, jewelry designers, and everyone else who is not drawing a salary but who is trying to go it on his or her own must act like a full-fledged businessperson if he or she wants an income. All those millions of self-employed individuals have made a choice to run a business, and now they have no choice but to run that business.

If you are self-employed, you know exactly how much

time and effort it takes to make a living. That effort can easily eat up all of your time as you work just about 24/7. It can also eat up your mind space, even when technically you're not working. Maybe you're no longer at your desk — but isn't your business still on your mind? Isn't there one more email to send? One more tech question to answer? One more lead to follow? One more product to complete? One more detail to iron out?

Should you read yet another business book? Or actually spend time every day building your business?

"Starting a business is similar to an athletic endeavor, like serving a tennis ball. Telling you how to do it is useless. You actually get better through a combination of practice, coaching, and repetitions with money on the line."
— Andrew Yang

If you're in this position, you probably already have far more than a daily practice in place — you may have an around-the-clock sort of thing going. In reality, though, a large percentage of self-employed folks, and creative and performing artists especially, do not actually pay much attention to their business. They prefer to design their fashions than to look at what they're doing as a fashion design business. A great many creatives actually need a daily business-building practice, because they aren't currently attending to their business very well — or even at all.

A basic business-building daily practice might look like you spending, say, an hour or two every day paying attention to the needs of your business. Maybe this paying attention would come directly after your creativity practice, making for a full morning of fashion design first thing and business right after. Engaging in those back-to-back

practices every single day without fail would definitely serve you, wouldn't it?

Maybe your particular business-building practice will look a little more idiosyncratic than that. Jillian had been working on her online business for about two years when we met. It wasn't wildly successful, but, unlike so many small businesses, it also wasn't failing. It brought in a regular, real income, though not enough to live on. It also required a ton of time and energy, time and energy she would gladly have devoted to it if she didn't also have to go off each morning to a day job.

"I don't need a daily practice," she told me. "I need more time to spend on my business. And I need it to make about three times as much money as it currently does, so that I can get rid of my day job."

Even though she wasn't sure that what she needed was a new daily practice, we spent a little time going over the elements of practice. One caught her eye.

"I think the daily practice I need is a practice that I tack onto my early morning work time and that focuses on…what to call it…'better completion'? I need to finish work on my business each morning in a different way, not all in a huff and angry at having to stop and sort of enraged about having to go to my day job, but…in some other way."

I laughed. "What might that look like?"

"I suppose I could meditate for a few minutes. Take some deep breaths. That sort of thing?"

"You could. But you don't sound too convinced."

"I'm not," she agreed.

"Let's go back over the main points," I said. "You need more time for your business, and you need your business to make more money. And you also need not to be infuriated by the fact that you still need a day job. You need a more peaceful relationship with that reality, yes?"

"Yes."

"If you were at peace with your day job, how would that look during the day when you're at it?"

"I would get my work done more quickly. I wouldn't putter around avoiding it and making faces. I have a finite amount of work to do each day, and I could do it in three hours rather than in eight hours, if I weren't fighting it."

Many of the tasks required by your business may bore you, irritate you, or make you anxious. But they must be done. A daily practice can help a lot!

"Everybody should do at least two things each day that he hates to do, just for practice."
— William James

"Could you then take time for your own business? Or would you need to sit there twiddling your thumbs or looking like you were working?"

"I could certainly take some time for myself!" She pictured that in her mind. "I could take two hours a day to spend working on my own business. I know how I would play that!"

"Okay! Then let's circle back around to the daily practice question. Is that any clearer?"

"It is. Of course, my whole life is a practice. I get that. But specifically, I want to end my early morning work on my business by announcing that I am not through for the day, that I get a nice chunk of time in the afternoon to

continue doing what I need. I want to take a moment and say, 'More time coming.' My practice is going to be exactly that short and sweet, a simple reminder every morning that I'm not being forced to leave my work, that I'm only shifting locations." She had to smile. "That's the mantra. 'I'm shifting locations.'"

Food for Thought

1. Would a business-building practice serve you? If you think that it could, what might its contours be?
2. In contemplating your prospective practice, what do you think is going to prove most challenging about it?
3. What strategy might you employ to meet that challenge?

Practice 12

YOUR ACTIVISM PRACTICE

Kirism takes into account your relationship to your culture and society, presumes that you will regularly be outraged by some societal injustice, and hazards the guess that you will number activism among your life purposes. A kirist, who lives by ideas like self-authorship, self-obligation, and absurd rebellion, is unlikely to shut her eyes to unfairness, injustice, and the many abuses of power that abound. As a result she is likely to add to her day, or to think about adding to her day, a daily activism practice either as her primary daily practice or as a second practice.

For me, my current activist energies and interests center around making the general public aware of the extent to which the methods and the very rationale of psychiatry and the mental health establishment are off; how children are negatively affected by the illegitimate practice of "diagnosing" and "treating" them for so-called "mental disorders" that do not exist and that, therefore, they do not have; how the diagnostic bible of the profession, the DSM (the American Psychiatric Association's *Diagnostic and Statistical Manual of Mental Disorders*), is not a diagnostic

tool at all but rather a labeling catalog and a cash cow; and related issues that concern those of us in the critical psychology and critical psychiatry camps.

My activism does not take center stage in my life, and your activism may not take center stage in your life. But you likely also don't want it to have no place in your life. That, however, can easily happen, since activism brings with it the very real risks of criticism, retaliation, and other, graver dangers; and the equally very real risks of demoralization, overwhelm, and despair. Why engage in something that doesn't feel safe and that brings you down? Well, because it's the right thing to do. But even though you may know with absolute certainty that it is the right thing to do, its significant downside may stop you from engaging.

If that's the case, then you may want to inaugurate a daily activism practice, to make sure that you get to something — your activism — that is very easy to avoid because of how unsafe and heavy it feels. If you are already an activist, someone who doesn't need a daily activist practice because you are doing it all the time, you might still want to think about adding a daily activist practice that fulfills some specific purpose. That was Molly's situation.

We may not be able to do a lot, but we can do what we can every day.

"There may be times when we are powerless to prevent injustice, but there must never be a time when we fail to protest."
— Elie Wiesel

Molly did many things. She wrote young adult novels, made short independent films, and engaged in street

theater as a performance artist. She was well-known for her pop-up theater, which often stopped traffic, riled the public, and sometimes even made headlines. She was political through and through and didn't want to just think about or chat about what was wrong with the folks in power. She wanted her whole life to ring of activism. The problem was, the state of the world was getting her too down.

"Fascism is on the rise everywhere," she said during one of our early coaching conversations. "Slavery is making a comeback. Millions of children are on psychiatric 'meds' that waltz them into addiction. Big businesses are corrupt, and small businesses are corrupt; national politics are corrupt, and local politics are corrupt; religion, as usual, is in bed with the fascists; and, almost worst of all, there's always a new Disney movie to make us not notice the thuggery and thievery. It's really impossible out there."

"Maybe you need a daily practice of a certain sort," I offered.

"Of what sort? Something that promotes amnesia? That would be nice! Maybe a daily lobotomy practice."

"You love playfulness," I said. "You love it in your novels, in your films, and in your performances. You are dead serious, and the world is dead serious, too, but maybe what you need is ten minutes a day of playfulness that helps purge some of the heaviness? Ten minutes of respite?"

"I do need that," she agreed. "But the times don't allow for it!"

"Not ten minutes' worth?" I said. "That leaves 1,430 minutes to fight like hell."

She laughed. "I also have to sleep."

"But seriously," I said. "You certainly don't need an activist practice, but maybe you do need a practice in the service of activism? Battle fatigue is real. Activism fatigue is real."

She thought about that. "I want a daily bath," she said after a while.

"A daily bath?"

She nodded. "A daily bath. In my tough-minded inner landscape, I know that I hold baths as indulgent. But I love them. And…I think I need to soak. I need to listen to music, shut my eyes, and feel warm. I really need to feel warm. I feel frozen." She glanced at me. "That is not a Disney movie reference," she said.

It is easy to know why to rebel. But it is not so easy to know how to rebel, given an individual's basic lack of power in the face of the huge mechanisms of society. It's not so easy to actually rebel, given how unsafe that can feel. And it's not so easy to put the brakes on once you are rebelling, as the amount that needs to be accomplished can seem overwhelming. If, however, you know in your heart of hearts that activism is or ought to be one of your life purposes, you may want to inaugurate a daily activist practice that helps you live what may be one of your most important life purpose choices.

> It may seem hard enough to meet your own challenges. Are you to take on the world's challenges, too? Yes!
>
> *"I'm for truth, no matter who tells it. I'm for justice, no matter who it is for or against. I'm a human being, first and foremost, and as such I'm for whoever and whatever benefits humanity as a whole."*
> — Malcolm X

Food for Thought

1. Would an activism practice serve you? If you think that it could, what might its contours be?
2. In contemplating your prospective practice, what do you think is going to prove most challenging about it?
3. What strategy might you employ to meet that challenge?

Practice 13

YOUR PERFORMANCE PRACTICE

You may not be an actor or a musician, but you may still be a performer. Almost everyone has to perform sometimes, whether it's to give a wedding toast, introduce a speaker, or make a presentation at work. A salesperson is a performer. A trial lawyer is a performer. A classroom teacher is a performer. A workshop leader is a performer. A pastor is a performer. A job applicant is a performer. Many of us perform a lot of the time. And very often those performances matter quite a bit.

I remember sitting on a hiring panel for two full days, during which time dozens of applicants vied for a single psychotherapist position with a City of Berkeley agency. The details of each applicant's résumé mattered much less than the quality of his or her performance. Some no doubt excellent candidates gave themselves no chance, by virtue of their weak performances. One woman stood out because she performed the best — and she got the job. Was she the best on paper? It didn't matter. What mattered the most was that she was the best in the room.

I've performed more times than I can count and

in more ways than I can count. The oral exams for my master's degree in creative writing. The oral exams for my family therapist license. Book signings. Radio interviews. Television interviews. Weeklong workshops. Panel discussions.

My time as a drill sergeant in the army was its own kind of performance! As was what followed immediately after being discharged: speaking at antiwar rallies.

You, too, may need to regularly or occasionally perform. It may well serve you to institute a daily performance practice during which time you rehearse, learn your lines, improve your playing, hone your material, organize your presentation, and so on. If you're a professional performer, you may want and need this to be a daily practice. If you don't regularly perform but have an important performance coming up — maybe it's giving a speech at your daughter's wedding — then you might want to institute a daily performance practice that lasts a limited number of days or weeks.

How might a performer make use of a daily performance practice, in addition to using it for basic rehearsing and practicing? Take Max, one of the last professional clowns around. He had created an act that included juggling, pantomime, pratfalls, magic, and enough other things to make him something of a wonder. Of course, it was next to impossible to make a living from clowning. But, remarkably, and through a lot of effort and perseverance, Max had gotten himself enough gigs around the country, at schools, fairs, corporate events, and the like, to keep himself afloat.

However, something nagged at him: his own "foolishness." He loved playing the fool with audiences. But he had somehow drifted into playing the fool in areas where he really ought not to, with contracts and other business dealings. He treated his business affairs too cavalierly, invoicing slowly, not negotiating for better rates, not following up on leads. It was really something of a miracle that, despite his "foolishness" in this regard, his business kept chugging along.

In the middle of one of our chats, he suddenly said, "I have my clown persona down pat. But I need a business persona. I can picture the type. Not a suit persona. More like the foreman at a jobsite. Sleeves rolled up. Hard hat. Barking orders. Taking deliveries. Not taking any guff. Hard hat Max."

"You know, that could be its own performance practice, practicing that persona," I ventured.

"I like that!"

"Why don't you flesh out how that might look?"

Max thought about that. "I'm going to get a work shirt. And work pants. Maybe even heavy boots, if they aren't too expensive. And a hard hat — maybe I'll decorate it. No — that's Max the clown. No decorations! I'll put on my foreman's outfit and do business for an hour every day in that persona, being appropriately tough. And serious."

I was genuinely curious to see how Max's new practice would play itself out. In his first follow-up email, he told me, "Jack — that's for Jackhammer — didn't show up. I dressed the part, but he just laughed at me. We'll see what tomorrow brings." The next day, he wrote, "Hard hat fell

off. Doesn't fit so well. But Jack didn't laugh at me. I felt almost there." A few days passed, and then Max wrote, "I sent the strongest email I've ever sent, to an organization in Minnesota, and heard back from them within an hour, proposing that we chat. I am Jack." A minute later, he wrote, "Almost Jack. Three-quarters Jack." Seconds later he wrote, "Jack says I shouldn't have sent that last email. He gave me what for."

You want to give a great performance. Maybe you can manage this without practicing. But how likely is that?

"Practice makes performance."
— Diana Gedye

Your daily performance practice need not be limited to playing the piano or learning your lines. It can be as inventive as you like: a time each day when you role-play upcoming situations, like a job review or a hard chat with your aging parents; when you refine your brand's talking points; when you practice how you intend to present yourself to a gallery owner across town or a literary agent at an upcoming meet and greet. A lot in life is performance — and a daily practice focused on improving your performance can lead to stellar outcomes.

Food for Thought

1. Would a performance practice serve you? If you think that it could, what might its contours be?
2. In contemplating your prospective practice, what do you think is going to prove most challenging about it?
3. What strategy might you employ to meet that challenge?

Practice 14

YOUR WARRIOR PRACTICE

Our six-year-old grandson takes karate lessons. It's good for him. All day long he has to sit and be a good little first grader. He has a billion kilowatts of energy, and it's a complete miracle that he can pull off that feat. But he desperately needs to kick and punch and shout for at least a little while each day. That doesn't disperse all his energy, and you will still find him flying around the house at a million miles an hour and knocking into things, including his little sisters. But it helps.

It helps on the energetic level, and it also helps build his warrior self. It is a kirist belief that each of us needs a warrior self. We are in absurd rebellion against injustice, unfairness, meanness, and all of that. We are also in absurd rebellion against the very facts of existence, which tell us that we are puny and that it is ridiculous of us to presume that we matter, ridiculous of us to presume that our efforts matter, and ridiculous of us to bother shouldering some responsibility for holding up the world. We need a warrior self for all that absurd rebelling.

What might a daily warrior practice look like? Well,

of course it might be a martial arts practice, like karate, judo, or kickboxing. It might be a practice that enhances our mind/body control, like yoga, meditation, or tai chi. It might be a special version of a personality upgrade practice, one in which we work to heal those psychological injuries that have made us a weaker version of ourselves. It might be a certain sort of creativity practice where we use our vivid imagination to visualize our superhero self in action. Your daily warrior practice is yours to dream up.

Is your warrior practice about defeating dragons and storming castles? Or are you transforming yourself into your best version of yourself?

"He who conquers himself is the mightiest warrior."
— Confucius

Leslie needed such a practice. Abused as a child, she had entered into one abusive relationship after another as an adult. Now she depended on painkillers and daydreamed about heroin. The only thing stopping her from going further were her twins, aged five, and her keen awareness of how guilty she would feel if she stepped over the line. But even the twins seemed only to be delaying the inevitable. We chatted about options.

"I can't do twelve-step meetings," she said, shaking her head. "I've tried them. I hate them."

"Okay."

"Or therapy. All that talk."

"Okay."

"If it wasn't for the twins, I'd just stay high all the time."

"Understood."

"I'm basically a junkie, you know, although I'm not all the way there yet."

I nodded.

"Who would really rather kill herself than do anything else," she said.

We both sighed.

"You know that movie *Million Dollar Baby*?" she said after a long pause. "I liked it."

"Yes. I did too." I didn't know where she was going but I took a stab. "Maybe you'd like to box?"

She sat up. "Box? Me?"

"I just wondered."

"Joe wouldn't let me," she said after a while. "Not a chance."

I nodded. "But what if you just watched a video and boxed in front of a mirror? How would he know?"

"It would sort of be like dancing," she said.

"Sort of. Warrior dancing."

She laughed. "Warrior dancing!"

I could see her picturing that in her mind's eye. Finally, she shook her head.

"He might find the gloves," she said, worried.

"I wonder, would you even need gloves?"

She thought about that. "Yes. I don't think it would feel real without the gloves."

We sat with that vision of her boxing in her laced-up gloves.

"I don't think I can pull that off," she said finally. "I could never buy those gloves. Impossible."

I nodded. "Is there any version you could pull off? Some reduced version, maybe without the gloves?"

"I could almost see doing a warrior dance, something tribal. Something that the women might do, not the men. I wouldn't mind researching that. 'Warrior dances for women.' I could maybe do that. When Joe's at work."

I never learned if Leslie had found her warrior dance or begun dancing, as she canceled each subsequent chat that we scheduled. But I did hear from another client, Adam, about how well it was going with one aspect of the quirky coaching training he was taking.

"We have to do a triathlon!" he informed me.

"A triathlon? To become a life coach?"

He nodded. "Well, a pared-down version. But still very rigorous. I'm in training every day."

I shook my head. "That's gloriously odd."

"I know! But there's a whole vision and philosophy of life behind it, going back thousands of years to Stoics and gladiators and I don't know who else. We're all buying into it! A hundred couch potatoes training every day."

"And?"

"And it's great! I think I've always needed a context or a reason or some impetus to be a warrior. With this framing, it's been almost easy. Well, no, it's not easy at all. But you know what I mean!"

No daily practice is a complete answer to the challenges of living. But a daily warrior practice can help in multiple ways. It can keep you fit, if it is a physical practice. It can keep you calm. It can build a mind/body connection between your intentions and your behaviors as you practice control. It can elevate your mood. It can change your identity as you build a stronger version of yourself. It

can increase your self-worth. Can a warrior practice really do all that? Done daily, with the twenty elements of practice in place, it can indeed.

Food for Thought

1. Would a warrior practice serve you? If you think that it could, what might its contours be?
2. In contemplating your prospective practice, what do you think is going to prove most challenging about it?
3. What strategy might you employ to meet that challenge?

Practice 15

YOUR HEALING PRACTICE

Over the years, I've done a lot of primary research into the effects on family members of authoritarian wounding. I've also written a book about it, called *Helping Survivors of Authoritarian Parents, Siblings, and Partners*. Authoritarian wounding is the wounding that occurs when you're obliged to live with an authoritarian parent, sibling, or adult child; when you come into close contact with some other family authoritarian, like a grandparent, aunt, or uncle; or when you choose an authoritarian partner as your mate and then have to live with him or her.

The negative effects of this authoritarian wounding are lifelong, as are the effects of other traumatic experiences, like physical abuse, sexual abuse, and neglect. These lasting effects include chronic anxiety and despair, poor relationship choices, an inability to think clearly or make reasoned choices, a lack of self-esteem and self-confidence, and other serious negative results. Who in this position couldn't make good use of a daily healing practice? That would be a smart choice!

Let's flesh out the idea of trauma a bit. Picture a

youngster who loves to draw but who is routinely smacked every time he tries to, those smacks accompanied by "reasons" like "Stop making a mess!" or "You're wasting paper!" He then (rather miraculously, rebelliously, and courageously) goes on to become a painter. Will he remember those smacks, have flashback memories of them or nightmares about them? Maybe yes, maybe no. But he will indubitably be harmed by them, even if he has no concrete memory of them.

What might the consequences of that harm look like? High anxiety every time he tries to paint. Lifelong despair. Little permission to advocate for the paintings that he does manage to complete. An abiding sense of doom and gloom. Yes, he may have no recollection of those slaps and, if questioned about them, might even shake his head and reply, "Never happened." But you can read those slaps in the way that he's living and in the difficulties that he's experiencing.

Trauma creates a shattering. What gets shattered? Sometimes it's our sense of safety. The world no longer feels safe to us. Sometimes it's our self-esteem and our self-image. We drop down many pegs in our own estimation and no longer see ourselves as competent, lovable, or worthy. Sometimes it's our basic relationship to life. One moment life was our oyster, and the next moment life has become a serious cheat.

What, then, might a daily healing practice look like? It might look as simple (and as difficult) as spending a dedicated amount of time each day just being aware. Trauma, while it can cause hypervigilance, ultimately reduces our awareness. Not noticing may well have helped the injured

party deal with his or her traumatic experiences. Then not noticing became that person's default way of being.

When that happens to you, you're at risk of not noticing triggers that bring with them a flood of painful emotions; not noticing that you're repeating unhealthy patterns, like yet again choosing an authoritarian life partner; or not noticing that you've found yourself in another abusive relationship. A part antidote to all this chronic not noticing is the creation of a daily practice devoted to noticing. A daily healing practice focused on awareness can help a lot.

This is how one daily healing practice might look. It might look like you spending some time every day calmly asking yourself, "Why?" "Why did I lash out at Bob when I really had no intention of picking a fight?" "Why do I keep telling myself that I have no talent when I know that thought can't possibly serve me?" "Why have I decided that life is a cheat and not worth living?" "Why am I still giving power to my parents when I know that interacting with them only harms me?" "Why do I refuse to give up 'friendships' with people I don't even like?" It might look like you staying put as you think, weathering the anxiety that comes with asking yourself hard questions, and doing the inner work required to answer those questions. You would fully expect that anxiety; of course

Let's say that your practice is a forgiveness practice or a surrender practice or a thankfulness practice. Well, you don't forgive just once or surrender just once or be thankful just once. You do it over and over again, every time you practice, and also over and over again in real life.

"You cannot forgive just once. Forgiveness is a daily practice."
— Sonia Rumzi

it makes us anxious to examine our self-sabotaging behaviors or our limiting thoughts. So you make sure to bring along your trusty anxiety management tools.

There is a strong prejudice against the idea of healing in our current mental-disorder-dominated landscape. In the current view, your difficulties are taken as symptoms of a chronic, lifelong illness best treated with chemicals. Even though healing is an honorable idea in the rest of medicine, as in the mending of a broken bone, when it comes to mental disorders healing isn't an option. You never heal from your supposed "bipolar disorder" or your "attention deficit disorder." That isn't allowed in the paradigm.

A kirist approach, on the other hand, honors the reality that circumstances matter; that traumatic experiences produce lasting effects, including in forming personality (thus making your difficulties personality deep); and that healing must therefore be hard-won but is a wise and worthy goal. You can help yourself achieve that healing by instituting a daily practice focused on reconstructing what's been shattered.

Food for Thought

1. Would a healing practice serve you? If you think that it could, what might its contours be?
2. In contemplating your prospective practice, what do you think is going to prove most challenging about it?
3. What strategy might you employ to meet that challenge?

YOUR PROBLEM-SOLVING PRACTICE

Mark was trying to make the transition from university employee to self-employed coach. As a certified mental health counselor in his school's counseling department, he'd designed workshops, run support groups, and worked one-on-one counseling students. Over the years he'd zeroed in on test anxiety and performance anxiety as his areas of specialization, although he had many other areas of expertise as well. He hadn't quit yet, because he needed the income, but he was hoping to resign within the year.

"Being an employee is one kind of hard," he informed me. "The office politics. My new boss, who leaves a lot to be desired. The hourly rate, when you work it out. The commute, which has gotten ten times worse over the last couple of years. A kind of tightening and meanness from the administration, as if we employees were vassals rather than honored workers. And the students, too — they've gotten harder. All in all, it's a pretty miserable situation."

He smiled. "But it came with a paycheck," he continued. "Being self-employed seems to come only with

expenses. And a million things one 'could' do. Run this sort of social media campaign. Get this app or this plug-in and follow their 'ten steps to financial independence.' Take this training, buy this workshop, read this ebook. It's kind of ridiculous."

We chatted about putting a business-building daily practice into place. After a bit, Mark shook his head. "I love the idea of a daily practice," he said. "But I need something before a business-building practice. Right now, I don't really understand what I should do. Being this kind of self-employed is not like opening a sandwich shop, where people walk by and you offer a free drink with your sandwich to get people to know about you. It's much more amorphous than that. It's more like a problem to be solved. I need maybe a problem-solving practice!"

I completely understood. "What do you think that might look like?"

"I'm not sure. But I can tell you I don't want to start reading this or that person's blog and go down the rabbit hole of somebody's ten-step method for growing a business, growing a mailing list, growing a brand, growing a campaign, growing a great website, or any of that. I don't want to go surfing."

I smiled. "You want to just sit there?"

"No." He thought for a moment. "I want...I want to make sure this even makes sense. I know maybe three life coaches who look to be making it, if they really are. I want to have coffee with each one of them and ask them — beg them — to tell me the truth. Both the truth as to whether

they are really succeeding and, if they are, the truth about what's worked for them. I need to get a real picture of how some actual human beings have made this work."

I nodded. "So the idea is to spend time every day, or at least regularly, chatting with coaches and picking their brains?"

"Yes! That's exactly what I need to do."

We didn't talk for a month, as Mark wanted time to set up the interviews and actually conduct a few. And he wanted time to think. When we chatted next, he seemed upbeat.

"I've learned some things and come to some conclusions," he said. "First, working with individual clients looks to be a bit of a trap. It's hard to get them and hard to keep them. The easier, higher-impact thing to do is to run a program that lasts a long time, like six months, where you can charge real money. Then you can focus on getting folks into just one thing, that program, rather than trying to herd them into individual coaching sessions. So I'm going to run a six-month performance anxiety program online, charge a few thousand dollars, and focus on getting fifteen or twenty participants. That would amount to real money. I don't know if that is exactly the right approach, but at least it makes sense to me. I'm excited to give it a try!"

Mark's problem-solving daily practice helped him move into a critical career transition. You might create a problem-solving daily practice to help you solve any sort of issue under the sun: finding the best nursing home for your declining dad, making sense of your retirement

income possibilities (are annu-
ities or reverse mortgages good
ideas or terrible ideas?), trying to
decide between a Western med-
icine approach or a traditional
medicine approach to your health
issue, and so forth. These are the
sorts of questions that require pa-
tient research, thoughtful analy-

Problems arise of their own accord. And then, if you're an artist, scientist, or inventor, there are the problems that you yourself set!

"I think I like to create problems for the love of solving them."
— *Ann Zielinski*

sis, and real attention. There is no better way to pay real
attention to a pressing problem than by attending to it
every day, in the context of a daily practice.

Food for Thought

1. Would a problem-solving practice serve you? If you
 think that it could, what might its contours be?
2. In contemplating your prospective practice, what
 do you think is going to prove most challenging
 about it?
3. What strategy might you employ to meet that
 challenge?

Practice 17

YOUR KIRIST PRACTICE

Kirism is a philosophy of life that I've developed over the years on the basis of an updated understanding of human nature and the challenges of living.

A contemporary philosophy of life has to take a lot into account. How meaning operates. The difference between life purpose and life purposes. The realities of work. The high-bar tasks of self-obligation and self-authorship. The challenges of culture and society. What ethical action looks like. And much more.

Kirism does that intricate work. If no philosophy or religion has made enough sense to you, take a look at kirism and see what you think. Kirism is a vital philosophy designed to meet today's challenges. Here's a brief fifteen-point kirist guide to living that will help you better understand what it is all about.

1. **Action Step: Identify your life purposes.** Kirists decide what's important to them. This sounds obvious enough as a sensible thing to do, but few people do it. Most people do not do it, primarily

because they've been taught that life has "a purpose" and so they keep hunting, unsuccessfully, for that singular purpose. Life has no purpose; rather, it is comprised of the life purpose choices that you make.

2. **Action Step: Live your life purposes.** Again, this sounds obvious enough. If you knew what your life purposes were, surely you would want to live them. But even people who accomplish step 1 have trouble accomplishing step 2. This is because tasks, chores, day jobs, errands, and every manner of other things are allowed to come first; because juggling multiple life purposes and keeping track of them is difficult; because our life purpose obligations are typically much harder than turning on the television; and for many other reasons. A kirist develops strategies for meeting these challenges and actually lives his or her life purposes.

3. **Action Step: Organize your life around your life purposes.** There are many things you could say to yourself when you wake and all day long, around the clock. Instead of saying, "What do I have to get done?" or "What's bothering me?" or "How do I get even?" or "How do I get ahead?," hear yourself say, "What are the important things?" These important things might include having that hard conversation with your son about his drinking, making a loud political statement, or creating a small business. Have "What are the important

things?" be the first thought you jump to throughout the day. Bring the important things forward!

4. **Action Step: Live as if you matter** and make yourself proud. The contemporary person has lots of reasons for believing that he or she doesn't matter. Aren't we just excited particles, excited into existence by a mechanical universe? But kirists reject the notion that just because we may be the product of a mechanical universe, we shouldn't act as if we matter. We matter by living our life purposes, by acting ethically, and, absurdly enough, by taking responsibility for keeping civilization afloat. This is pure self-obligation, ordered by no one and ratified by no one, and it is the way that we make ourselves proud.

5. **Action Step: Live ethically.** We live in a time when that stalwart phrase from the nineteenth century, "Truth, beauty, and goodness," has been torn asunder by the knives of language analysis and deconstructive postmodernism. It is hard to use those words with a straight face any longer. And yet we are obliged to circle back around to absurd innocence and to stand up for personal goodness, even though we know the extent to which badness is

What will your kirist practice look like? It might look like anything, so long as it supports your intention to live your life purposes and do the next right thing.

"Hip-hop is a human skill, and the practice of real hip-hop should remind us of our humanity."
— KRS-One

rewarded, even though we know that there are no absolute moral principles, and even though we know that our many values compete with one another, making it hard to announce, "This is right." But kirists make that personal demand, that they will live ethically. Do the next right thing and the next right thing after that.

6. **Action Step: Be an individual.** Many forces in the family and in society will attempt to constrain you, often via authoritarian tactics like bullying, shaming, hurling insults, invoking arbitrary rules, and employing every manner of violence and meanness. You may be silenced and made small in subtle ways; or you may be told flat out that you do not count, that you will never amount to anything, and that you had better fit in and listen. Fight this your whole life. Fight to be the individual that you are, that you are obliged to be, and that you want to be. Stand up for yourself, even if that is downright terrifying.

7. **Action Step: Aim for meaning but do not crave meaning.** The experience of meaning is just that, a certain sort of experience. We can endeavor to have more such experiences: we can certainly try to coax meaning into existence. But we should not pine for meaning, and we do not want to go hunting for it, as if it were a lost wallet or something to be found at the top of some mountain. Kirists understand that meaning is merely a certain sort of psychological experience. They do their best

not to overly crave it and to focus instead on living their life purposes. Actively coax meaning into existence while focusing on your life purposes.

8. **Action Step: Give life a thumbs-up.** Without quite realizing it, many people have given up on life. They have made the mental calculation, often just out of conscious awareness, that life has cheated them, that life isn't what it ought to be, that life isn't worth the candle. Naturally, this conclusion leads to chronic, even lifelong, sadness. It makes it next to impossible to stick to things, to believe in your own efforts, or to rally in support of our species and the world. Kirists make the conscious decision to give life a thumbs-up, even if there are abundant reasons to come to a harsher, more negative conclusion. All day long, metaphorically and literally, give life a thumbs-up, even if you aren't feeling like life deserves it.

9. **Action Step: Start your day with a practice.** It is unsettling and unsatisfying to rush through life, doing one thing after another but never getting to those things that matter to you, things with names like "sobriety," "getting my play written," "feeling less sad," "building my important nonprofit," or "telling the people I love that I love them." Kirism has no menu of obligatory practices, but a suggested one is a morning practice that helps you settle and attend to your life purposes. A regular daily practice, whether accomplished first thing or

at some other time of the day, becomes an anchor in a sea of chaos. Create and institute a daily practice that supports your life purposes.

10. **Action Step: Organize each day.** Kirists conceptualize each day as something requiring a high degree of mindful organization. Because what's most important may also be what is hardest to accomplish, kirists know that they are likely to avoid their important tasks unless they pencil them in and underline them. An organized day might include an hour devoted to creating, an hour devoted to relating, an hour devoted to activism, many hours of everyday drudgery, and a bit of relaxation. This might well amount to an excellent day, given life's realities. Every day, think through how that day ought to look, leaving some room for spontaneity and opportunity.

11. **Action Step: Think thoughts that serve you.** While we are not solely what we think, we are largely what we think. If we are thinking thoughts that reduce our motivation, make us doubt our abilities, increase our anxiety, or plummet us into despair, we become a weaker, less mentally fit, less physically fit, and less courageous version of ourselves. Kirists set the cognitive bar high by asking — even demanding — of themselves that they think only thoughts that serve them. This means that they hear what they are saying, see through their own tricks, and instantly dispute and replace derailing thoughts. Set the bar high and demand

of yourself that you will only think thoughts that serve you.

12. **Action Step: Indwell with awareness.** Kirists see value in the metaphor of the room that is our mind — a place that we inhabit, that has qualities (like airlessness), that we can redecorate (say, by adding windows that let in a breeze), and where we cultivate a particular indwelling style, one that does or doesn't serve us. It might be a place where we nag ourselves, obsess unproductively, or talk ourselves into despair; or it might be a place of calmness, quiet contemplation, and passionate creation. Kirists see this as in their charge and indwell with awareness. Enter into a new self-relationship by examining how you indwell, deciding on what might need changing, and making those changes.

13. **Action Step: Upgrade your personality.** Kirists use a simple model of personality made up of three component parts: original personality (who we are as we come into the world), formed personality (who we stiffen into), and available personality (our remaining freedom to make changes and to be who we want to be). Kirists use their available personality to come to terms with their original personality and to upgrade their formed personality, creating more available personality in the process. This simple model, rich in complexity, helps kirists remember that they themselves are their primary project. Upgrade your personality

so that you become the person equal to creating the life you envision for yourself.

14. **Action Step: Deconstruct work.** Most people are obliged to spend two-thirds of their waking time doing work to pay the bills. Some small percentage of workers love what they do. Another small percentage are able to approach their work with equanimity. The vast majority, however, do not like what they are doing and even hate it. For most people, work is the great robber, stealing huge amounts of time and energy. Kirists understand that no philosophy of life can prove pertinent if it doesn't address the lifelong challenge of needing to earn money. Rethink work, taking into account core kirist ideas about individuality, self-authorship, making meaning, and living one's life purposes.

15. **Action Step: Live a kirist life without embarrassment.** If you live as an individual, thinking your own thoughts, acting ethically, speaking up when you need to speak up, and living the fullness of your life purposes, you are bound not to fit into society all that well and bound to have to deal with forces that want to quiet you. Kirists live a life of action and courage as absurd rebels who have decided to matter. They live this life openly and proudly, without embarrassment. Live in the light, as a kirist, proudly and happily, no matter what.

There is no single prescribed kirist practice, and there are no dogmatic kirist practices. Your daily kirist practice is completely yours to develop and create. A daily kirist practice might look like you taking time to do any of the above. And it might serve you beautifully! Give creating a daily kirist practice some thought. You can learn more about kirism at kirism.com.

Food for Thought

1. Would a kirist practice serve you? If you think that it could, what might its contours be?
2. In contemplating your prospective practice, what do you think is going to prove most challenging about it?
3. What strategy might you employ to meet that challenge?

Practice 18

YOUR "ANY ACTIVITY" PRACTICE

You can organize a daily practice around just about anything. To give a few examples:

- You could organize it around a quality you are looking to increase, like calmness, passion, or courage. Doing this every day would amount to an ongoing personality upgrade practice.
- You could organize it around the idea of taking a time-out, maybe a time-out from rushing around, a time-out from worry, or a time-out from your usual ways of thinking. Doing this every day would help your mental and emotional health.
- You could organize it around being of service, say, as a mentor to young professionals in your field, as a volunteer in one of the organizations to which you belong, or as a volunteer at an emergency nursery or a soup kitchen. Doing this every day would benefit others at the same time that it serves you.

- You could add a business-building practice to your established creativity practice. You might get to your creative work first thing and then, later in the day, spend a real hour or two doing business. Doing this every day would help you generate income.

- You could organize it around the idea of change or transition, maybe using it to begin to visualize how it would be to leave your job, leave your career, or leave your town, how it would be to return to dating or return to marital intimacy, or how it would be to live a kirist life. Doing this every day would invite the change to come much sooner.

- You could organize it around something you love that you rarely get to, like reading fiction, looking at art books, listening to classical music, or strolling around the lake. Doing this every day would improve your mood and lighten your load.

- You could organize it around a lifelong learning goal, like acquiring an additional language or deepening your understanding of a scientific subject. Doing this every day would keep your mind sharp and help counteract the effects of aging.

- You could organize it around maintaining or improving one particular relationship, making it a daily practice to be in touch with, say, your busy daughter who lives five thousand miles away or with your aging aunt who lives in a nursing home back where you all grew up. Doing this every day would add warmth and love to your life.

- You could use it to supplement or complement a primary daily practice, say, by adding a mental health practice to supplement your health practice. Here's a good example of how one practice can complement another.

Maryanne had a solid daily yoga practice in place. But something about it wasn't sitting well with her. She had the sense that she was holding it in too rigid and controlled a way. For her this connected with how she followed all rules too closely, which would get her good grades but result in stomachaches, yield good job evaluations but leave her with the sense that she was being overworked and victimized.

She knew that this had to do with her authoritarian upbringing and that she was still tied in knots around it. It made her yoga practice downright unpleasant and affected all aspects of her life. She explained what she wanted to see change. "I want my yoga practice to feel a lot lighter," she told me. "And I want to break rules. I want to break them without getting scared or sick."

"Which rules?" I asked.

"Just about every single one!" she exclaimed. "I kind of want to overthrow my life."

We sat there.

"That would be...a lot," I said after a while.

"Probably too much," she agreed. "And impossible. Maybe...could I break a rule a day?"

I laughed. "That sounds excellent! But what would that look like?"

"There's a very particular way that kids get dropped off at school. You get into this long, long line and wait your turn. It's kind of an unspoken rule that parents will operate this way and not jump the line. And then some parents don't give a damn and just jump ahead and drop off their kids the way they want."

"You want to be that 'bad' person?"

"Actually, no. I thought that maybe I did — but I don't. And I don't want my house to get dirty, just to break some rule around tidiness. I don't...I guess there are lots of rules I don't want to suddenly start breaking. That's pretty confusing."

Is it still a practice if you know what you're doing? Of course! No reason not to be a master with a daily practice!

"What are you called when you're not practicing anymore and finally know what you're doing?"
— Chuck Bridges

I had a thought. "I wonder if the right complementary daily practice might be to list the rules in your life and to see which you don't want to break and which you do want to break. Maybe some principles would emerge. At the very least, you might learn something."

"I like that!" Maryanne said. "You know, my yoga practice already feels a little lighter somehow, just knowing that I'm going to face this head on. I think I might actually be looking forward to yoga tomorrow!"

In kirism, we talk about meaning investments and meaning opportunities. Maintaining a daily practice, one organized around anything you deem important, is a way to help keep meaning afloat on a regular basis. It is a place to put your human capital every single day and a place to

make yourself proud every single day. Its content might be anything under the sun, but that it is daily is key, and that it is demarcated from the rest of the day is key.

Food for Thought

1. Is there some particular practice that would serve you? If you think there could be, what might its contours be?
2. In contemplating your prospective practice, what do you think is going to prove most challenging about it?
3. What strategy might you employ to meet that challenge?

Part III

CHALLENGES TO DAILY PRACTICE

In part III, we'll look at several common obstacles to maintaining a daily practice. At least a few of them are certain to rise up to confront you. We'll examine eighteen of these common challenges, among them the challenges presented by anxiety, distractibility, physical restlessness, a lack of progress, and unhelpful self-talk.

Given these many challenges, it's easy to see why maintaining a daily practice can prove hard. However, by identifying the exact challenge confronting you and by making an effort to meet that challenge, you'll have an excellent chance of persevering. Each of these eighteen challenges can be handled!

Indeed, part of the power conferred by maintaining a daily practice comes from meeting challenges of this sort. When you can handle unhelpful self-talk, distractibility, and all the rest, you haven't just helped yourself maintain a daily practice — you've upgraded your personality. That's a great outcome!

Challenge 1

MINDSET

Your whole mindset or some single aspect of it may prove unsupportive of your efforts to create and maintain a daily practice. If you're of the mind that you have no talent, no chance, nothing to say, and nothing much to live for, how easy will it be for you to start a daily creativity practice and keep at it? If you're of the mind that you can't pay attention, even though you pay perfect attention to the things that amuse you and only scant attention to boring things and hard things, how likely is it that you will pay attention to your daily practice? Your mind is derailing you.

The modern helping professions know all about the extent to which you are what you think. You have this or that recurrent thought, and that causes you sleepless nights and high anxiety. You have this or that stray thought, and suddenly you're off on some misadventure. You insist on a certain preference and refuse to look at smart alternatives. You hold to a certain opinion and make the same mistake over and over again. In each case, your mind makes up its mind, with or without evidence, with or without good reasons, and always with consequences.

You already know this. Still, you're unlikely to credit the problems you're having with your daily practice to your mindset. You're much more likely to say, "I don't seem to have time for this" or "This isn't working right" or "This doesn't seem to be for me." That is, your very mindset prevents you from naming your mindset as the culprit. That's how tricky our mind is, and that's why we do such a poor job of realizing our dreams and achieving our goals.

Jerome was a well-known screenwriter whose last film had bombed. The many demons he'd held at bay over the years — his drinking, his anger, his recklessness — could not be contained after this failure, and he went on one wild escapade after another, finally hitting bottom in a desert jail after a bar fight. He slowly worked his way up from that bottom and at a certain point tried to resume writing. But he couldn't. That's when we met.

We worked on him instituting a daily writing practice, something that had been second nature to him as a young man, back when he'd had hope, enthusiasm, and ambition. Now daily writing seemed next to impossible. He knew what screenplay he wanted to write. He still had the best connections in the industry. He knew that he had a thousand times better chance of selling his screenplay and seeing it made into a motion picture than you or I have. But he couldn't write, not daily and barely at all.

At some point, several months along, I said, "It's probably more than this or that tactic not working or this or that strategy not working. It's probably your whole mindset."

"Ah, that sounds like a lot. Just my whole mindset." After a while, he ventured, "What would changing my whole mindset look like?"

"Step one might be, you'd completely let go of screenwriting as the only important thing in life. You've already done that letting go in one sense, negatively. Now you would do it positively, as part of a vision of life being made up of lots of important things, things that maybe you're going to struggle to identify, because right now nothing feels important."

He mulled that over. "I get the difference."

I went on to describe what he would need to do. How he would need to hear what he was saying to himself and maybe even how he would have to write down tons of his thoughts, to see which ones were serving him and which ones weren't. How he would have to deal with each thought that wasn't serving him by disputing it and by generating a different thought instead. How we would have to spend a lot of time on this, whether or not it felt boring, whether or not it felt painful, whether or not it felt pointless. I outlined a simple program for cognitive health.

"That's a lot to remember." He laughed. "But actually,

> Maybe you hold some deep-seated, half-unconscious prejudice against trying hard. Who knows where that may have come from? But does it still serve you? Did it ever serve you?

> *"It is time to reverse this prejudice against conscious effort and to see the powers we gain through practice and discipline as eminently inspiring and even miraculous."*
> — Robert Greene

not really. I get it." He fell silent. "Maybe this is my daily practice, not the writing. I mean, I must get to the place where I write every day. But first maybe I need to get my mind straight, and maybe the only way to do that is to seriously focus on tackling my thinking."

In my own mind, I considered whether I should suggest that Jerome try both, a daily right thinking practice and a daily writing practice. Jerome beat me to the punch.

"Would it be too much to do both the mind practice and the writing practice?" he asked.

"I was just wondering the same thing," I said. "What do you think?"

"I think they might support each other. At least, I could see how that might be. If I put off the writing until I get my mind right, that would make for a lot of painful days of not writing. I think I'd like to try both. I know that the odds are long that I'll pull that off, but let's give that a shot."

"One should be primary," I said. "Which is your primary daily practice, the mind one or the writing one?"

"The mind one," he replied instantly. "I can see how that has to come first. If I don't get to the writing, I don't get to the writing. But if I don't get to the mind one, nothing will change."

The Buddha famously said, "Get a grip on your mind." That means considerably more than avoiding negative self-talk. It means powerfully supporting yourself by only thinking thoughts that serve you. That is a very ambitious goal, but it is also an appropriate one.

Food for Thought

1. Are you regularly challenged by your mindset?
2. Are you specifically challenged by your mindset when it comes to your daily practice?
3. What might you try to meet this challenge?
4. How might you proceed with your daily practice even if you can't completely meet this challenge?

Challenge 2

CHAOS AND NOISE

Our mind, which we would love to have be a nice, calm, quiet place equal to the work we would like to ask it to do, is more often a noisy, chaotic place so full of crashes, jackhammering, and shouting as to resemble a construction site. Imagine trying to be with your mindfulness practice or your instrument practice at a construction site! You would literally not be able to hear yourself think.

Although this sounds extreme, it is rather how many minds actually are. This is why it is so hard to think a thought to its conclusion, so hard to solve a knotty problem that requires intense contemplation, and so hard to keep the moving parts of a creative project in focus and all together. The din is just overwhelming. Often that noise stops only when we lose ourselves in some idle relaxation, like playing a repetitive game or watching a television show. Then our mind is quieted, but that particular quiet is of no use to us. That's just the quiet of mindlessness.

Helen had been hoping to write her memoir for more than a decade. She knew that for most of that time she'd been avoiding writing it, not actually writing it. With my

support, she put a daily writing practice into place, which was helping enormously. Sometimes she wrote for three or four days in a row, which was something of a miracle, given that she'd been in the habit of letting months slip by without writing.

As well as she was doing, her practice was still very tenuous. In fact, it felt to her like she was holding on to the side of a cliff by her fingernails. She had the sense that her practice could disappear at any moment and that she would find herself right back where she'd been for too long, overwhelmed by life, not writing for long stretches, and disappointed with herself.

She knew that her main problem was how noisy it was in the room that was her mind and how chaotic it felt in there. It felt as if she were engulfed in a sandstorm. As we talked about what might help, it seemed logical to her to try the three-step cognitive approach of listening to her thoughts, disputing those that didn't serve her, and replacing those with more useful thoughts. But that approach struck her as just a bit too obvious and too mechanical. She wanted to try something different.

"What might that be?" I inquired.

"I think I need the breathing component and the ritual component of the incantations. I'd like to try that and do that seriously, maybe trying a couple of your incantations and a couple of mine."

"Okay. Let's give that a shot."

Of the twelve incantations in *Ten Zen Seconds*, she decided that she wanted to experiment with "I am completely stopping" and "I feel supported." Then we brainstormed

about which two of her own she'd like to try. Her first attempts didn't feel convincing to her. Then she landed on "My life is important." That struck her as very powerful.

"Do you need a second one?" I asked. "Or is that enough?"

"I think I do need a second one." She fell silent. "I think I need one directly in support of the writing," she said after a while. "Something with 'writing' in it. Maybe 'I write every day.' No, that's not quite it. Maybe 'I'm called to write.' I think I like that!" she said. "That's a keeper."

"How do you want to use these four? One after another? Or in some other way?"

"One after another doesn't feel quite right. I'd like to give each its own space, its own weight. I think maybe I have to figure that out in the doing." We set up a chat for two weeks hence. I didn't hear from Helen during that time, which I didn't take to mean anything in particular, as silence can indicate that a client is working well, not working at all, or anything in between.

Can you run away from all that chaos and noise? Wouldn't it be better to stop and create some silence?

"Many of us have been running all our lives. Practice stopping."
— Thich Nhat Hanh

When we chatted next, Helen had good news to report.

"I've been writing! I created a routine that I love with those four incantations. I use 'I'm completely stopping' as the ceremonial bridge to get to the writing. I say it and breathe it a few times to get myself ready. Then I go to 'I feel supported.' That gives me a really good feeling. Even if the material I'm working on is painful, I can get near it after saying, 'I feel supported.'

"So I get going that way. Then I don't really say

the other ones, 'My life is important' and 'I'm called to write' — I just feel them. I think I am maybe saying them but, because I'm also writing, I'm not exactly aware that I'm saying them. They're like a kind of background hum — or maybe a background hymn." She smiled. "However that all is, it's working perfectly!"

For many people, dealing with that inner chaos and noise is worth a daily practice all its own. It is so consistently a problem that tackling it justifies daily attention. You might spend a few minutes first thing each day visualizing inner calm or ceremonially banishing a recurrent thought you'd like to silence. Or you might take longer than that and maybe engage in some focused journaling, where you create the thoughts that you want to be thinking and describe how you'll align your behaviors with those upgraded thoughts.

Remember: noise is no friend to your daily practice. If the noise is coming from the jackhammering outside your window, put on your noise-canceling headphones or head to a café. If your mind is generating the noise, then the challenge is greater; but it can still be met by a daily practice that focuses on calmness and cognitive change.

Food for Thought

1. Are you regularly challenged by inner chaos and noise?
2. Are you specifically challenged by that chaos and noise when it comes to your daily practice?
3. What might you try to meet this challenge?
4. How might you proceed with your daily practice even if you can't completely meet this challenge?

Challenge 3

RESTLESSNESS

There are many reasons for the epidemic of restlessness we're witnessing. One reason is the culture-wide movement toward an ever-faster, even instantaneous, delivery of images, words, ideas, and other bits of sensory information. Movie scenes last barely fractions of a second, ads pop up and vanish, phone texts appear and disappear, and news headlines scroll by. All this excited activity produces a deep restlessness, which carries over when we try to engage with our daily practice.

A second reason is the culture-wide acceptance of the model that labels the fidgeting and restlessness of both children and adults as mental disorders. Children receive the pseudomedical diagnosis of attention deficit hyperactivity disorder (ADHD), and adults receive the equally spurious pseudomedical diagnosis of adult attention deficit hyperactivity disorder (adult ADHD) or adult attention deficit disorder (adult ADD), turning an everyday state that might be tolerated or even ignored into a symptom of disease. It is that much harder to maintain a daily practice if what you are telling yourself is "Wow, this is really going to be hard, given my ADD."

A third reason is our growing anxiety. Anxiety has always been a feature of the human condition and always will be, as it is integral to our warning system against danger. If we feel threatened, we get anxious. Among the consequences of that anxiety are agitation and restlessness. Just picture a worried parent needing to pace in a hospital waiting room. We have more reasons than ever to feel anxious, given the threats to our cherished institutions and the state of the world, and so our agitation and restlessness have also increased. That restlessness is bound to make it more difficult to stay put and practice.

A fourth reason is the relationship between boredom and restlessness. If the content of our practice doesn't interest us on a given day — if we aren't that interested in practicing the piano, working on our nonfiction book, or tackling some boring problem presented by our online business — we will naturally grow fidgety and want to leave. How long can you sit there, disinterested and just going through the motions?

For these and for other reasons, too, we had better be prepared to be challenged by restlessness as we practice. Your tactics might include dropping the thought "I am perfectly calm" into a deep breath, one that is five seconds long on the inhale and five seconds long on the exhale, and breathing and thinking the restlessness away; or visualizing in your mind's eye a calmness switch that you flip in the direction of calmness; or some tactic of your own creation that helps you eliminate or at least reduce your experience of restlessness.

Take Joe. Joe rather cherished his ADD diagnosis, which he felt helped explain his whole life. It did not strike him as a paradox that he had no trouble paying complete attention to those things that he liked, like his video games, and that he only had major difficulties staying put when it came to things he found boring or difficult. In fact, that made perfect sense to him. "Doing something I like helps my disorder," he explained.

As a singer-songwriter, he needed to practice playing the guitar, compose songs, practice his covers and his own material, and perform in public. He complained that "all of that triggers my ADD." We worked on instituting a performance practice whose contours kept shifting, as one week it was practicing the guitar he found most difficult, another week the composing, another week all of it. The content of his practice remained something of a moving target.

Restless during your practice? Hardly paying attention? Well, that isn't the ideal practice. But better to fulfill your commitment than to flee the encounter.

"Try to be content with your practice, whatever it feels like, even when you are doing little more than paying it lip service, because at least you are making an effort."
— Dzongsar Jamyang Khyentse Rinpoche

Whenever we spoke, Joe seemed palpably anxious. It struck me that having Joe try out one or another anxiety management strategy would make good sense. But he balked at the idea that anxiety might be an issue.

"I'd rather try out some other sort of strategy," he said.

"Okay." I described a few possibilities. "What's calling out to you?"

"I want to try the ceremonial mantra thing," he replied. "How does that work?"

I explained the logic of a ceremonial mantra: the idea that a very few words could capture a person's basic life orientation, provide motivation, and bring calmness, all at once. I told him that mine was "Do the next right thing" and shared with him some of the ones that my clients had come up with and liked, among them "Right here, right now" and "This is the work."

He pondered that for a while and then smiled.

"Here's what I want to try," he said. "'Adventurous playful performer.' My APP will replace my ADD!"

"Okay! How will you use it?"

"I don't know exactly. Maybe…maybe I can tape it to my guitar!"

When we chatted again in a couple of weeks, not much had changed. Joe had only gotten to his practice a few times, and even when he had showed up, he hadn't been able to stay for very long.

"I'm too restless to practice," he said. "I'm going to check on some new medication for my ADD. Maybe that will help. Right now, the ADD is too strong."

"You're going to hold off practicing until you get the new medication?"

"Yes. I don't have a choice."

"When's the performance?"

"It was going to be in three weeks. But I canceled it."

"You canceled it?"

"I'd only sold a few tickets. I was running short on time to market and promote it. So I've postponed it for a few months. That will give me the time I need…and by then the new medication will have kicked in."

Eventually Joe decided that he wasn't ready to commit to a daily practice. "There are other things I need to be doing, like getting my life in order." I wondered if he might want to design a daily practice to help him with the challenge of getting his life in order. He declined, explaining that, for now at least, "my ADD isn't letting me stay put. Trying to do anything on a daily basis just isn't going to work for me." Soon Joe discontinued coaching, thanking me and saying by way of goodbye, "I'll be back, once I get my ADD medication worked out!"

Having trouble with your practice? Maybe what you need is more practice at it!

"Practice takes practice."
— Sharon Rowe

Food for Thought

1. Are you regularly challenged by restlessness?
2. Are you specifically challenged by restlessness when it comes to your daily practice?
3. What might you try to meet this challenge?
4. How might you proceed with your daily practice even if you can't completely meet this challenge?

Challenge 4

TIME AND SPACE

Your daily practice requires both time and space. If you can't find the time for your practice or if you don't make the time, you won't have a practice. If you can't find a place for your practice or if you don't make a place, you won't have a practice. Many people are challenged in these regards, either in finding time and space, making time and space, or both. If you are one of them, your daily practice will hang in the balance.

One way to make time is to sleep less. This isn't ideal, but it is a possible option. Another way is to spend less time on the things you don't really need to be spending time on, like watching television, surfing the internet, playing video games, and other soothing pleasures. Another way is to take shortcuts in life, accepting canned soup over homemade, or dust bunnies over shining floors. There are other ways to make time, too: by not giving it away when you don't really mean to, by radically changing your circumstances, by delegating tasks that can be delegated, and so on.

None of these ways will work very well, however, if you are really using lack of time as an excuse not to practice.

You won't find or make time if you feel building your online business is too daunting, if you've secretly given up on your novel, or if you so dread performing that you have no real intention of writing the one-woman show you claim to be working on. The same is true with space. You will never clear out that spare room full of things that ought to be thrown out if what you are really doing is avoiding your practice.

Sometimes special or unusual circumstances regarding time and space crop up in life. Maybe another one of your life purposes suddenly demands all of your time. Maybe you're forced to work extra-long hours at your day job. Maybe you need to put up your sister and her family after a fire destroys their home. Life is not static or simple. Things come up, including terrible ones. Consider Angela's situation.

Maybe your space is perfect and you have all the time you need in order to practice, but still there's something in the way. Then that's the challenge that needs tackling!

"I play the piano. I bought an upright piano that is actually electric, so I can practice my scales with headphones on and not make my neighbors' lives hell!"
— Eva Green

Angela had lost a daughter to a horrible illness and pledged that she would honor her daughter's memory by starting a nonprofit that supported parents of adult children stricken with terrible illnesses. She believed that she knew what services her nonprofit would offer; she had friends, family, and an extended network ready to help her; and nothing seemed to be standing in the way of her working on her nonprofit as her daily practice. But it wasn't happening.

During one session, a thought popped into my head. "Where are you trying to do this work?"

"At the kitchen table. Our kitchen table is the hub of life in our house, and I love being there."

"And people come and go?"

"Of course. All day long on the weekends. And in the mornings, in the afternoons, sure. It's a bustling place!"

"A lovely place for living," I said. "But for working on the details of launching a nonprofit?"

"I like being there," she said. "I *need* being there."

We sat for a long moment.

"I can't see being stuck away in a room somewhere. That's too depressing."

"Is there such a room?"

She shook her head. "No."

"None?"

"There's Lisa's room," she said after a while. Tears began to stream down her face. "It's…" She could hardly go on. "It's exactly the way she left it."

We sat in silence.

"It's not a shrine," she said. "It's…I just need to be able to walk in there and be with her."

I nodded. "Of course."

"You want me to use that room?"

"I have no want, one way or the other. I only have a wonder. I suspect it's too hard to do the work you need to do while sitting in the kitchen in the middle of things. So…I do wonder about using Lisa's room."

"No way," Angela said. "It's impossible."

We chatted again two weeks later. "I've been working

on the nonprofit every day for the past week," she informed me.

"Where are you working?"

"Sometimes in the kitchen, when it's quiet," she said. "And sometimes...in Lisa's room. I...reorganized it."

We sat together quietly.

"It's almost unbearable in there," Angela continued. "At the same time, there's nowhere else I really want to be. So it's kind of the perfect place for Lisa's Room."

"That's what the nonprofit is called?"

"Yes. It is."

Time is limited, and space is limited. You are in charge of dealing with those limitations. You can't add hours to the day, but you can better arrange the hours that you do have. You can't add space to your cramped apartment, but you can make decisions about your available space that take your daily practice into account and that honor your intention to live your life purposes. You may not find perfect answers to your time and space needs, but you can find better answers, if you try.

Food for Thought

1. Are you regularly challenged by time issues and space issues?
2. Are you specifically challenged by time issues and space issues when it comes to your daily practice?
3. What might you try to meet this challenge?
4. How might you proceed with your daily practice even if you can't completely meet this challenge?

Challenge 5

SELF-TALK

It amazes me how self-critical people regularly are in the privacy of the room that is their mind. It is remarkable how they tear themselves down, create dramas, and talk themselves out of doing what they know they ought to be doing. The main operating instruction that we seem to have been born with is "I need to believe the thought I just thought because I just thought it." It can take a good part of a lifetime to realize that we do not have to agree with a thought just because it popped into our head.

You're feeling a little tired. You hear yourself say, "I'm tired." That seems to confirm matters! But that's just a reflexive thought, one that could be disputed. Disputing it would sound like, "Ah, yes, I'm feeling tired, but it's time for my practice, and I can engage with my practice, or maybe a shortened version of it, even though I'm feeling tired." That's a bit of a mouthful to think, so we need to train ourselves to dispute thoughts rather more rapidly and robustly, which in this scenario might sound like, "Tired? Ha! Off to practice!" or "Practice will energize me!"

You are in charge of how you respond to the thoughts

you think. Maybe you can't keep a thought from bubbling up. Maybe, as an overly vigilant person, you can't help thinking, "There's dust in that corner again." But you can learn to deal with that thought differently. You can respond to that thought with, "Oh, darn, there I go again, worrying about dust, when I should be heading off to my practice. Am I going to let dust stop me again?" Or, more rapidly and robustly: "Dust? Ha! Off to practice!"

If you let them, your disruptive thoughts can stop you from staying with your practice for its full length of time or from getting to it at all. Of course, the challenge we're chatting about isn't as simple as hearing a thought that ought to be disputed and immediately disputing it. It has to do with looking at our entire way of thinking and how that thought connects to our belief system, our identity, and our personality. That's a lot. And, for most people, too much.

Larry was in recovery from alcoholic drinking and had instituted a recovery practice as part of his AA-based program. But he couldn't stick with it and seemed rather annoyed by it. The way he put it, his PTSD from his time as a Marine in Afghanistan was "out of control." I wondered about this whole way of thinking — that is, about the very idea that he had a thing called "posttraumatic stress disorder" — and began exploring that question with him.

"You're thinking in terms of this thing called 'posttraumatic stress disorder,'" I offered. "Forget about that label for a second. Think about this. A soldier goes over there, kills a lot of people, sees a lot of his buddies killed, feels nothing, and we want to call that 'normal.' Another

soldier goes over there, experiences all of that, ends up with painful memories and a guilty conscience, and we want to call him 'mentally disordered.' That's how the system wants us to see things. Is that how you want to see things?"

"I don't have a guilty conscience," Larry replied, bristling. "I'm pretty mad that you think I ought to have one."

Not happy about what you're doing? Change your instructions to yourself. Wouldn't that make for an amazing daily practice?

"Via self-talk we give our mind instructions on what we expect of ourselves and so behave accordingly. Change the instructions, and we change the outcomes."
— Sam Owen

These are the hard moments that helpers must face. It is much easier to provide a label and chemicals than to sit with a person who is furious with you for criticizing him. People aren't easy, in life or in session. I suspected that this might be my last chat with Larry.

"So you believe that you have posttraumatic stress disorder?"

"Yes, I have that."

"You have a mental disorder?"

"I do."

"And you had none of these problems before going over there?"

I knew that Larry would want to reply, "Of course not!" But would he be able to? Not if he was being truthful. He took a long time to answer.

"I've always had these problems," he finally said grudgingly.

"So you've always had PTSD?"

"I suppose."

I waited.

"What the hell is going on then?" he exploded. "If it isn't PTSD?"

"Maybe you've been angry and upset for a very long time. Maybe you still are. Maybe that's what's interfering with your recovery practice and threatening your recovery."

I saw Larry another time or two. I fully expected him to be too attached to his PTSD label — and to the way that worldview helped him deny a lifetime of anger and pain — to want to continue. He had his "mind set." The mental health system provided him with a label, and that label sat well with his need to defend himself from learning what was really going on. As a means of defense, his thoughts were indeed serving him. They were functioning as he hoped they would function, to keep a wall up. But were they serving his daily recovery practice or his basic well-being? They certainly weren't.

Your self-talk arises for reasons, and you may have to bravely deal with those reasons in order to begin to think thoughts that serve you, in order to live the life that you dream of living, and in order to maintain your daily practice, whatever sort of practice you're attempting. It would be nice if a thought were just a thought and could be arm-wrestled to the ground and dispensed with. But thoughts are expressions of our identity, our personality, our history, and the very way we organize reality. In order to successfully tackle and transform them, we may need to put into place a whole separate personality upgrade daily practice.

Food for Thought

1. Are you regularly challenged by your self-talk?
2. Are you specifically challenged by your self-talk when it comes to your daily practice?
3. What might you try to meet this challenge?
4. How might you proceed with your daily practice even if you can't completely meet this challenge?

Challenge 6

BODILY SENSATIONS

We have bodies. That isn't always so convenient. Maybe we clench our jaw or scratch our head as we write: then we end up with an aching jaw or a bleeding scalp. Maybe our feet ache because we dance. Maybe our arms ache because we sculpt. It might be lovely to not have a body to concern ourselves about, but, well, that's not going to happen.

Our body announces that we are enthusiastic. Our body announces that we are anxious. Our body announces that we are exhausted. Our body announces that we are injured. Our body announces that we are famished. Our body announces that we are aroused. Our body provides us with sensations around the clock…including during our daily practice. We are not immune to bodily sensations just because we have set aside time to practice.

This can prove a real challenge. How easy will it be to write if your back is hurting? How easy will it be to dance if your hip is aching? And what about those bodily sensations that arise *because* of our practice, those butterflies in our stomach because we're painting in a new style and

can't tell if it's working, those headaches that suddenly and explosively arrive because we're concentrating so hard on the physics problem that we're trying to solve? Our body is its own real challenge.

Consider Gloria. Gloria, who identified primarily as a poet, decided to also institute a daily activism practice separate from her poetry writing. She didn't want to impose any "activist needs" on her poetry: she didn't want her poetry burdened in that way. At the same time, she felt it her duty to speak out against the terrible new trend of "mildly" electroshocking children as they slept as a "treatment" for ADHD.

She couldn't abide this abuse. And indeed, she was managing to spend a full hour or two every day blogging her views and interviewing experts for her new podcast. But she felt terrible the whole time. Headaches plagued her, and her stomach, which couldn't tolerate the abuse, also couldn't tolerate her activist efforts. The whole thing was upsetting her, and her body was reacting and rebelling.

How long will that sensation last, the one disturbing you? Maybe a while? Or maybe for just another moment or two?

"A sensation is always the same as a piece of news, and a piece of news never lives long."
— Jostein Gaarder

"What do you think is going on?" I asked.

"I think it's probably pretty simple," she replied. "I'm frightened. Doing what I'm doing must frighten me. I'm sure it does."

"Would it be of any value to get at why it's frightening you?"

"I doubt it. It's really pretty obvious. I'm frightened that I'm going to get attacked. And I should be frightened, shouldn't I, because whistleblowers do get attacked, and ruthlessly, don't they?"

"Yes."

"I hate conflict. Always have. So my body is acting up, just as you'd expect it to act up. I may have to just live with these feelings."

"That seems awfully hard," I offered. "Can a person really maintain a daily practice that makes them sick every day? That's hard to picture."

"Well, if you're committed, you have to. I don't really see that I have an option. I hate what's going on, and I have to continue, even if it's literally making me sick. I can't stop."

We sat in silence.

"This might," I said after a while, "be a perfect problem to sleep think on." I briefly explained the basic idea of sleep thinking: that the brain is happy to do some excellent thinking during the night and can be enlisted to solve problems while you sleep. She seemed intrigued.

"How would I go about doing that?"

"It's really as simple as choosing a sleep thinking prompt — a question you ask yourself before you go to sleep — and letting your sleeping brain work on it. Then you'd do a little processing first thing in the morning."

"What should the question be?"

"Maybe this," I said. "'I wonder what could be different?'"

After a while she nodded. "I'll try that. What do I do? Repeat the question a few times? And then what?"

"And then sleep," I said, smiling. "In the morning, ask yourself the question again, and if something comes to you, write it down. It's that simple. But give it a few nights running. You may not get the answer on the first try."

We chatted again a few weeks later.

"Anything come of the sleep thinking?"

"Yes. I got the answer."

"Which was?"

"Turkey."

"Excuse me?"

She laughed. "I've done poetry open mikes in the past. And they would make me extremely anxious. So I researched performance anxiety tricks to help me deal with my stage fright. One that got my attention was what performers ate before they performed. So many of them opted for a turkey sandwich! There's apparently something soothing about turkey. Who knows, maybe it's all mental. But I tried it, and it made the open mikes much easier. So I thought, why not give it a try with the activism? But I didn't want to eat a whole turkey sandwich that early in the day. So I started making a plate of turkey on crackers. And, bizarrely enough, it really did help. Maybe it was just a trick of the mind, or maybe it actually was something physical, but the whole answer turned out to be turkey."

What will work for you? If your body is balking or rebelling, you may find yourself tempted to give up on your daily practice. Try finding solutions before giving up. Maybe what's needed is a change in thinking, a lifestyle change, a dietary change, or a medical visit. Your body

makes its demands, including the demand that you listen to it. Listen and respond as best you can, for the sake of your practice.

Food for Thought

1. Are you regularly challenged by problems with your body?
2. Are you specifically challenged by problems with your body when it comes to your daily practice?
3. What might you try to meet this challenge?
4. How might you proceed with your daily practice even if you can't completely meet this challenge?

Challenge 7

DIFFICULTY

If what we're working on during our daily practice presents us with difficulties, we're that much more likely to abandon our practice. If you're learning the oboe and you find everything about that hard — and you might, as it is a devilishly tricky instrument to master — you might well want to throw in the towel after not too long. The same if you're working on a knotty problem in a scientific field, or trying to create and run a workshop with many moving parts to it, or struggling with the very health issues that you're trying to address in your daily health practice.

Much in life is difficult, especially when we set ourselves challenges like mastering a musical instrument, building a one-person business, writing a self-help book, or living our life purposes. It can seem ever so much easier to give up that instrument, that business, that book, or the very idea of living our life purposes and as a consequence give up the practice that goes with it. The second you say, "This is too hard" and allow that conclusion to sit there undisputed, building into a crescendo, you stand on the threshold of aborting your daily practice.

Often, it's the case that you are equal to certain hard tasks but not to others. Maybe you've gotten practiced at dealing with the difficulties associated with making abstract paintings come alive. But the new challenge that you've set yourself of painting in a super-realistic style is proving a difficulty of another order of magnitude. Maybe you're a veteran teacher who's mastered the classroom, but this year you're teaching a new grade. Maybe you're a seasoned therapist who's begun to work with court-mandated clients. Changes of this sort tax us and test us.

We know better than to suppose that our practice will be easy. But shouldn't we expect it to at least get easier? Isn't that where repetition and mastery and all the rest are supposed to lead? No. Because the work itself may always prove difficult, if we have chosen work that is difficult.

"It is a mistake to think that the practice of my art has become easy to me."
— Wolfgang Amadeus Mozart

Or maybe the challenge you've set yourself is so different from anything you've tackled before that you and your practice are stymied; maybe it calls on skills or talents that you may not possess much at all. Such was the case with Harry, a construction site foreman. Harry had set himself — or been handed — the task of writing a wedding speech for his daughter's impending nuptials. He'd given that a daily try, spending an hour or so each day writing and deleting, and then he'd thrown in the towel. For a full week, he'd skipped trying at all.

The wedding was now only three weeks away. He hated the idea that he might just scribble something at the last minute. That didn't at all match his sense of the

importance, even the majesty, of the moment. He was honest enough to know that he wasn't meeting the mark in any of his drafts, but he couldn't understand why such a "simple" task was feeling so amazingly difficult.

"Your job is just a job?" I said. "Being a foreman?"

"Yes."

"Does it rise to the level of life purpose choice?"

He shrugged. "It's something that I need to do. It brings in the money. And I feel some pride that I can pull it off day in and day out. But life purpose choice? I don't think so. I would set the bar quite a bit lower."

"And this speech?"

"There the bar is very high!"

I nodded. "That's both a good thing and part of its difficulty, isn't it? It's lovely that you're taking it seriously. But taking it seriously also puts on added pressure."

"It does!"

"Plus you aren't practiced at writing speeches."

"I'm not."

"And it may not be your skill set."

"I think that's a given!"

Shouldn't the challenges we encounter as we practice finally go away? That's like asking, Shouldn't it finally stop snowing some winter? Maybe those challenges will vanish; but until then, we must keep plowing the roads and making our way through the snow.

"No matter how much falls on us, we keep plowing ahead. That's the only way to keep the roads clear."
— Greg Kincaid

"But let's play with the idea that this is one of your life purpose choices. That it's to be taken seriously. If you held this, not as 'writing a speech for my daughter's wedding,'

but as 'a life purpose choice,' what might you do differently?"

He considered that for some time. "Well, I wouldn't take a week off from doing it!" he finally exclaimed.

I nodded.

"Two things," he said after a moment. "I would come at it from a different place in me. On the job, I come from a tough place. That's as it has to be, or I'd get walked all over. For this I have to come from a soft place. And…from a noncritical place. A nonjudgmental place. I kind of want to keep joking about her 'youthful escapades,' about the men she's dated, about all the trouble she got into. But really, that's not about me being lighthearted or funny, that's about me wanting to get a few digs in."

He paused.

"And I'd work on it a lot," he said. "Not just for an hour a day. And certainly not for no hours a day! I'd take some days off from my job to work on it."

We let that conclusion sink in.

"And?" I wondered.

"And that's what I'll do," Harry said. "I'm not sure I've ever taken a day off for a reason like this. But this demands it."

When your practice proves difficult, as it almost certainly sometimes will, what will you do? The temptation will be to avoid it or even to abandon it. We all know that temptation. But if our goals are to fully live our life purposes and to consistently do the next right thing, we'll look that temptation in the eye and announce, "I'm showing up, even though I don't really want to."

Food for Thought

1. Are you regularly challenged by some particular difficulty?
2. Are you specifically challenged by some particular difficulty when it comes to your daily practice?
3. What might you try to meet this challenge?
4. How might you proceed with your daily practice even if you can't completely meet this challenge?

Challenge 8

ANXIETY AND DISTRACTIBILITY

Many things make us anxious. The primary way that we deal with all that anxiety is to flee, by physically running away or by losing ourselves in a shopping spree or a television series. Such flight soothes us somewhat but tends to do nothing very substantial to quell the anxiety. The shopping spree is over, and we are anxious again. The television series ends, and those worried thoughts return. Flight works temporarily, which is why we flee. But only temporarily.

Because we may not want to tell ourselves the truth about the situation — namely, that we are feeling anxious — we look for distractions that we can use as excuses to justify our flight. Rather than honestly announcing, "Trying to write this chapter is making me damned anxious!," we let the sound of the rain on the roof distract us and cry, "I can't write with all that rain!" Or we entertain a stray thought, like "I wonder if the kids are asleep?" or "I wonder if I turned off the oven?," and use it to allow ourselves to flee our study and traipse off to the kids' bedroom or the kitchen.

This is all very normal and natural, to experience anxiety, to want to flee from it, and to provide ourselves with convenient distractions that permit us to flee. But this is also a practice destroyer. To have a daily practice, you will need to recognize the way that anxiety threads through everything, and you will need to deal with that reality rather than finding ways to escape it. You might as well want lightning not to shock as to want life not to make you anxious.

Take Sandy. Sandy was an academic physicist specializing in tachyonic particles, hypothetical particles that travel faster than light and that play a significant role in theoretical physics. While she thought about them all the time, her thoughts would get jumbled with the other affairs of life, from departmental politics to the tribulations of her teenage son, who rarely left his room. So, while those particles were always with her, she couldn't really give them the attention they deserved.

It therefore seemed important to create a daily practice where she got to think about them exclusively. She decided that from 8 AM to 10 AM every day she would do her particle work at home, away from campus distractions, and see if she could make some real progress with her theoretical investigations. But she found it impossible to stay put in her study. It was quiet there, comfy there, and altogether hospitable there: except that her mind wouldn't settle.

She was completely derailed by the thought "This won't work." She knew that this ominous phrase stood for

several different distressing ideas: that she wasn't smart enough for this top-level intellectual work; that the work itself was suspect and likely just a creation invented to while away the time of theoretical physicists; and that she hadn't the personality — the endurance, the moxie, the something — that a topflight physicist needed.

Can you get better at dealing with your anxieties? Yes! That is completely possible.

"The people who move forward and overcome their fears do not have some special powers or a magic pill they take. They just have more practice in facing their fears."
— Dave Anderson

"But mostly, it's free-floating anxiety," she said. "I'm being made anxious by everything. The news. The world. Eddie in his room. How my last date went. How my next date will go. It's as if every single thought wants to provoke anxiety, even thoughts like 'Do I want the short fork or the long fork?' Eating a salad makes me anxious! Maybe it's the world right now, the rising fascism. Maybe it's that I can hardly tolerate teaching. I don't know! It feels like it's everything!"

There are innumerable ways to work on anxiety issues. A psychiatrist would likely immediately head down the road of chemicals. A therapist, coach, energy healer, acupuncturist, or other helper would propose his or her favorite technique. I like to start with a simple visualization. I invite clients to imagine there is a switch inside of them that they can flip to achieve instant calmness. I shared this calmness switch visualization with Sandy, who grudgingly promised to try it out. We chatted a few weeks later.

"It has gotten better," Sandy confided. "I don't know if

I'm really flipping a calmness switch, but I think that just saying *so clearly* that I'm feeling anxious has helped. I've known I was feeling anxious, but I somehow wasn't really admitting it. Now I can say, 'I'm anxious!' and just let that be. It isn't that I'm now in some new postanxiety paradise. But I think that I've normalized the anxiety. I can stay put now."

Anxiety is a big deal. Watch out for the way that anxiety threads through the process and the havoc it wants to wreak. And get ready for your own antics: the distractions of your cat strolling by, that idle thought about having agreed to host a huge Thanksgiving gathering, or the sound of a door slamming down the street. If we let it, just about anything can prove distracting. If you're looking for a menu of anxiety management strategies from which to pick something that might work for you, I recommend that you take a peek at my book *Mastering Creative Anxiety*, where I describe more than a score of tactics. Be prepared for anxiety and distractibility and have some strategies in place for managing them when they arise.

Food for Thought

1. Are you regularly challenged by anxiety and distractibility?
2. Are you specifically challenged by anxiety and distractibility when it comes to your daily practice?
3. What might you try to meet this challenge?
4. How might you proceed with your daily practice even if you can't completely meet this challenge?

Challenge 9

SKILL SET ISSUES

Your daily practice may involve you doing something that you aren't very skilled at doing or maybe aren't skilled at all at doing.

Maybe you're a complete beginner at the piano. Maybe you're writing your first screenplay. Maybe you have great enthusiasm for building a business but have little knowledge about how to proceed. All of this is natural — and daunting. It can jeopardize your daily practice if you find yourself wanting in the skills necessary to do the thing you're attempting. That lack of skill can prove downright paralyzing.

We understand all about being a beginner, about steep learning curves, about not being able to master French or chess in an afternoon. But that we understand these truths is not the same as surrendering to them. When a child isn't able to master the rules of chess in two minutes flat, he's liable to knock the set off the table. Adults aren't all that different. Somewhere inside of us we are saying things like "This shouldn't be this hard!" and "I have so far to go!" and "I hate this!" And so we knock the board off the table, sending the pieces flying.

Often, we lack not just one skill but multiple skills. For a short time — one day — I worked as a carpenter's helper in Ireland. There was not a single thing about removing and replacing centuries-old glass that I understood. I couldn't have proceeded more tentatively, not wanting to break all that irreplaceable glass. My boss, who was my friend, laughed, paid me my Irish pound, and fired me. Clearly I lacked prying, sizing, and hammering skills!

Frequently a situation arises where we could proceed without refining a certain skill but only by doing a half-baked job of it, whereas if we weathered the learning curve of refining that skill, we could proceed at a much higher level. For instance, our drawing skills may be just serviceable enough to let us get away without practicing them and improving them, maybe because the art we do is loose or abstract and doesn't require any realistic drawing. At the same time, we may know very well that if we did pay daily attention to drawing and improved that skill, that would deepen our art.

Equally tense and complicated is the situation where we aren't sure if adding a new skill is actually a necessary improvement or whether it is more like chasing the newest, latest shiny object that is winking at us and demanding we be interested in it. A coaching client of mine, Liz, found herself in this precise situation.

Liz was a beginning photographer who adopted a daily creativity practice around her desire to produce a series of stark images of puppets placed in deep shadow. She knew what she wanted these images to look like and had

begun capturing them with the camera that came with her phone. But she quickly got stuck because, fortunately or unfortunately, she also possessed a "better" camera that had cost her a pretty penny to purchase, that was significantly more advanced than her phone camera, and that she had no idea how to operate.

Her practice had stalled because she couldn't decide which of her two cameras to use. The phone camera was easy to use but didn't produce the same quality images that her single-lens reflex camera could produce. But the learning curve associated with the Olympus camera felt steep and daunting — like climbing Mount Olympus.

We talked it out. I suggested that she perhaps consider the phone camera images different from, rather than worse than, the images her new camera might produce. She liked that idea a lot. "I actually love the puppet photos I take with my phone," she said. "I should stop bad-mouthing them!" I wondered if a possible plan might be to complete a photo series using the camera phone while at the same time learning how to use the more advanced camera. She agreed that that made good sense.

> Brilliance seems so magical, so wonderful. Is there anything equally wonderful about daily application and hard work? Yes!
>
> *"If people knew how hard I had to work to gain my mastery, it would not seem so wonderful at all."*
> — Michelangelo

"So we're talking about two separate practices?" I asked.

"Meaning?"

"Well, there's one daily practice where you use your

phone camera, create a series, and see if that series can be shown somewhere?"

"Yes."

"And then there's a second practice where you get help with the Olympus? Maybe from that friend you mentioned?"

"Ah, yes."

"Should those both be daily practices, do you think?"

"The phone series definitely should be," she said. "The second one, learning how to use my Olympus, depends on my friend's schedule. I think that's probably more like weekly or intermittent. That one's harder to say."

"But you'll attend to it?"

She laughed. "I will."

"Okay. So now you have a daily practice that doesn't suffer from any skill set issues? You know how to use your phone camera, right?"

"I do!" She laughed again. "Very well!"

"And the Olympus?"

"That's going to be a pain in the neck! I already hate thinking about it. But just so long as I'm able to take photos I like with my trusty phone camera, I think I'll be able to tolerate learning that — let me be friendly about this — that amazing piece of machinery."

This way around a skill set issue happened to work in this case. But you may not be so lucky. You may have to directly deal with a skill set deficit in order to proceed with your daily practice. In that case, assess your current skill set, determine what skills are lacking, and create a daily practice aimed at acquiring those skills.

Food for Thought

1. Are you regularly challenged by your lack of certain skills?
2. Are you specifically challenged by your lack of certain skills when it comes to your daily practice?
3. What might you try to meet this challenge?
4. How might you proceed with your daily practice even if you can't completely meet this challenge?

Challenge 10

CIRCUMSTANCES

Your daily practice isn't off on some island, separated from the rest of your life by oceans of insulation. It is smack in the middle of your life and must be affected by whatever affects you. Your health deteriorates. That matters. Your work environment becomes toxic. That matters. You and your partner are fighting. That matters.

If we wanted to, we could make an endless list of the kinds of circumstances likely to have a negative impact on your daily practice. But you know what I mean without having to look at such a list. You know how much harder it would be to get to your life purposes and your daily practices in the middle of worsened circumstances. And yet we have the quirky habit of not quite taking changed circumstances into account. Isn't that odd?

Here's a typical scenario. A publisher expresses interest in publishing your novel. That gets your hopes up. As you wait, you work well on your next novel. You're in a fine mood and have high hopes for both books. Then you hear from the publisher that they intend to pass on publishing your first one. Hurt and demoralized, you stop working on your second one.

Nine out of ten writers won't come close to attributing abandoning their second novel to that painful event. Rather, they will have "no idea" why their second novel no longer interests them. Most writers in that position have a defensive need to refuse to acknowledge the pain caused by the rejection or admit the causal relationship between that rejection and the abrupt end of their daily writing practice.

Don't have every single thing you need for a perfect practice? Don't have the right light, the right silence, the right tools? Practice anyway.

"A good swordsman is more important than a good sword."
— Amit Kalantri

Circumstances really do matter. Take Victor's case.

Life had looked one way for Victor. He'd had a huge success as the creator of a specialty app, but he found himself ousted, for reasons he couldn't fathom, from the company where he'd had that huge success. It had something to do with personalities, with office politics, with the company "going in a new direction," but ultimately the ouster made no sense to him. He'd provided them with their biggest hit; he'd brought in many millions. And then to be kicked out?

He had no idea how to proceed. There was a feature-length film that he wanted to make, but he didn't have the knowledge, the resources, or the finances to zoom off in that direction. He could find another firm to develop apps with, but he wasn't sure that he wanted to create an app ever again. He'd long had the dream of being a musician — he'd had a band in school that had done surprisingly well — but now, in his late thirties, how realistic was that? And he had two small children to clothe and feed and a wife who fully expected him to make money.

I asked Victor how he thought he might proceed. It seemed unlikely that he could just initiate a creativity practice, given that he didn't know what he wanted to create or even whether he still wanted to create. That daily creativity practice would have been the most natural practice in the world — if he was still making apps. But his circumstances had changed radically.

He decided that what he wanted to begin was a daily warrior practice. "I need to stand tall and fight my way out of this predicament. Like those fabulous samurai warriors who had great sword skills but could also write poetry. I want a samurai practice."

I asked him what that might look like. "I don't know yet," he replied. "But I know it's the right practice for this moment."

Within a week he had opted for the most literal interpretation of his idea possible: he began daily karate lessons. He loved his daily private lessons and never missed a one, increasing his practice by adding on group lessons. Several months later he shared with me that he was going back to developing apps.

"There's an app I want to create," he told me. "I've already talked with a company in Japan. They want it."

"And it will do nicely?"

"It will do beautifully! It will make a lot of money."

"And is it... what's that word you used that other time when we chatted about making apps? Is it a worthy enterprise?"

"I will have to hold my nose a little," he said. "But I accept that, just as a real-life samurai had to accept the imperfections of the lord he chose to protect. In the samurai

movies, there are two lords, and one is good, and one is evil. In those romantic movies, a samurai had a clear choice. Go with the good or go with the evil. When he went with the good lord, he could do so with a clear conscience and give up his life gladly and easily.

"In real life, it's much more likely that one lord is 60 percent evil and the other lord is 30 percent evil. So the samurai still has his choice to make — but he has to hold his nose a little, even if he chooses the better lord. I think I've ended my love affair with romanticism, and I'm going over to the side of multiple life purposes, each of which is fraught. Yes, this will be worthy enough. It will provide for my family, and I'll get plenty of strokes. At the same time, I'm going to pay attention to my other life purposes."

"And become a black belt?" I laughed.

"In my style of karate, red is the highest. But I don't think I'll quite get there!"

If you're having trouble maintaining your daily practice, ask yourself the following two simple questions: "Have my circumstances changed?" and "Have those changes affected my practice?" That may be the place to look.

Food for Thought

1. Are you regularly challenged by your circumstances?
2. Are you specifically challenged by your circumstances when it comes to your daily practice?
3. What might you try to meet this challenge?
4. How might you proceed with your daily practice even if you can't completely meet this challenge?

Challenge 11

HEALTH

You may be able to maintain a daily practice even if you aren't in good health. But poor health can make it harder or even downright impossible. Chronic pain is a game changer; circulation problems will make it hard to sit for the length of time you were hoping to sit; arthritis may ruin your ability to fabricate your miniature sculptures; and so on. It is lovely to have a body and not just be a brain in a pickle jar. But our body is not always our friend. Our daily practice is an embodied thing and may fall away if our body refuses to cooperate.

You may be very adaptable and clever and find ways to deal with your body failing you and to compensate for a loss of aptitude and skills. Matisse famously dealt with the just about crippling arthritis in his hands by moving away from painting, which was no longer a possibility, to large paper cutouts. Indeed, his blue women cutouts are among his most famous and honored works. His fortitude and adaptability were remarkable. But not everyone will be able to pull off such a winning switch. Could a concert pianist or a concert violinist?

Physical problems naturally also produce emotional problems. They get you down. They put you very much in touch with your mortality and can easily send you down the path of despair. They can make you feel that life has cheated you, that life is unfair, that life is a hopeless affair with no respite. In our current labeling system, you will probably end up with a "diagnosis" of "clinical depression" and be put on powerful chemicals, which themselves are likely to make life harder by increasing your thoughts of suicide, reducing your desire to create, and flattening your feelings into a pancake.

This can all make for a very difficult ride. Take Laura. Laura had embarked on a taxing, psychologically draining round of fertility treatments. She'd been working a daily creativity practice and getting to her poetry regularly, but the physical and emotional toll that the treatments were taking had begun to derail her practice. She found herself dropping from writing six days a week to writing four days a week to writing only on the occasional day. Even that occasional day was beginning to slip away.

To try to deal with both the effects of the treatments and the vanishing daily practice, we chatted about many options, and Laura bravely gave each a try. But they weren't bearing fruit. Weeks had gone by now with no writing at all. We met via Zoom, and Laura announced that she was really not feeling very well, either physically or emotionally. But, she hastened to add, she didn't want to give up. Giving up could not be allowed to be the conclusion.

"I need something more...what?" she said.

I waited.

"Something more comprehensive," she said after a long pause. "Something that helps me hold all of these difficulties in one basket, if that's the way to say it. The... why am I doing any of this?"

"The fertility treatments? And the poetry?"

"Yes."

"Because they're important to you?"

She shook her head. "Are they? The treatments are knocking the wind out of me. And each month, when it doesn't work..." She trailed off.

"This is a difficult time," I said. "But that doesn't make the effort to have a child unimportant or put the value of poetry into question, does it? These are difficult times, but these are important things, yes?"

She wasn't in the mood to agree. "I'm not sure."

"But if they aren't important any longer, where did their importance go?"

"Maybe nothing's important."

"That's it, isn't it? You've peered behind the curtain at the void. In that dark, empty space, nothing is important. But what if you returned that curtain to its customary place, hid the void again, and changed your focus? What if you focused on...holding your child's hand?"

She began sobbing. "That is just too painful," she said between tears.

Poor health is a real thing. How will you construct your daily practice so as to take that reality into account?

"My advice to other disabled people would be, concentrate on things your disability doesn't prevent you doing well, and don't regret the things it interferes with. Don't be disabled in spirit as well as physically."
— Stephen Hawking

After a while I said, "You can let the void breathe nothingness into your life, or you can decide to hope. That hope is going to brim with pain. But do you want to vote for the void?"

She sat up a bit taller. "I don't want to vote for the void."

"Write poetry from this place," I said. "Whatever this place is exactly."

She nodded. "I completely understand."

Laura resumed her poetry practice. She wrote bathed in pain, but surprisingly easily. She reported that it was a very odd experience, to enjoy writing so much even while suffering so much. Then she got the news. She was pregnant.

"Will this stop the writing?" I asked her.

"I know what you mean," she said. "I can see how it could. I don't want to write about the baby, as that might jinx something. And I don't want to write about other things, about June, the moon, or anything that isn't the baby. I'm not sure." She paused. "But I'll get back to it at some point," she said. "Because it is important."

Food for Thought

1. Are you regularly challenged by health issues?
2. Are you specifically challenged by health issues when it comes to your daily practice?
3. What might you try to meet this challenge?
4. How might you proceed with your daily practice even if you can't completely meet this challenge?

Challenge 12

DEFENSIVENESS

No roadblock to daily practice is more difficult to overcome than the one we ourselves present when we defensively refuse to acknowledge our challenges and as a result don't meet them or defensively refuse to acknowledge our personality shortfalls and as a result don't change.

Everyone is somewhat defensive, and some people are very defensive. This is natural enough. Why wouldn't I want to protect myself from accusations, even true ones? Why wouldn't I want to ignore my faults and avoid the hard work of upgrading my personality? Why wouldn't I call my alcoholic drinking "social drinking" if I want to keep drinking a lot? But while such defensiveness is completely natural, it is also a serious deterrent to daily practice.

Sigmund Freud and his daughter Anna described many of the sorts of defenses that human beings regularly employ. Intellectualization. Rationalization. Denial. Repression. Sublimation. Projection. Displacement. And so on. Psychoanalytic theory has done a lovely job of investigating how we keep painful or uncomfortable information from our own view, miraculously not noticing

that we are lying in a pool of our own vomit or that we've kicked the dog because we hate our boss. All human beings employ these tactics, and some human beings do such a beautiful job of defending themselves that they are well-nigh oblivious.

Tom loved the idea of self-improvement. He loved workshops that promised he would come out a better man. He loved the men's group he'd been attending for a decade. He loved self-help books that assured him all the difficulties he experienced as a man were natural and that help was possible. But then why was it, he lamented, that the woman he lived with was threatening to leave him if he didn't "grow up"?

He promised her that he would change and as a gesture of good faith embarked on a personality upgrade daily practice. She remained skeptical, saying only, "I'm 100 percent certain that isn't the answer."

Having a problem with your practice? Let down your guard, and you may solve it.

"There is a certain degree of satisfaction in having the courage to admit one's errors. It not only clears the air of guilt and defensiveness, but often helps solve the problem created by the error."
— Dale Carnegie

"What do you think she does think is the answer?" I asked him.

"I have no idea."

"What are the charges exactly?"

"That I'm passive-aggressive. I don't really know what she means. I'm never aggressive. I hate aggression, saw too much of it at home. And I'm hardly passive. I do things all the time."

"What does she have in mind? Concretely?"

He shook his head. "Here's an example. I was deep into a woodworking project, and I forgot to make dinner, and it was the night she was having her parents over. I just forgot. That's what happens when you're really working on something, right? You kind of vanish into inner space where there is no time or space. But I came out of it in time to have a great meal delivered, so no harm, no foul! That shouldn't have been a big deal, should it have?"

"Hard to say. Does this happen a lot?"

"No! I've missed picking her up at the airport a few times. Maybe I forgot to mail in a renewal or something like that. Like, her passport renewal. But it's hardly happened more than a handful of times during the eight months we've been together!"

I nodded. "So how have you been using your personality upgrade practice time? What have you been trying or doing?"

Tom got very animated. "I've been reading up on men's issues. I have a dozen books I want to get to. There's so much good stuff out there!"

"And what's the upgrade you're working on?"

"On being more open!" he exclaimed. "More present. More generous. Acknowledging my feelings."

"Ah, yes." I paused. "So you're reading during your personality upgrade practice time. And then you're manifesting these upgrades…where?"

"All over the place! Especially in my men's group. I've been doing a lot of sharing there."

Tom and I chatted two weeks later. "We broke up," he said.

I wasn't surprised.

"Before she left, she taught my parrot to say, 'Stupid Tom!'"

"That's harsh."

"And she's calling *me* passive-aggressive! As if that isn't worse than anything I've ever done!"

"Was there some last incident?"

"No! Nothing important. My men's group ran over, and I was a little late for dinner. Couldn't she have waited twenty minutes? What's twenty minutes?"

"Not much," I agreed. "Though twenty minutes here and twenty minutes there probably does add up."

"Twenty minutes is twenty minutes! Period!"

As with many people, Tom found it extremely hard to see himself or to admit to chronic defensiveness. And, yes, it is a bit odd to ask you to do a better job of noticing how your defensiveness may be derailing your daily practice if you're defensively committed to not noticing. But maybe a part of you, even just a small part, is noticing. If it is, then let me speak to that part.

Yes, it may shake you up to admit what's going on. Yes, it may wound your ego, embarrass you, or sadden you to acknowledge that you have certain faults and foibles. Yes, there will be consequences to being honest. But you know that's the grown-up thing to do, don't you? For the sake of your daily practice but, more importantly, for the sake of your life, bravely peer around the wall that you've erected and look into the darkness.

Food for Thought

1. Are you regularly challenged by your defensiveness (if you can penetrate your defenses enough to know)?
2. Are you specifically challenged by your defensiveness when it comes to your daily practice?
3. What might you try to meet this challenge?
4. How might you proceed with your daily practice even if you can't completely meet this challenge?

Challenge 13

LACK OF PROGRESS

A goal of your daily practice may be that you make progress: that you increase your endurance as a marathon race approaches, that you upgrade your personality in a certain way, that you get better at your flute playing. If you aren't feeling as if you're making progress, that can demoralize you and threaten your practice. It's one thing to intellectually understand that progress may prove a painfully slow affair. It's another matter to try to do something day in and day out that should be progressing but feels stagnant. One part of your mind may be saying, "Give it more time." But another part is likely screaming, "Enough of this!"

Even if you are holding your daily practice as more of a process sort of thing rather than a product sort of thing and even if you have the clear sense that you do not want to begin measuring the utility of your practice according to outcomes, it is still hard not to feel some attachment to the idea of progress. We want to see things happen. It is completely natural to get down on our practice, even to the point of wanting to abandon it, because we're experiencing no forward movement.

Emily was a successful painter who specialized in rural scenes. She had an appealing way of rendering animals, and her barns were especially in demand. She had commissions from all over the world; for her more ambitious projects she would travel to the location rather than working from photographs. What with travel, painting, and her large family, she was enormously busy. And she loved what she was doing.

But something nagged at her. She didn't want to abandon, overthrow, or repudiate what she was doing. But she wanted more, and in two different senses. She wanted to render her subject matter in a new style — but she didn't know what that style might be. And she also wanted to tackle some new subject matter in that new style —

Not feeling like you are making any progress? First, your daily practice isn't essentially about progress. Second, the progress is in there! It will appear in some surprising ways.

"The progress is in the process, and your success is in consistent, intentional practice."
— Melissa Steginus

but here she was doubly stuck, as she didn't know either what that new subject matter or that new style might be. Together, we dreamed up a daily process practice focused on experimenting with new styles and new subject matter choices. But that wasn't going swimmingly.

"I don't think I'm making any progress as a painter," she gloomily informed me one day.

I laughed. "We were going to focus on process, not progress."

"Easier said than done! I like to make completed

things. The second I start something, I want to see it on to completion. By the third brushstroke I'm invested and already thinking about the framing!"

"You are *so* accustomed to turning out product," I said. "You paint, you finish a painting, and there you are with another completed thing. That's excellent! But the flip side is proving problematic. You're used to things just appearing for you…and right now they aren't. How can we make that be okay?"

"I don't know if we can."

"Talk me through it. You can somehow arrive at a new painting style without…experimenting? Without trying things out and throwing them away?"

Today may be the day that you make progress. Or maybe it will be tomorrow. It could happen any day!

"Success may require a lot of days. But progress only requires one."
— T. Jay Taylor

"I don't mind throwing things out!" Emily exclaimed. "But I need to *feel* like I'm making some progress!"

"So we're talking about a feeling?"

"A feeling. But also, a reality. I'm just not learning anything. I don't see even the slightest hint of something exciting or new coming. *That's* the lack of progress I'm feeling. That there's not even a glimmer of the thing I'm looking for in these experiments."

"And you've lost hope?"

"No," she said. "I'm just frustrated."

We sat quietly.

"I wish I believed that something new was coming," she said. "I wish I believed that...I can get better." She shook her head. "It isn't about something as puny as progress. It's about greatness. I don't think I believe that I have greatness in me."

I nodded. "That's probably the mantra then, don't you think?"

"'I have greatness in me'?"

"That's the one."

It is natural to want to make progress. But wanting to make progress is also a trap. Sometimes we may go for a long period of time without making discernible progress, even though we are honorably doing the work, and that can feel terrible. It may be that the progress we hope for is just around the corner — but it may also be that it isn't. Maybe we're obliged to spend a whole week, a whole month, a whole year not experiencing progress. Then that is what we are obliged to do.

Want to make progress? That's reasonable; that's even admirable. But do not stake the life of your daily practice on whether or not you are making progress. Maybe sometimes, for shorter or longer periods of time, progress will not prove to be the right measure. Have a way of making peace with a felt lack of progress when, for too long, your novel doesn't inch forward, your piano playing remains about the same, or your anxiety hasn't lessened.

Stay with your practice; predict success; and do not harp too much on progress.

Food for Thought

1. Are you regularly challenged by a felt lack of progress?
2. Are you specifically challenged by a felt lack of progress when it comes to your daily practice?
3. What might you try to meet this challenge?
4. How might you proceed with your daily practice even if you can't completely meet this challenge?

Challenge 14

MISTAKES AND MESSES

I'm not sure I've ever encountered an odder presenting problem in coaching. Jason, an anthropology professor, had gotten it into his head to become, at his relatively advanced age, a chess grand master. He couldn't explain why. It just came to him as something that he simply had to do. But he was coming up against the following perplexing problem.

"Do you know chess?" he asked during our first chat.

"A bit."

"Okay! So some of the greatest players have preferred to open with the king's pawn. But I have an affinity for queen's pawn openings. But for some reason I like lines that get me into trouble. It's not that I don't know any better. Right there, even on the second or third move, I can hear myself saying, 'Don't do that. That's weak.' Then I do it."

"And you don't have a clue why?"

"I don't! It's bizarre. It's not that I like sabotaging myself. I quite like winning. And what's so funny is that when I get into the middle game, I play very solidly and don't

choose moves I know are weak. It's just in the opening, in those first two or three or four moves. There some trickster inside gets to me."

"Well," I said, "maybe that should be the subject of a daily practice."

"Meaning?"

I explained the idea of a daily practice. "But I'm not sure exactly. The answer doesn't seem to be going over and over the right opening moves. Apparently, you already know what those right moves are. And it isn't that you're making mistakes in any simple sense of the word. It's like there's a conflict. But between what and what?"

He laughed bitterly. "It's like that old movie *Dr. Strangelove*. That evil genius in a wheelchair, his one arm trying to hold back the other arm from giving a 'Heil Hitler!' salute."

I nodded. "Well, let's give the following a try. Let's create a daily practice whose focus is on the question 'Why am I making this particular mess? What's up with me?'"

"And what would that practice look like?" he wondered rather ironically.

I laughed. "I have no idea. You tell me."

"I could set up a game and stop right before I'm about to make that weak move. Typically, that would be right before move three. I could sit there and try to analyze what the hell is provoking me to make that weak third move. That could be the practice."

Were we gods, would we still need to practice? Who knows? We aren't gods.

"Practice does not make perfect. Imperfect makes us practice."
— Mokokoma Mokhonoana

"That sounds perfect," I agreed. "Any sense of how long you might need to sit there or be able to tolerate sitting there?"

He gave that some thought. "Ten minutes," he said. "Maybe fifteen."

"Okay! We have a plan."

At our next meeting Jason reported that he had some inklings but nothing solid enough to name. We tweaked the plan by adding sleep thinking. In the new plan, he would go to bed with the sleep thinking prompt "What's going on?" and invite his sleeping brain to tackle the problem. Then, first thing in the morning, he would go straight to what he'd decided to call his "trickster practice." Two weeks later we chatted again.

"It looks to be four things," he said. "First, computers have gotten so good at the game that playing chess is kind of ridiculous now. Even the world champion won't play the best computer programs. So in making those weak moves, I'm somehow commenting on the absurdity of bothering to play. My weak move is a way at thumbing my nose at computers, artificial intelligence, technology, and the age we live in."

> You made a mistake. The canvas is a wreck. You could wring your hands, or you could move on to the next canvas. Your daily practice isn't over just because a canvas needs chucking!
>
> *"So, make those mistakes, and start over again. It's by fumbling and repetitive effort that real growth and accomplishment happen."*
> — Samantha Dion Baker

"That's quite something," I said.

"Second, it's the way for me to make sure that I don't notice my basic lack of talent. By making that weak move,

I must lose, so I haven't really tested myself at all. Brilliant, yes?"

"Quite."

"Third, it has something to do with a lack of vision. The great attacking players had one sort of vision. The great positional players had another sort of vision. All the great players could see something that wasn't there yet. This is very different from seeing X or Y moves ahead. It's...imagination. I'm making these mistakes to make sure I don't notice that I have no imagination."

"Wow. Okay."

"Fourth, I'm just anxious. It's a way that my anxiety plays itself out. I can't say a lot more about that, as that hasn't become completely clear. But anxiety is a quarter of it."

"And so?"

"And so, I'm through with chess! I've changed my mind," he said. "I've decided to learn to let go. It's even harder than chess."

I had to laugh. "And how will that help?"

"I have no idea! But I'm looking forward to the challenge."

Your daily practice may come replete with mistakes and messes. Whether they are of the most ordinary kind or of the most extraordinary kind, there they will be, ready to derail you. Did you fumble over that chord progression for the umpteenth time? Did you turn your beautiful colors into mud? Did you forget your audition piece at exactly the same point again? Ah, you are not happy! But

do not let your chagrin foil you. Your daily practice is too important to be hijacked by some pratfalls.

Food for Thought

1. Are you regularly disturbed or derailed by the mistakes and messes you make?
2. Are you specifically disturbed or derailed by the mistakes and messes you make when it comes to your daily practice?
3. What might you try to meet this challenge?
4. How might you proceed with your daily practice even if you can't completely meet this challenge?

Challenge 15

FAILURES

It is hard to maintain a daily practice if you experience too many failures. What sorts of failures? Consider Lynda. Lynda had made the difficult, scary transition from worker bee in the corporate world to self-employed business coach. She created a disciplined daily business-building practice and spent between three and four hours every day making the effort to market and grow her business. But her efforts weren't paying off.

The retreat she planned to run didn't fill. The workshop she intended to lead didn't fill either. Both had to be canceled. She tried a collaboration with a colleague that turned into something of a nightmare. She next tried teaching an online class, and while that attracted enough participants, she ended up getting the kinds of biting criticism and complaints that made her resolve never to deal with another human being. Then she created an ebook, producing a lovely and useful product that sold hardly a handful of copies.

"If a friend brought this to you, what would you say?" I asked her.

"That it takes time. Not to quit."

"Which you tell yourself already, I'm sure. And which doesn't seem to be enough. So what else might you say? Or do?"

"It can't be just about reframing these failures as something other than failures," she said. "I know it makes sense not to call these efforts 'failures,' but if they feel like failures, they feel like failures."

I had to nod.

"I don't want to play the game of calling something that didn't work a 'success' or a 'valiant effort' or even a 'learning experience.' That's not going to work."

"Okay." A thought occurred to me. "Maybe what needs to be at the center of your practice is forgetfulness," I offered. "Forgetfulness combined with increased effort. Calculated amnesia and more hours put in."

She contemplated this. "I can buy that. But how do I forget? What does that forgetting look like?"

"It's an interesting question. Anything come to mind?"

"Something did. But I forget."

That got us chuckling. But the dilemma remained.

"Maybe this," I said. "Put up a blank sheet of paper. And when a sense of failure wells up in you, you look at the sheet of paper and forget everything."

I could see her envisioning that. "You know what's funny?" she said after a while. "That sheet of paper has to be just the right size. If it's too big, it won't work. It'll feel, I don't know, overwhelming. And if it's too small, it'll feel too…puny. It has to be just the right size."

"Which is?"

"Eight and a half by eleven."

We both laughed.

"Well, that's easy enough to get your hands on."

"Yes. I believe I have some of that around."

Lynda's tactic worked. That blank piece of paper turned out to be a bit of magic. It also helped that she started putting in more hours and that the next workshop she ran filled up; increased effort and some success gave her a needed boost. But to her mind nothing helped quite as much as that blank sheet of paper, which possessed the magical power of producing the precise amnesia she needed in order to move forward.

Failures, or whatever you're inclined to call them, are bound to happen. It's vitally important to realize that only some percentage of the things you try will work and that, dismayingly enough, that percentage may be a small one. Do you need every one of the short stories you write to be brilliant? Not going to happen. Do you need every one of your marketing efforts to prove profitable? Not going to happen. Do you need every one of your concerts to bring folks to their feet in thunderous applause? Not going to happen.

So how do you want to hold writing an ordinary-and-not-brilliant short story collection, producing an effortful-but-not-successful marketing campaign, or performing an okay-but-rather-lifeless concert? As failures? Or as an inevitable part of the process? Your daily practice may hinge on the relationship you forge with the realities of process. If you understand that not everything will

work and if you do not need everything to work, then you can return to your daily practice day in and day out.

Still, a string of whatever you call them, failures or something else, is bound to prove demoralizing and maybe even practice threatening. It would help a lot if you could increase the percentage of things that do work. And you can. Your daily practice is the path to that goal. It allows you to finish the short stories that may not be working and get to the ones that will. It helps you grow in expertise and understanding as you put in all those thousands of hours in the service of playing the piano, building businesses, supporting causes, or living another of your life purposes. It itself is the path.

Is failure the end? Hardly! It is and must be just the beginning.

"When you 'fail,' you can immediately begin practicing again."
— Bryant McGill

Food for Thought

1. Are you regularly challenged by your failures?
2. Are you specifically challenged by your failures when it comes to your daily practice?
3. What might you try to meet this challenge?
4. How might you proceed with your daily practice even if you can't completely meet this challenge?

Challenge 16

PERSONALITY

Our own personality can get in the way of us starting up a daily practice or maintaining the daily practice that we've begun.

Remember the simple model I presented earlier of personality being made up of three parts — original personality, formed personality, and available personality? Let's refresh our memories, because what may be getting in our way could be an aspect of our original personality or could be an aspect of our formed personality, and those are very different situations calling for very different remedies.

Say that you were born with a high intelligence. That's a feature of your original personality. It quite likely might follow that certain repetitive tasks and types of activities that do not engage your intelligence may seriously bore you and make it hard for you to stay put. That you are intelligent isn't the problem. That it may be difficult for you to tolerate boring tasks is the problem. One possible solution? If you can, make the task more intellectually challenging or interesting. This might mean, for instance, writing a complicated book rather than a formulaic book.

You might have good reasons for writing that formulaic book — for instance, that a publisher and your readers are waiting for it. Maybe it's the kind of book that you enjoy reading as light entertainment. But in the absence of good reasons, you might want to honor your nature and do the intellectually more challenging work. That might sustain your writing practice over the long haul in a way that writing formulaically may not.

On the other hand, let's say that the issue is more a matter of your formed personality than of your original personality. Maybe you've become angry, oppositional, and stubbornly unwilling to compromise as a result of too many experiences where you had to relinquish control and play by some authoritarian's rules. That anger may not "really be you," but it is, now. Those pitched battles you fight all the time may not "really be you," but they are, now. The solution? Maybe a separate personality upgrade daily practice during which you try to heal the wounds caused by that authoritarian contact.

Of course, these matters are fantastically complicated in real life. How do original personality features like high intelligence and keen existential awareness, which can lead to lifelong sadness, play themselves out in a person who grows up with an authoritarian father and an indulgent mother? Just imagine! And what if we try to factor in another dozen original personality traits and another dozen formed personality traits? It would make our head spin. Human beings are fantastically knotted.

Take Jack. I knew Jack professionally, as he was one of

those psychiatrists in the critical psychiatry camp who, as I do, have grave doubts about the logic and legitimacy of psychiatry. I've written many books in this area, among them *Rethinking Depression*, *Humane Helping*, and *The Future of Mental Health*, and we knew each other from conferences, panels, and organizations to which we both belonged, like the International Society for Ethical Psychology and Psychiatry.

Jack wanted to write a case study book in the style of Oliver Sacks's *The Man Who Mistook His Wife for a Hat* and Irvin D. Yalom's *Love's Executioner*. In it, he hoped to show how psychiatry didn't have to be a purely "diagnose and prescribe" sort of thing but could include heart, soul, and wisdom. He wanted the intricacy and complexity of real cases to stand as counterpoint to, and maybe even as a kind of antidote to, the oversimplification of labeling someone as mentally disordered and doing nothing more than prescribing a powerful chemical.

Having trouble figuring out how exactly you need to upgrade your personality? Then that is the work!

"It takes a lifetime of practice, persistence, and commitment to unearth just a few elements of our personality."
— Dr. Prem Jagyasi

Sympathetic to those goals, I hoped that he would find his way to writing it. But he wasn't writing.

"What's getting in the way?" I inquired.

"Me."

I smiled. "What part of you?"

"The part of me that has a failed imagination."

I suspected that I understood what Jack meant, but I couldn't really be sure.

"A failed imagination?"

He nodded. "Even as a little boy, I was the one who had to draw absolutely within the lines. There was a right way to do things and a wrong way to do things. Math was perfect. Math always made sense, even ideas like irrational numbers. Irrational numbers were far more rational feeling than my parents' screaming! I got stuck somewhere with blinders on and my nose to the grindstone."

I thought about that. "And what's funny..." I began.

"I know!" Jack interrupted. "For someone gripped by the need to draw within the lines, why opt for psychiatry, where everything is so muddy? I think I chose psychiatry because I was in some sort of battle with myself, a battle between real science and something...something more artful. Somehow psychiatry seemed like a marriage made in heaven, because you could do real science, like psychopharmacology, and something artful, like psychotherapy. Or so I thought. I had no idea that psychiatry was so far removed from real science." He shook his head. "Maybe I even landed in the right place, because I do help people. But when it comes to tackling this book, I'm positive that I don't have the personality of an artist."

"Do you know what's very much like drawing within the lines?" I said. "Curating a gallery show. An artist provides you with hundreds of images, and you have to put a show together that fits the space and makes sense. That's

not quite math but it does have that flavor of drawing within the lines. Yes?"

Jack nodded. "It does."

"So maybe you can curate a case study, rather than write it. Imagine a case study as a series of images that you select from and line up. That might be a way of working that suits your personality."

"That's very interesting," he said after a while. "Really interesting!"

"It might amount to a personality fit," I ventured.

"It just might!"

Your personality affects your daily practice. How could it not? In order to maintain your daily practice, you'll also need to maintain awareness: an awareness about how well or how poorly your personality is supporting your efforts. If you train your focus on you by identifying any personality changes that you may need to make and then making them, you greatly increase the odds of maintaining a successful and powerful daily practice.

Food for Thought

1. Are you regularly challenged by aspects of your personality?
2. Are you specifically challenged by aspects of your personality when it comes to your daily practice?
3. What might you try to meet this challenge?
4. How might you proceed with your daily practice even if you can't completely meet this challenge?

CONFLICT

Some people thrive on conflict. Most people are put off by it, even paralyzed. An external conflict — say, between you and your boss — is likely to affect your daily practice at least to some extent, even though it isn't connected to it. The residue of that conflict causes a good bit of agitation and ambient anxiety to remain, polluting your practice. That pollution may or may not grind your practice to a halt, though it certainly has that potential.

If, however, the conflict is between two warring positions inside of you and is directly related to the substance of your practice, that will almost surely cause you to abandon your practice. If, say, your doctor is saying one thing and your herbalist is saying another thing and you find both of them rather credible and also a bit dubious, how likely is it that you'll be able to create a daily health practice you'll feel motivated to maintain? Isn't it probable that you'll find yourself in some sort of limbo, halfheartedly doing one thing, then halfheartedly doing another thing, and then maybe doing nothing?

One conflict I encounter all the time is the conflict

that a writer is experiencing when she can't decide if the book she intends to write ought to be a memoir or a novel. Wouldn't a memoir be truer, more honest, and more like the book she intended to write? But as a novel wouldn't it be much less likely to rile up her family? Honesty? Or safety? Honesty? Or safety? Writers in this predicament can get stuck for years and decades.

These internal conflicts are often fantastically tangled. Take Amelia, a successful and well-respected painter who had stopped painting.

"What's getting in the way, do you think?" I asked as we began.

"That I don't want to do this."

"Do which?"

"Be a painter. My father wanted to be a painter. My mother wanted to be a dancer. Neither did what they claimed they wanted to do. Both of them turned art into religion. At least, they talked a good game. And somehow talked me into becoming a painter. But filling up canvases really holds no meaning for me any longer."

I nodded.

"It isn't that painting can't do powerful things," she continued. "There's this Romanian painter who paints crowds of alienated people. They are superb. Makes your heart stop. But that's all it does. It doesn't change the fact that seventy million people are refugees. A painting has never influenced real life. Not Goya's firing squad paintings, not Picasso's *Guernica*, certainly not social commentary urinals. A painting can be beautiful, it can be powerful, it can be amazing, but it can never really matter."

"Then why not stop?"

"I have stopped."

"But you were sort of saying that your stopping was more a block than a decision. Is it a decision?"

"It is a...painful decision. Because I do love something about it."

We fell silent.

"So you haven't completely decided?"

"No, I haven't."

"You can't paint your way through it?"

"No."

We thought.

"You could make paintings," I said, "and donate a percentage of what you sell to the organizations that really can help."

She laughed. "I've considered that one. That's completely sensible. But it leaves me cold. Plus it reminds of those robber barons who went on to donate libraries and medical wings. They were still robber barons."

"You're equating painting with something...unethical?"

"Indulgent."

"But unethical?"

"Indulgence is unethical."

"Even including that Romanian painter?"

"No!" She shook her head. "I value what he does."

"And you couldn't somehow value what you do?"

> The conflict may be between you and you.
>
> *"We are split people. For myself, half of me wishes to sit quietly with legs crossed, letting the things that are beyond my control wash over me. But the other half wants to fight a holy war."*
> *— Zadie Smith*

"I don't know," she said. "That's probably *the* question."

Sometimes a conflict gets resolved. Sometimes one side surrenders. Sometimes it is not resolved and persists for all time. I tried a gambit.

"If one side were to surrender, which side would you want it to be?"

She looked at me. "What are the two sides, exactly?"

"To paint or not to paint?"

Tears formed. "I would like the side that does not want me to paint to surrender. I would like the side that wants me to paint to win."

"But…?"

"But the battle is still pitched."

I remember a small but poignant pitched battle I waged with myself. I had written a book that had come out in two sizes and had done well in each size. A publisher wanted to print a sequel in one size only and asked me which size had sold better. The truthful answer was that they had sold about equal numbers. The strategic answer was to say that one had done much better than the other, making the publisher's decision an easy one. I waged that pitched battle, came down on the side of honesty, and the publisher passed on the project.

Conflicts are tangled, insidious, and draining. They arise for all sorts of reasons — because two band members are squabbling, because two ideas are squabbling, because

> Or the conflict may be between you and them.
>
> *"When I was a kid, my friends would call me to go out with them. But I would stay home because I had practice the next day. I liked going out, but you have to know when you can and when you can't."*
> — Lionel Messi

two personality traits are squabbling — and they come in every shape and size. Even the most minor of internal conflicts can bring your daily practice to a grinding halt. Can that conflict be resolved? That's certainly the desired outcome. That would be lovely. And if it can't be resolved, maybe one side can volunteer to surrender? Maybe a truce can be arranged? If the conflict continues and all else fails, then it will take astounding perseverance on your part to maintain your daily practice anyway.

Food for Thought

1. Are you regularly challenged by conflict?
2. Are you specifically challenged by conflict when it comes to your daily practice?
3. What might you try to meet this challenge?
4. How might you proceed with your daily practice even if you can't completely meet this challenge?

Challenge 18

BOREDOM AND MEANINGLESSNESS

In kirism, we understand meaning to be a certain sort of psychological experience that naturally comes and goes, like any other psychological experience (joy, wonder, anger, sadness); that, on balance, is more made than found; and that can be helped or coaxed into existence by employing certain everyday tactics (like repeating activities that have felt meaningful in the past). We take this to be an unusual understanding of meaning and also a true understanding.

Many important observations follow from this view. One is that, to repeat, the experience of meaning naturally comes and goes — and when it goes, life feels more meaningless and we feel more bored or despairing. A project like writing a book may feel meaningful when we start it; less meaningful when, in the middle of working on it, we see that it is not going well; less meaningful when one day we notice that a book like ours came out on Amazon; less meaningful when, a month later, we change our mind about our central thesis; and so on. Meaning is not anything like static. It doesn't stay put for all time.

The same thing applies when it comes to our daily practice. One day it will feel more meaningful, and one day it will feel less meaningful, even completely meaningless. Why should repeating a chord progression for the umpteenth time not bore us or not feel meaningless? Of course, it might. We need to expect that feeling, understand that it is *just a feeling*, and get on with our practice anyway. If we are living one of our life purposes by sitting there and rehearsing, then that is exactly what we are doing, whether or not we are getting a certain feeling out of the experience.

Another truth about meaning is that we may get only a slight meaning payoff from doing those things that we have every reason to do. Say that you've put a daily activism practice in place and every day you spend a dedicated hour sending out emails to legislators alerting them about what you see to be a problem. You might do that week in and week out and not once be blessed with the feeling of meaningfulness. Indeed, your efforts may strike you as pointless and ridiculous and anything but meaningful.

Then one day you get an email from a legislator saying that she will propose a bill supporting your point of view. In that split second, a wave of meaningfulness might wash over you. Then and there is the meaning payoff, which may last for exactly a minute and not come back for another month of Sundays. Kirists understand that even if they consistently manage to do the next right thing, they may get a meaning payoff only occasionally. The rest of the time they may be poignantly feeling its absence and

pining for it. But they aren't wondering where it went, and they aren't dashing out of the house looking for it. It didn't "go somewhere," any more than joy or anger fled to a neighbor's house. There is nothing to chase: there is just the next meaning to coax into existence.

What does it feel like when we aren't experiencing meaning and don't understand its nature? We feel bored. Life feels empty. We can't find reasons for proceeding. We despair. We doubt our understanding of life and the universe. We pine for something we can't name and don't know where to find. All of this angst just because meaning has gone away for a bit! In kirism, we try to know better than to make too big a deal of meaning having left the room. We are confident that it will return, for fleeting seconds at least; that it is no big deal that it fled; and that it is more likely to return if we make what in kirism we call "meaning investments" and if we seize meaning opportunities.

Will doing the work bore you sometimes or even often? It may. However, will you be wasting your time? Absolutely not!

"Unless you're a true prodigy, you're going to have to practice for a while being bad before you get any good. And it will seem like a waste of time. I remember that feeling well."
— Brad Paisley

We learn to deal with the exact reality of meaning as something that comes and goes. We endeavor to coax meaning into existence by living our life purposes, by repeating what has proved meaningful in the past (like taking our child to the zoo, visiting a great museum, or speaking truth to power), by trying out new experiences that seem like they might provide a moment or more

of meaning, and in other tried and true ways. We don't panic, and we don't announce that "life is meaningless." We smile a small smile of dismay at the nature of reality and get back to living our life purposes.

Say that you've put a business-building practice in place and you are working for three hours every day, half-exhausted after coming home from your day job, trying to grow your online company. So many of the things that you will be doing during those three hours will not feel the least bit meaningful! They will bore you, they will tire you, and they may go zero way toward providing the feeling that you were hoping for and craving, the feeling that "working on my business feels meaningful." If you don't understand what is going on here, your daily practice (and your emotional well-being) will be severely threatened.

Your novel writing was feeling meaningful enough. Then, for some reason — a hard bit, a cloud passing in front of the sun, a headache — meaning leaked out of it, and you no longer found writing it a meaningful experience. A kirist chooses to smile a bit and lament, "Ah, meaning fled. Let me take a shower and then get back to work." Or she says, "This life purpose choice is super dull this split second. Let me go live one of my other life purpose choices." Then she bakes cookies with her daughter or takes up her sharp pen in support of a cause. Or she says, "Let me ceremonially reinvest meaning in my novel. My novel matters to me, and I'm not going to let a whiff of meaninglessness get to me." Then she ceremonially touches the stack of pages that have accumulated, or lights

a candle, or goes to the bookshelf where her published books reside, and murmurs, "You matter, novel. I'm coming back to you now."

Boredom, meaninglessness, and other meaning events, like meaning leaks and meaning shortfalls, are serious threats to your daily practice. It is not so easy to get to your daily practice when what you are feeling is "Damn, this is meaningless!" You can sturdily arm yourself by getting clear on the nature of meaning, a reality that includes its inevitable disappearance...and its regular reappearance. This is an area where kirist thought may particularly serve you. I invite you to learn more, for the sake of your daily practice and for the sake of your overall well-being.

Food for Thought

1. Are you regularly challenged by boredom and meaninglessness?
2. Are you specifically challenged by boredom and meaninglessness when it comes to your daily practice?
3. What might you try to meet this challenge?
4. How might you proceed with your daily practice even if you can't completely meet this challenge?

THE POWER OF DAILY PRACTICE

People who settle into the routine of a daily practice typically love it. They respect themselves for manifesting daily discipline and devotion and appreciate the way that a daily practice helps them get things done. They know that without it they wouldn't write their book, build their business, or sustain their mindfulness practice. But despite all those benefits and goodness, they're quite likely not to continue their daily practice.

Why? We just looked at eighteen characteristic challenges in part III. Those were real, powerful reasons, each capable of stopping a practice in its tracks. The difficulty of the thing undertaken. Boredom and repetitiveness. Inner and outer chaos and noise. Unhelpful circumstances. A felt lack of progress. And then there are the challenges that we didn't explore, like the power of other people to get in the way of us practicing and the sheer, rather amazing difficulty of instituting a new habit. You may be absolutely clear on the benefits of a daily practice and still not pull one off.

Unfortunately, however, if you don't pull it off, you'll

be sacrificing a large measure of your power and squandering a lot of your potential. A daily practice is real muscle, muscle that can't be acquired any other way. And it leads to genuine accomplishments, accomplishments that can't be achieved any other way. Listen to the great pianists or violinists. You are feeling their power and experiencing their accomplishments. Do you suppose that in the process of becoming who they are, they practiced just a few times a year?

Is a solid, meaningful daily practice possible? Of course it is!

"I would not ask you to do this practice, to undertake this path of liberation from the habits of suffering mind, unless it were a feasible path."
— Sylvia Boorstein

I think that the best way to maintain a daily practice is to make it integral to your life as part of a comprehensive philosophy. It isn't just something that you do — it is part and parcel of how you live. That's why I invite my readers to learn about kirism, to see if it is contemporary enough, wise enough, smart enough, and engaging enough to hold your interest. It presents a picture of a way of life within which a daily practice or multiple daily practices fit beautifully. Your daily practice isn't then just some kind of add-on.

Personally, I write every day (or just about). That is my primary daily practice. As a result, I've written between fifty and sixty books. I may write for only an hour; but I write pretty much every day. And so, as effortlessly as ripe apples falling off an apple tree, books accumulate. Yes, there are tedious days. Yes, there are difficult days. Yes, there are days when everything I produced must find its

way to the trash. But none of that jeopardizes my practice, because showing up to the writing every day matches my vision of how my life ought to be lived.

I have other important life purposes that also require daily attention. I have a business to run, which needs me every day. I have a relationship with my wife to enjoy, one that I've been savoring — and paying daily attention to — for more than forty years now. I'm involved in several activist causes, primarily in the areas of critical psychology and critical psychiatry, that don't amount to a daily practice but that I attend to regularly. Every day is a day to pay attention.

Practice. And then just wail!

"You've got to learn your instrument. Then, you practice, practice, practice. And then, when you finally get up there on the bandstand, forget all that and just wail."
— *Charlie "Bird" Parker*

So I have walked this walk. It is a lovely walk. I hope that you'll come join me and do something purposeful every day. That won't necessarily make your day easier, but it will absolutely make it better. Give it a month. Better yet, give it a year. Better yet, give it a lifetime!

I hope you'll take a look at kirism at kirism.com. And come visit me at ericmaisel.com. If you'd like to drop me a note, I'm at ericmaisel@hotmail.com. May your daily practice — or multiple daily practices — serve you beautifully!

ABOUT THE AUTHOR

Eric Maisel, PhD, is the author of more than fifty books in the areas of critical psychology, writing, creativity, and the creative life.

Dr. Maisel, widely regarded as America's foremost creativity coach, is a former psychotherapist, active creativity coach, and critical psychology advocate. He writes the *Rethinking Mental Health* blog for *Psychology Today*, lectures nationally and internationally, and delivers keynotes for organizations like the International Society for Ethical Psychology and Psychiatry and the American Mental Health Counselors Association.

Dr. Maisel facilitates deep writing workshops in locations like Paris, London, New York, Dublin, Prague, and Rome. He has provided reporters hundreds of print, radio, and television interviews and has taught tens of thousands of students through his classes with DailyOM. You can learn more about his workshops, trainings, books, and services at ericmaisel.com and more about kirism at kirism.com.